D1625974

Mastering Black & White Photography

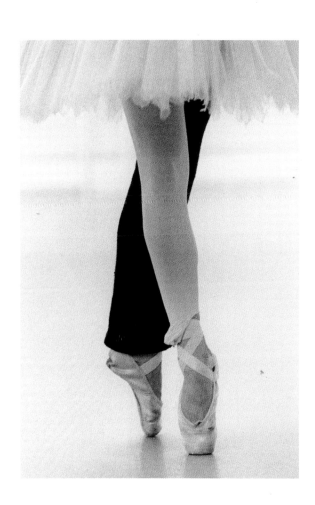

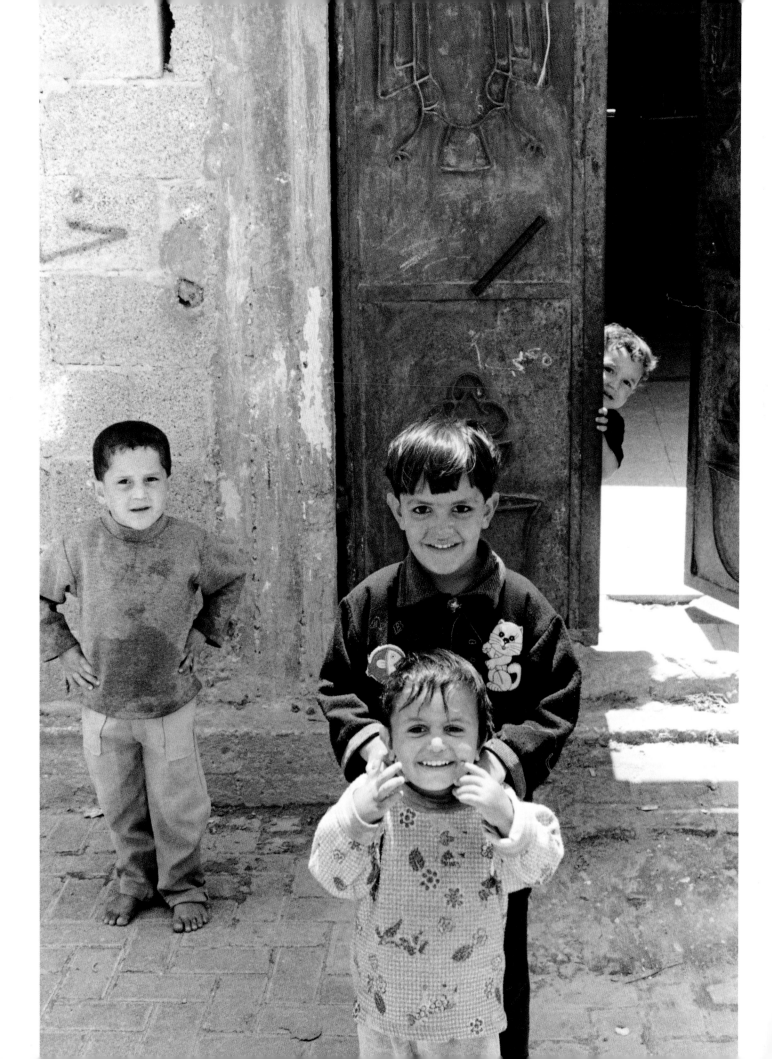

Mastering Black & White Photography

John Garrett

MITCHELL BEAZLEY

Mastering Black & White Photography

by John Garrett

First published in Great Britain in 2005
by Mitchell Beazley, an imprint of Octopus Publishing Group Ltd
2–4 Heron Quays, London E14 4JP

Copyright © Octopus Publishing Group Ltd 2005
Photographs © John Garrett

All rights reserved. No part of this book may be reproduced or
utilized in any form or by any means, electronic or mechanical,
including photocopying, recording or by any information storage and
retrieval system, without the prior permission of the publisher.

ISBN 1 84533 069 2

A CIP record for this book is available from the British Library

Set in Bembo and Gill Sans

Colour reproduction by Sang Choy International Pte Ltd, Hong Kong
Printed and bound in China by Toppan Printing Company Ltd

Commissioning Editor Michèle Byam
Executive Art Editor Sarah Rock
Project Designer Jeremy Williams
Senior Editor Peter Taylor
Production Gary Hayes
Copy-editor Andy Hilliard
Proofreader Kim Richardson
Indexer Sue Farr

Contents

6 Introduction

10 Cameras, films, and lenses

14 Printing techniques

20 PORTRAITS

22 High key: Darcy Bussell

26 A window portrait: Nick

28 Facial geography: Agnieszka

30 Tight composition: Martin Flett

32 Medium Format: A Cretan priest

36 "Snapshot": Mike and Rhella

40 Reportage portrait: Prayer

44 Travel portrait: The widow

46 Heroic portrait: Irek Mukhamedov

50 Sitter and environment: Henry Korda

54 Group portrait: A football team

56 Child portrait: Nick

58 Flash fill with daylight: Dog and hills

60 LANDSCAPES

62 Classic landscape: A Scottish burn

66 Darkroom visualization: Rock stacks

70 Skyscape: Sardinian sheep

74 Right place, wrong time: A landscape saved

78 Nostalgia: An old farm

82 An urban landscape: East End

86 STILL LIFE AND NUDES

90 Graphical composition: Shadow play

94 Tonal management: Angel

96 Low-key window light: Pots

100 Minimalism: A woman's hands

102 Reportage: A man's hands

104 Sculpting with light: Nudes

110 High-key: Flowers

114 ARCHITECTURE AND THE ARTS

116 Filtration: A glass building

118 Abstraction: Skyscrapers

122 Homage to Edward Weston: Virginian church

126 Available light: Canary Wharf

130 High key/low key: Abstract dancers

132 Composition by camera angle: The painter

136 Perspective control: The grain silo

138 REPORTAGE

138 Street photography: Boy and coat

142 Silhouettes: Ballet

146 Management: The wedding

150 Finding symbols: A child

154 Narrative: Police visit

158 News coverage: The checkpoint

162 Corporate reportage: The Savoy Group

164 Glossary

168 Further reading

170 Index

171 Acknowledgments

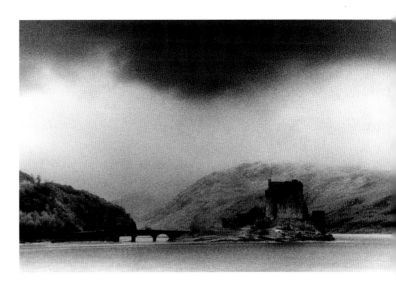

Introduction

THE BACKGROUND

When I was a student, I had an insatiable appetite for the great magazines that featured page after page of wonderful photography. They ranged from *Harper's Bazaar* and *Vogue* to *Life* magazine and *Paris Match*. I also bought or borrowed every book I could get hold of by my favourite photographers: Richard Avedon, Irving Penn, Edward Steichen, Henri Cartier-Bresson, Eugene Smith, Ansel Adams – the list could fill this page.

These publications were inspirational and intimidating at the same time. I was discouraged by the seeming infallibility of those photographers. You never saw the frames that didn't work or a set of contacts that showed you the progression towards the great picture. That's what I'm aiming to do here: to create a book that I would have found very useful in my early years.

THE LEVEL OF THIS BOOK

This book is not aimed at the complete beginner. I have assumed that you will have a reasonable amount of experience – that you will understand the relationship between shutter and aperture, for example, and that you will have developed your own films and have a working knowledge of printing. In other words, I would expect that you have a few other photography books on your shelves (I hope some of them are mine!).

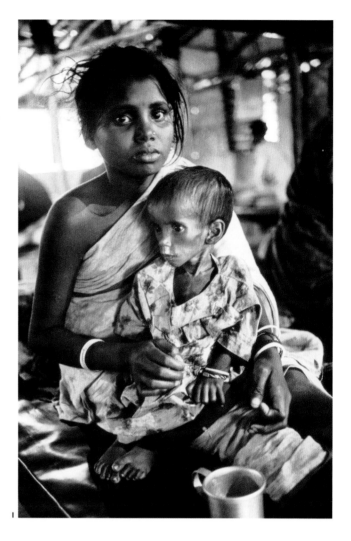

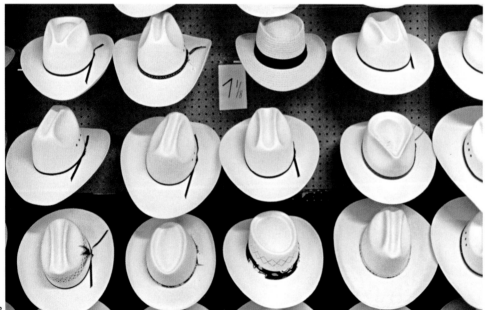

1. REFUGEE MOTHER
This is a picture of a young mother of 15. A refugee from East Pakistan, now Bangladesh, she was a civilian casualty of the India–Pakistan war of 1971. There were thousands of these young girls, their pregnancies the result of rape by soldiers. Many of the babies starved to death. The picture was on the front page of *The Times*.

2. AMERICAN STILL LIFE
Cowboy hats in a shop window in New Mexico. As a traveller passing through, it just said USA to me – it could not have been taken anywhere else. Small still lifes can often tell a much bigger story than more grand subject matter.

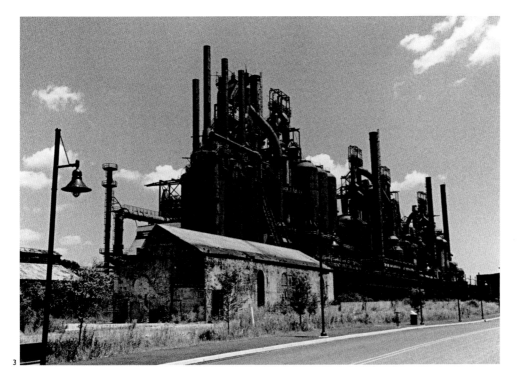

3. INDUSTRIAL LANDSCAPE
The sadly derelict foundries of the once all-powerful Bethlehem Steel works of Bethlehem, Pennsylvania. This is just a small section, but I was attracted to its rather sinister black sculpture. I shot on 24–85mm zoom using a red filter. Kodak T-Max 3200P film added some grainy drama.

4. PORTRAIT
Paul McCartney shot for *The Sunday Times* magazine back in 1983, when we were both much younger. It was actually a colour assignment; I just snapped a few black and white frames for myself at the end of the session. I used the trusty window light and shot on Ilford HP4 using a 105mm lens. He is a nice guy, actually.

VISUALIZATION

Having said that, I would like to emphasize that you should not be intimidated by the technical side of photography. Photographic technique has always been shrouded in mystery – unnecessarily so, I feel. All the technical knowledge you need to make a good picture can be learned quickly.

I have always believed that knowing the background of an image, understanding the circumstances surrounding its creation, is as important as the technical information when it comes to learning about taking pictures. The key to black and white photography is visualization: the ability to see our colour world in black and white. Technical decisions become creative decisions as the photographer's ability to visualize improves. In this book I have tried to pass on to you how it really is, the why of the pictures and not just the how.

In the real world the conditions in which professional photographers have to work are often less than ideal. But if you want to get paid for the job, excuses are not acceptable; only good pictures will make the grade. So over the years one learns to produce an interesting black and white print pretty much anywhere and at any time.

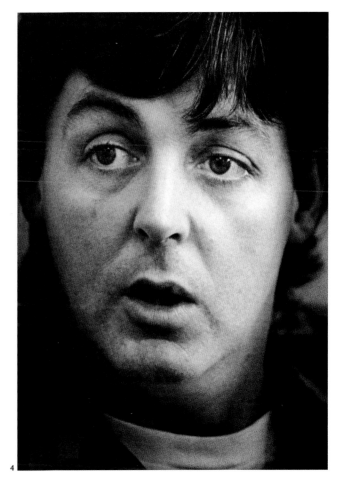

I trust that my experience in the making the most of conditions will be helpful to you.

FILM VS DIGITAL

This book applies to digital photography as well as those using the traditional approach; the visualization is the same – it is only the technology of recording the image that is different. Whether you choose to print on the computer or in the darkroom you need to know what a good print looks like and the potential of the negative or the digital image when you get down to making a print. The ultimate aim is to be able to see that finished print in the mind's eye before you even start to take the photograph.

I have taken all these pictures on film because that is the method I have used all my life. I have used digital on commercial jobs, where it makes the production end easier for my client. However, I have yet to see a digital print that is better than a darkroom print, so I continue

1. THE CHEESE MAKER
I was staying at his farm in Sardinia and he was kind enough to pose for this portrait. I have exaggerated the size of his hands and the cheeses by using a 28mm lens. The low angle adds some authority to his image.

2. CHURCH, TAOS, NM
I love the adobe buildings of this area of New Mexico. This church has been photographed by Ansel Adams and Edward Weston to name just two. I went for the frame-within-a-frame composition with my 28mm perspective control lens.

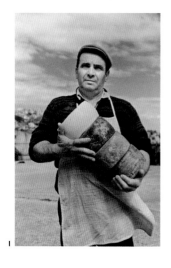

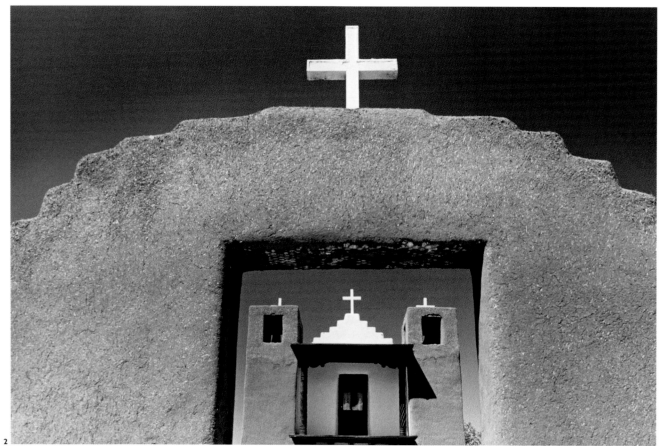

3. POVERTY
A strange portrait taken on an assignment about poverty in the UK (c.1975). The distorted body shapes and the odd composition add to the tension that is obvious in each person. I used a 28mm lens in available roomlight. The Ilford HP4 film was pushed to ISO 800.

4. THE NEGOTIATOR
The 80–200mm zoom used at 200mm has enabled me to make a bold composition of this Palestinian negotiator during a TV interview. The lighting is by the camera crew. I shot on Ilford HP5+ rated at ISO 320. The aperture was wide open at f2.8.

5. REFUGEE, GAZA CITY
When I turned to take her picture she flashed the victory sign at the camera. I find her intensity very moving. The selective focus that has made her sharp and her fingers in soft focus adds much.

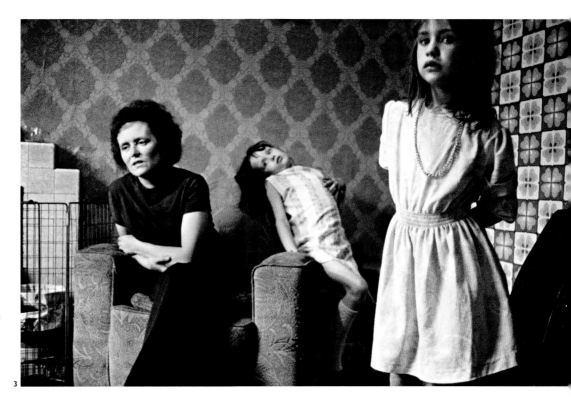

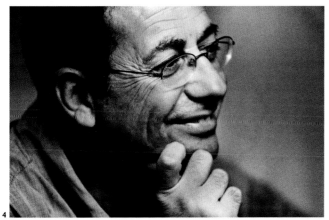

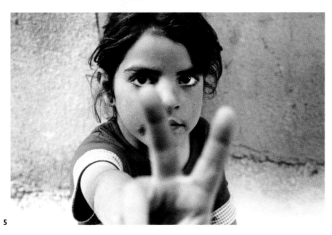

to shoot most of my black and white photographs on film.

The bottom line is that photography is more about the photographer than it is about technology, about his or her ability to really see – to unlock the patterns which make up our world. The study of light and what it does to tonal management is the essence of black and white photography, and technical knowledge used creatively mightily enhances that visualization.

KEEP AT IT!
Photography should be a joyful experience, so let's not get hung up by a few failures – I am learning all the time and still manage to screw up occasionally. I just try to learn from the mistake and load another film into the magic box.

John Garrett

Cameras, films, and lenses

CAMERA FORMATS

Analogue camera formats divide into three basic groups, depending on the size of the negative: 35mm, medium format, and large format. The 35mm negative is 36 x 24mm. Medium format has three main divisions: 6 x 6cm, 6 x 4.5cm, and 6 x 7cm. Large format goes from a 5 x 4in to a 10 x 8in negative. The theory is that the larger the negative that you print from, the greater the quality of the print. But what is good quality? Traditionalists mean a very fine grained, pin sharp print with a full tonal range. To me, a good quality negative is one that provides me with the information that I visualized when taking the picture. That could well be a grainy, soft focus, contrasty negative. Having worked for most of my career as a photojournalist, 35mm accounts for about 75 per cent of my output and the rest is on 6 x 6cm (using a Hasselblad).

FILM

Film divides up into three major groups according to its speed (the rating in ISO of a its sensitivity to light). As a general rule, the slower the film (and the lower its ISO rating), the finer its grain structure, the higher its resolution (sharpness), and the higher its contrast. Slow films range from ISO 100–125, medium speed are ISO 400, and fast films go from ISO 1600 upwards.

The workhorse of the black and white practitioner is the versatile medium speed film, examples of which include Ilford HP5+, Kodak Tri-X, Agfa APX 400, Fuji Neopan 400, Ilford Delta 400, and Kodak T-Max 400. These films reproduce an enormous tonal range and are sharp and fine grained. For subjects such as portraits, landscapes, and still life, I rate the film at ISO 320; for reportage I rate at 600.

My advice is to find one or two films that you like and get to know them. I have used Ilford film all my career,

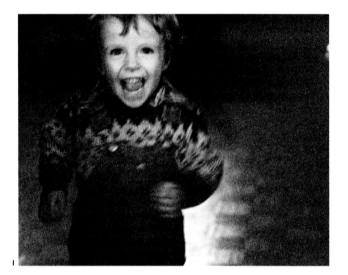

1. FAST FILM
This is an example of the use of Kodak T-Max film rated at ISO 5000 and pushed in the development. There was very little light and this little fellow was on the move. The grain structure is large but that only adds to the energy of the picture. The alternative would have been flash. I prefer the look of the available light treatment.

2. SLOW FILM
This is the kind of subject that one usually associates with slow film. The detail that the Agfa APX 100 has reproduced is remarkable and confirms the potential of the 35mm format. The original print looks as though it could have been shot on 5 x 4in film. The superb cross light has greatly helped the sharpness of the image.

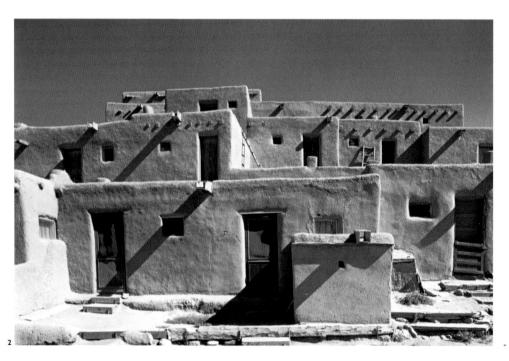

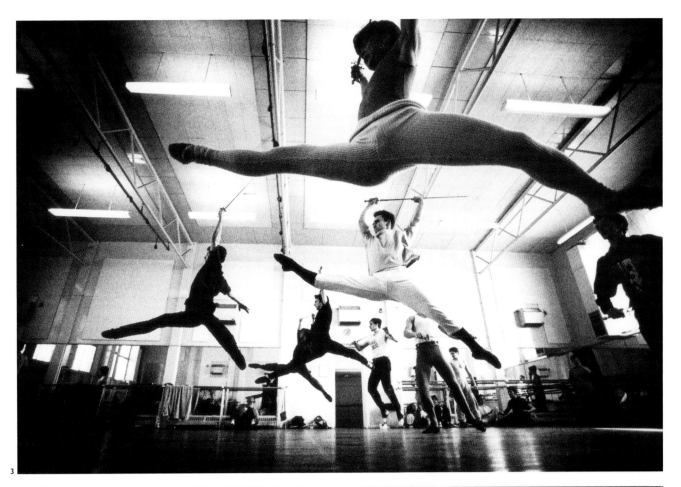

3

3. FAST SHUTTER SPEED
The fast shutter speed has frozen the dancers and created a powerful composition by providing hard edges to the tones. The shape of the foreground dancer has created a frame within a frame.

4. SLOW SHUTTER SPEED
Here is an example of a slow shutter speed on a moving subject. Note how all the tones have merged together at 1/8 sec. The impression of movement is created by the blur of the tones. By slowing my shutter speed I had to stop down to f16 to maintain a correct exposure.

4

but Kodak and Agfa are first class too – it's simply a case of what you get to know best.

APERTURE AND SHUTTER SPEED

I am assuming that the reader has a basic knowledge of the way the shutter and aperture mechanisms work to control the exposure of film in the camera. Beyond this, they offer ways of planning the tonal management of the picture.

Aperture controls the depth of focus of the photograph. By shooting wide open (using a large aperture, eg f2), you can throw the foreground and background out of focus (known as selective focus). Alternatively, by stopping the aperture right down (eg f16) it is possible to hold sharpness right through from foreground to infinity. When using selective focus you are creating a soft merging of the

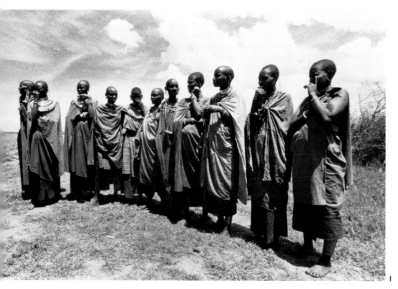

1. WIDE ANGLE LENS

The exaggerated perspective created by the 24mm wide angle lens has created the compositional interest of this portrait of Massai women in Tanzania. The difference in scale of the front figure to the back figure is much greater than to the naked eye.

2. TELEPHOTO LENS

A 300mm telephoto lens has pulled the background in closer to the cowboy than it really appeared. I shot on a fairly large aperture (f5.6) to ensure soft background tones that would not distract from my star.

3. MIRROR LENS

Mirror-type telephoto lenses are very compact and inexpensive, but do have the disadvantage of having a fixed aperture. Out of focus reflected light produces a distinctive "doughnut" effect with this kind of lens that can sometimes enhance your pictures.

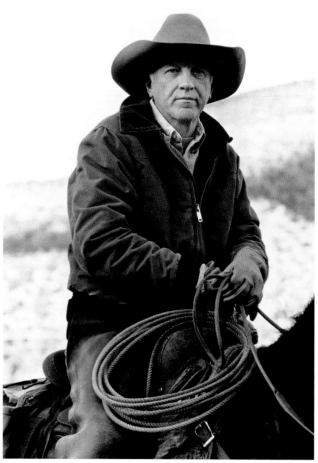

LENSES

Most people use their telephoto to get them closer to a subject and their wide angle to "get more in", but these lenses have other great creative applications built in. Lenses control perspective. The longer the telephoto lens, the more it condenses perspective; equally, the wider the angle of a lens, the more it exaggerates perspective. Those properties can be used most effectively in tonal management of black and white images. The telephoto has the ability to "pull up" the background until the subject and background appear almost pasted together. The tele lens also has an inherent lack of depth of focus and used wide open can produce an extreme of the selective focus effect; alternatively, by stopping down, it can hold all those "pasted on" background tones sharply separated. The wider the angle of a lens the greater is its inherent depth of focus. We can use that property to hold sharp-edged tones. I would strongly suggest that you do lots of experimentation. Shoot the same subject on a variety of lenses and it will really open your eyes to

tones in the foreground and background, as compared to the sharp-edged tones created when you stop down.

The shutter can also be used as a creative tool. A high speed will freeze movement, resulting in sharp, clearly defined tonal separation. By using a slow shutter speed on the same subject you can blur the tones together to create an entirely different tonal composition.

the creative possibilities that your zooms or fixed focal length lenses offer you.

FILTERS

Basically, coloured filters lighten the tones of colours in their own end of the spectrum and darken the tones of the colours at the opposite end, eg a red filter will turn the blue sky of a landscape dark grey and the red roof of the farm house to almost white. They are the most dramatic way for a photographer to manipulate tonal contrast. Filters increase contrast, so you need to be careful to get enough exposure into the shadows, otherwise you will end up with a thin (underexposed) negative that will be difficult to print. If I am using the camera's meter I add 1 stop for a red filter and a ½ stop for an orange filter. I also use a polarizer that works by cutting reflected light to more contrast. A graduated neutral density filter is useful to even out the contrast if the prevailing contrast of the light threatens to produce a neg that will be difficult to print with a good range of tones.

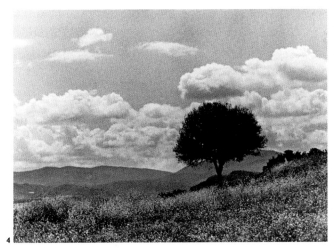

4

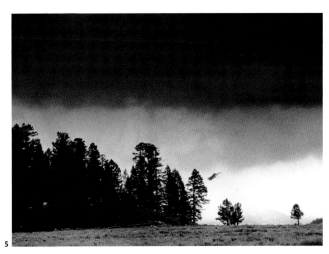

5

4. ORANGE FILTER
A typical example of an orange filter at work. The effect is more subtle than that of a red one (compare with illustration 6). I find that I am choosing the orange filter more often than I used to.

5. NEUTRAL DENSITY FILTER
A graduated neutral density filter cuts the exposure to half of the frame, but in a gradual not a hard line. There was a dark area of cloud in the top half of frame but I have exaggerated it with the filter. You will find examples in the book where I have used a grad to even out the exposure when the contrast top to bottom of the negative was too great, which would have made printing difficult.

6. RED FILTER
The good old red filter. I now carry a light red and a dark red filter in my bag. Sometimes I find that the dark filter sends the sky too black and the light one is just the job.

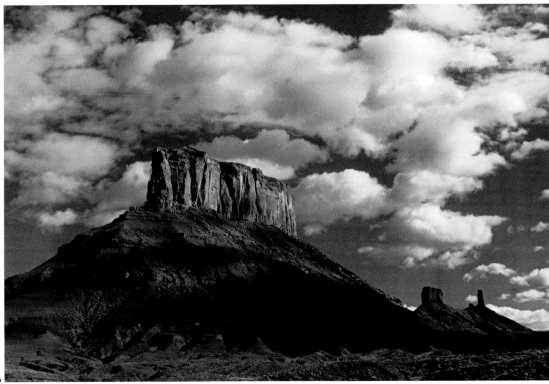

6

Printing techniques

I am assuming that the reader has some basic darkroom experience. This section is a brief overview of my own printing techniques and a resource to return to when reading the case studies.

THE NEGATIVE

The negative is the most important single element in black and white photography. I think that we often make the mistake of taking negs for granted and placing nearly all darkroom emphasis on printing techniques.

Negative quality starts with the decision of what film we choose. As I said earlier, film speed dictates the potential contrast of your neg (slow film – high contrast; fast film – low contrast). So, the decision can be based on several criteria. 1) Do I want high contrast, fine grain, and high resolution? 2) Does the subject require fast film, eg low light conditions? 3) Do I want grain for its creative contribution? 4) Will I be shooting in a range of lighting conditions on the same film? 5) Do I want a negative with as complete a range of tones as possible?

FILM AND DEVELOPER

There have been reams written about which developer produces the ultimate negative from each film, but I believe in simply using the developer that the manufacturer recommends for their films. Despite regular experimentation, I always come back to the combination of the Ilford's HP and FP films with their Microphen developer. As a general point, I believe you need to add 15 to 20 per cent to manufacturers' recommended development times to get a complete tonal range.

DIGITAL PRINTING

For computer printing the vision is the same, you are just using different tools. However, you can't make a good print on the computer unless you know what a good print looks like. When I talk about dodging or burning in you have the tools in Photoshop to do exactly the same thing. I prefer the darkroom print technique personally because I think that it can't be bettered, and I love the craft of traditional print making.

THE BASICS OF PRINTING CONTACTS

The first step once you have produced a negative is to make a sheet of contacts. I file my negs in transparent rather than translucent sleeves so I can make contacts with them in the sleeves. This is much quicker and saves unnecessary handling.

1–3. FILTER GRADES
I have included these prints as examples of the variable contrast system. The first print is made on grade 1, the second on grade 3, and the third on grade 5.

I selected only these three grades because the subtlety of difference between all the grades may get lost when printed in the book.

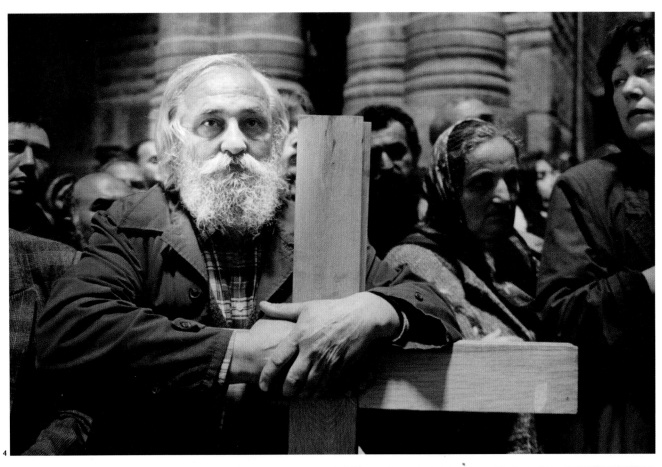

4

4. SHADING/DODGING
The man with the cross is an example of shading back to place greater emphasis onto a portion of the print, in this case the man's face (4 secs). I also burned in some extra density into the surrounding figures (5 secs).

5. BURNING IN
I burned in the sky considerably (25 secs, in fact) to add some drama to the road into Death Valley. I also shaded the road to to emphasize the dawn light that was falling on the wet tarmac (5 secs).

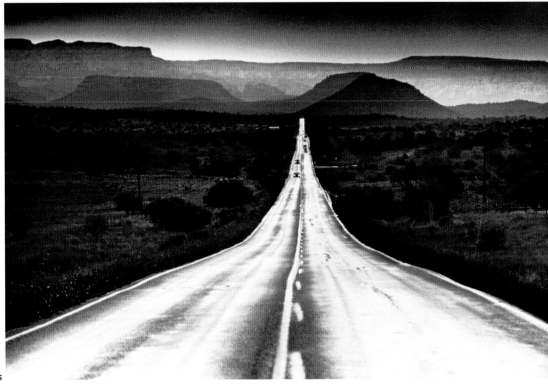

5

I prefer to make low contrast contacts so that I can see all the tones available to me in the negative. Make sure that you number the negs and contacts and get them into a file straight away to avoid chaos later on.

PAPERS

Traditionally, printing papers come in 5 grades, 1 being the lowest contrast and 5 being the highest. Personally, I regard the arrival of variable contrast papers as a huge improvement. With these you only need one box of paper because the contrast is altered by either changing filters or, if you have a multigrade head on your enlarger, by selecting your preferred contrast. This is not only more economical, but more flexible too: you can go between grades, eg 2½ and also use several grades on the same print. Another boon is the development of resin coated (RC) papers. Coated on a plastic rather than a fibre base, the prints only require 2 minutes

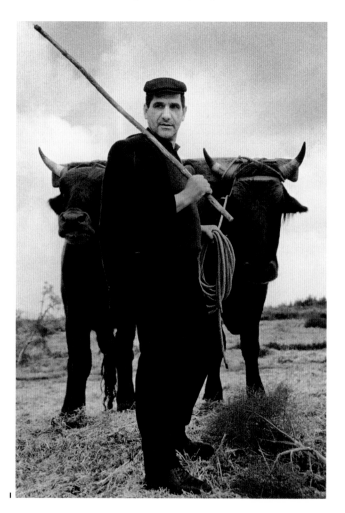

washing rather than 45 minutes for fibre-based (FB) prints. The loss in quality is marginal.

I mostly use Ilford and Forte papers because I have got to know their properties over the years, but all the papers on the market are very good. It is when you come to toning (see later) that paper choice become critical.

BURNING IN AND SHADING

Almost every print benefits from a degree of burning in or shading. Burning in is adding additional exposure to an area of the print that seems too light. Shading – or dodging – is giving less exposure to an area a print by holding a dodger or a hand between the lens and the paper. Dodgers are made by cutting pieces of card to a shape similar to the area of the print you want to shade and fastening it to a thin wire (piano wire is good). You can buy dodger kits in big photographic shops.

The primary decision is whether you are going to make an all-over exposure and shade back the areas that are printing too dark (subtractive printing) or make a basic exposure for the most of the print area and then burn in the highlights with additional exposure (additive printing). Some prints require both approaches.

To really control these techniques I strongly recommend that you print large enough (at least 10 x 12in). On a small portrait, for example, it is almost impossible to make a dodger tiny enough to shade the eyes if they are going too dark – and they usually are.

FLASHING IN

If the contrast range of the negative is so extreme that it difficult to hold detail in the highlights, try flashing in. Make an extra short exposure of the paper either before making the print (without the neg in place) or during the development of the print. The highlights will fog in with detail without hurting the rest of the print. I prefer the flash during development method because I can see what's going on. I have a tungsten light on a dimmer switch a metre (3 feet) above the developing dish. I dim the light until it is only about 10 watts. When the print has developed for 45 of its 90 seconds development time, I flash the light on for about a second. As soon as

1. A "NEG FROM HELL" (left)
The unusual diffused backlighting resulted in a very uneven negative with an extremely difficult tonal range. In retrospect, a fill flash or a reflector fill would have been wise. I used a basic exposure of 14 secs at f5.6 on grade 4 contrast and shaded his body and the bullocks for 6 secs. I then burned in the surrounds for 14–15 secs. After drying I decided that the print was still too flat so I bleached it back for a minute in Farmer's Solution to add that old-world colour.

2. HEAVY TONING
This is an over-the-top example of toning. I include it to demonstrate the amount of colour saturation that you can get from toning if that's what you're looking for. I used the Fotospeed Palette toning kit – blue tone, obviously.

3. SPLIT TONING
I used two toners to get this effect. I sepia toned the ballerina first and then decided to go mad and tone the print again in gold toner. The result is a bit extreme, I suppose, but the print does have that great glow that gold toning produces. Both selenium and gold toners add a rich depth to prints.

4. A RESCUE JOB
The rain had just started to fall and the light was dull, dull, dull. The first print attempted lacked contrast in the mid-grey tones, and the white driveway was not showing as well as I would liked. I made a print on grade 5 contrast that was about 60 per cent darker than I finally wanted and then bleached the print for 5 minutes in Farmer's Solution. The bleach stripped the drive to a bring it alive, as well as adding some contrast overall and imparting a tone to the print.

2

3

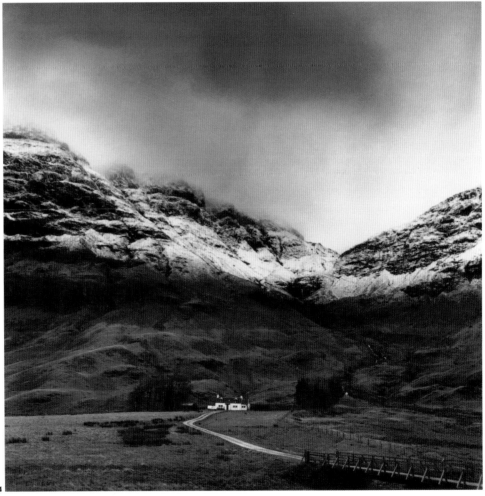

4

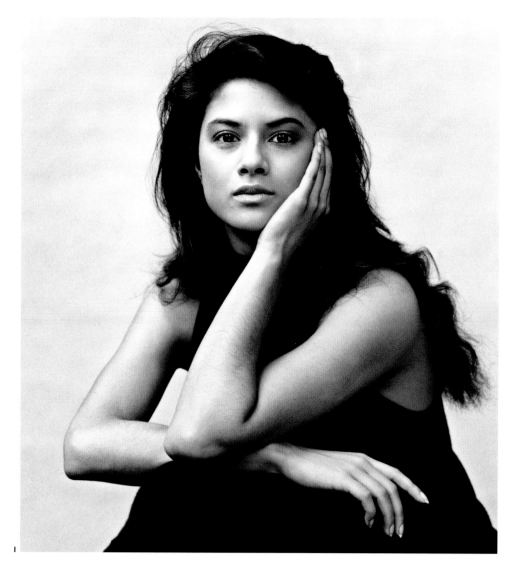

1. FLASHING IN
I often use a flash in for this kind of situation. The white background needed a slight grey tone to hold the portrait onto the page. It would be impossible to burn in as evenly as this in the enlarger. The flash in technique has added a grey to the background without degrading the tones of the subject.

2. DIGITAL RETOUCHING
I have used a portion of a negative that has blemishes to enable me to talk about retouching in Photoshop. Dark marks like these are really a pain to remove with the traditional method – scraping away with a scalpel. It is a difficult skill to master. The cloning tool in Photoshop (shown just to the right of the marks) can erase them in seconds.

3. SPOTTING
I retouched this pic with the traditional spotting method. I was unhappy with the shape the sweater was making. I filled in the offending holes in the line of the sweater with spotting dye using a very fine camel hair brush. As the method suggests, it is literally done one spot at a time.

some highlight detail appears, I whip the print out into the stop bath.

TONING

Toning is not only used to add colour to a black and white prints, but also to increase their archival longevity. Selenium toner is the most commonly used archival preservative, but gold toner and sepia are also effective.

Toners produce very different results depending on which manufacturer's paper you use, so you need to experiment. In general, fibre-based papers respond better to toning than resin-coated papers. Gold tone will turn Forte FB papers a subtle blue and do nothing to Ilford RC papers, for instance.

The development of one-bath toners has been a great blessing. You can now create an almost endless variety of tones, from the most subtle to the most garish, with toning kits. You don't have to bleach the print and then develop back the image in the chosen toner; you just pop the print in the toner and the job is done.

It is essential that you thoroughly wash your prints before toning, otherwise you risk staining. Five minutes in running water at 20°C/68°F is ideal. Most toners reduce the print density by about a third, so remember to print a third darker than usual. They also increase contrast, so you may want to print a half a grade softer. I always make make at least three prints to tone, each one a slightly different density.

As always, be fastidious about cleanliness to avoid contaminating your dark room, and if you use selenium or gold toners, ensure good ventilation – the fumes are toxic. Also, make a darkroom diary; otherwise you forget what you've done and learn more slowly.

BLEACHING BACK

Bleaching is the first process in traditional sepia toning. The usual choice is Farmer's Solution, a combination of potassium ferricyanide and hypo. I like to use it as a process without the sepia too: a short dip in a weak solution of Farmer's strips a print's highlights and brightens it up by increasing its contrast. The usual dilution of about 10–15 parts water to the Farmer's needs to be increased to about 25 to 1. I keep a dish with running water next to the bleach and just bleach for about 10 seconds at a time, then wash off and bleach again if needed. The bleaching process continues slightly in the wash, so go easy. If you bleach back strongly you will produce a warm Victorian sepia tone. To avoid staining make sure the prints are well washed before bleaching.

Farmer's Solution is also used for localized bleaching of the print. Once again, I recommend a weak solution. Use a windscreen wiper to wipe the excess water from the print. I dip a cotton bud in the bleach and in short stages apply it to the area. If the area is really small I use a fine spotting brush. Keep washing off after each application until you achieve the required result. Be patient: localized bleaching is a painstaking process; you may find it easier to do the job in Photoshop.

RETOUCHING

Most retouching of prints can be avoided by making sure the negs you are printing are completely dust free. Keep your drying cabinet clean and avoid using a fan heater to dry the negs – it stirs up dust.

To remove the white spots caused by dusty negs use spotting dye on a fine camel hair brush; black spots can be scraped off with a scalpel. The more creative area of retouching is the improving of shapes by adding tone with the brush. These methods are slow and tricky to perfect; it is in retouching that I think Photoshop really comes into its own.

2

3

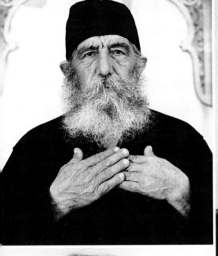

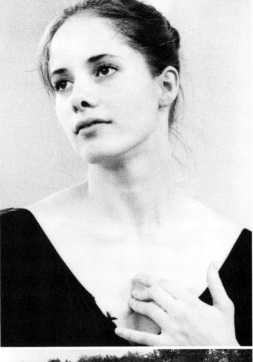

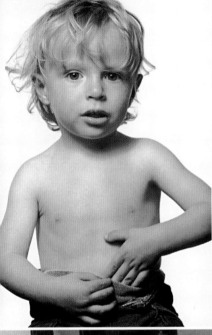

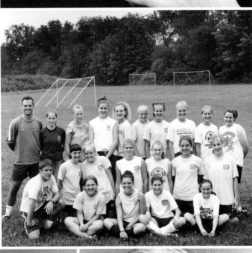

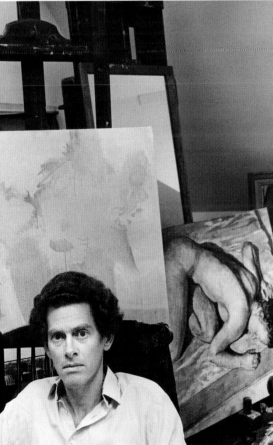

Portraits

So much has been written about photographic portraits by so many learned people that I hardly know where to begin. There is an almost infinite variety of styles, from the high street portraitist's faithful likeness to the personally interpretative portraits of, say, Bill Brandt or Arnold Newman. Over a long career I have had to shoot flattering portraits, including beauty portraits to sell cosmetics, as well as critical portraits to illustrate magazine articles. In the course of earning a living – as photographers in the real world must, just like carpenters or accountants – I have learned a trick or two that makes the taking of a portrait a much easier and less stressful job than it was in my early days.

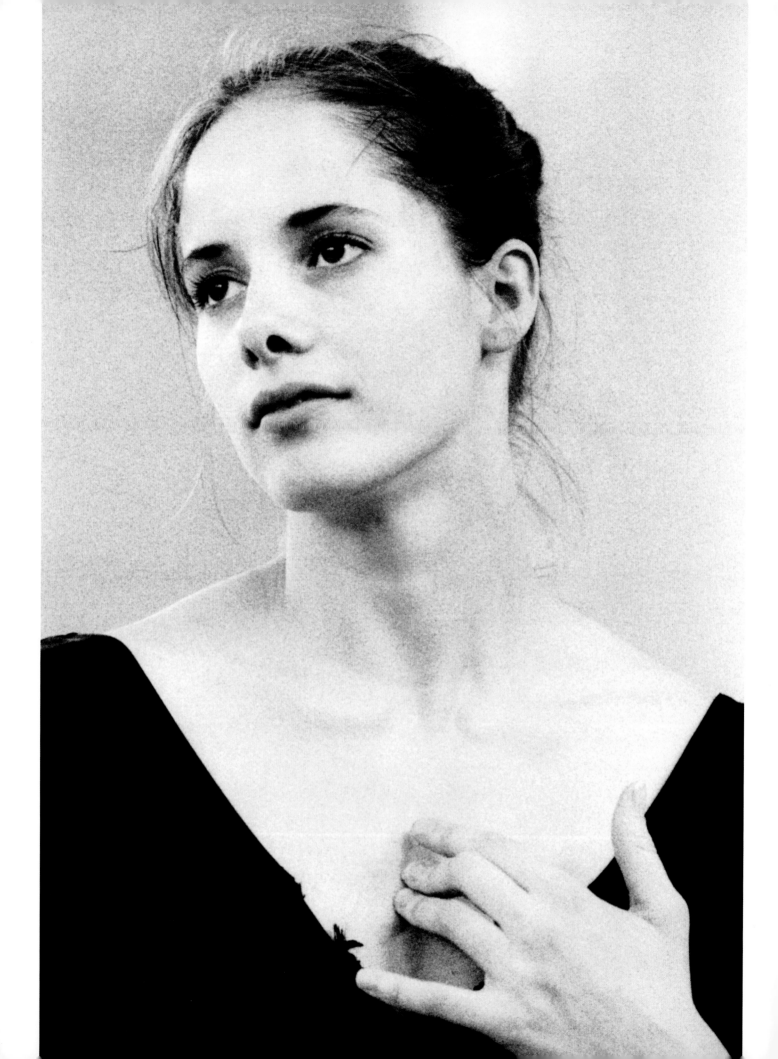

High key: Darcy Bussell

Darcy Bussell is one of the greatest ballerinas and, I might add, one of the most beautiful. Most of the portraits one sees of her show a dazzling smile, but ballet isn't a glamorous or pretty profession – it's a hard, sweaty business, and to be a star you have to be tough.

EYE POSITION
I made this portrait during a pause in a Royal Ballet rehearsal. The tendency when taking portraits is to have the subject looking straight at camera – the eyes being the windows of the soul, as the cliché has it. Though I wouldn't argue with that, I think that a portrait of the subject looking away from camera, in their own world instead of reacting to the photographer's directions, can reveal more about them. I chose this portrait because Darcy is with her own thoughts, perhaps visualizing a piece of choreography, and it has a certain penetration to it.

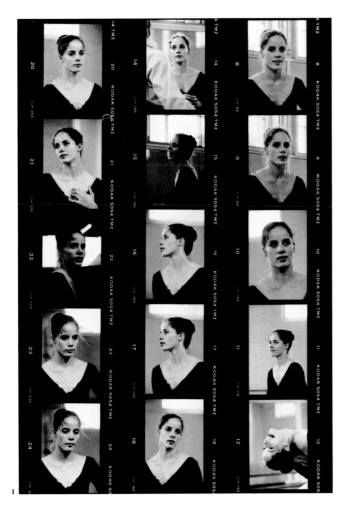

Tonal management of the picture was presented on a plate. I had a diffused backlight from skylights and large studio windows, which was bounced back to Darcy off white walls, thus creating the classic high-key portrait light. The black leotard doesn't distract from her face; its frayed edge adds a bit of grit. I shot from a low angle, which not only meant that I could show her swan-like neck and isolate her against a non-distracting background, but also that I could keep myself out of her eyeline so she wouldn't react to the camera.

REVISITING SHOTS
When I first printed this picture (five years ago), I cropped the hand out, thinking that it distracted from the face. When I later reassessed it I realized that in fact the hand added greatly to the portrait, the tension revealing some of the feeling going on behind the face. I often see my pictures quite differently when I return to them after a while. Some of the emotional connection from the session has faded, so I am more detatched and critical, perhaps viewing the pictures more as a printer than as a photographer.

I chose Kodak T-Max 3200P film rated at ISO 3200 – the fast film allowed me to freeze the action, while its grainy character added some grit to the picture. I used an 80–200mm zoom lens, wide open at f2.8. The narrow depth of focus that the zoom gives at f2.8 has thrown the background way out of focus, thereby removing any distracting background detail.

PRINT LARGE
Remember that to make good portrait prints an image must be large enough to permit the use of dodgers to lighten eyes. I print on 12 x 16in paper and leave a border, but size varies depending on format, crop, and so

I. CAPTURING CHARACTER
I've included the contacts here to illustrate the context from which the portrait was taken. The series shows the search you make trying to find the definitive interpretation of character. The composition of the chosen picture stands out, I think you'll agree – the angle of the head is more pleasing.

on. I shot a test roll at the end of the session to use as a processing test – for anything important or tricky I always do this. Development time was 13½ mins in T-Max developer at 20°C (68°F). Kodak's recommended time is 11 mins, but makers' times are always out. My first test print was 10 secs at f4 on grade 3. The result was too flat, not the high contrast I wanted. My second attempt was 12 secs on grade 4½. The eyes were too dark, so the final print was 12 secs, with each eye shaded for 3 secs. I printed on Ilford Multigrade warmtone semi-matt FB.

In the darkroom the final decisions are made that affect the emotional impact that a portrait has on the viewer. I recommend that you test several grades of contrast before you decide which works best for the portrait. There are grades ½ to 5 at our disposal – why not try the lot?

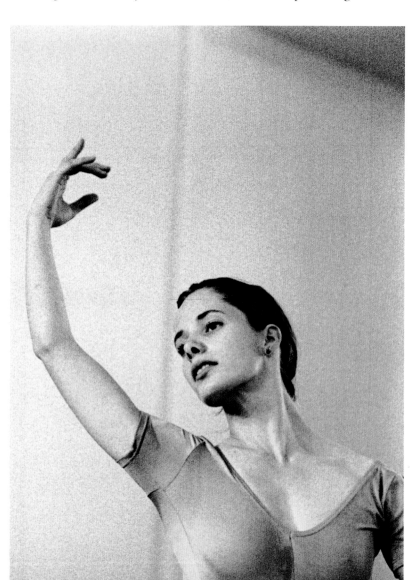

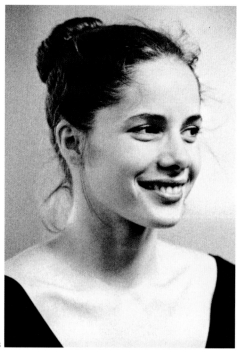

2. DISTRACTING TONE
I took this picture on a previous shoot. Note that the light-coloured leotard doesn't work as well from a tonal point of view as the black one. These are the details that matter so much in black and white.

3. SHADOW
The famous smile, but the lower position of the head has shadowed the face and neck – not an elegant solution really.

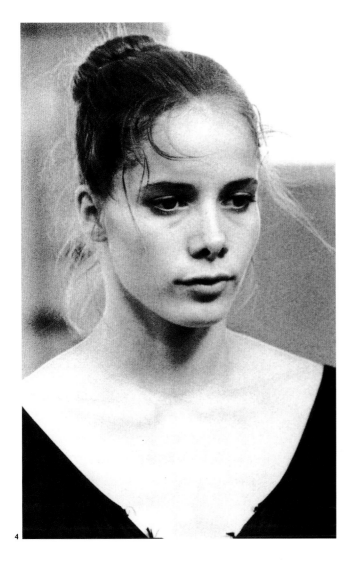

4

4. EYES
I like her intensity here but the eyes are rather dead, having not picked up the top light due to her lowered head.

5. FINAL PRINT
The light in Darcy's eyes, the angle of her head, the added drama of the hand and the shape of the leotard have combined to make a stronger portrait. It's extraordinary when you analyse the number of decisions one has to make during the taking of a simple picture.

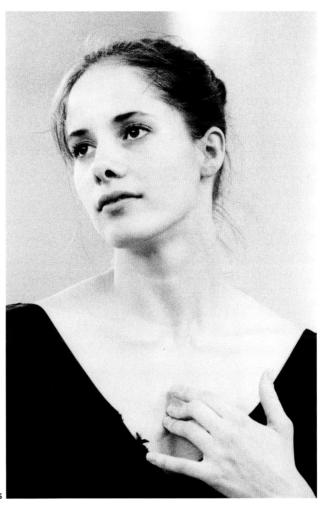

5

SUMMARY

- The subject does not have to be looking at camera.

- Can the hands add to our understanding of the sitter?

- The contrast you choose to print at is very important to the feeling created.

- **Camera** Nikon F90x. 80–200mm zoom lens.

- **Film** Kodak T-Max 3200P rated at ISO 3200.

- **Developer** Film: T-Max 13½ mins at 20°C/68°F. Print: Ilford Multigrade.

- **Exposure** Camera: 1/500 sec at f2.8. Print: 12 secs at grade 4½. Right eye shaded for 2 secs.

- **Paper** Ilford Multigrade warmtone semi-matt FB.

A window portrait: Nick

This portrait of my son Nick is an example of the classic window light portrait, loved by the Old Master painters. The common window is my favourite portrait light source as it's infinitely versatile: you can light from the front, side, or back, and with reflectors can create almost any look you want. Most studio portrait lighting set-ups are copies of daylight effects, usually window light. I've never managed to improve on, or even match, its qualities artificially.

LOW LIGHT IS GOOD

This was taken on a dull day. Don't imagine that a low light level means poor light quality – quite the contrary. I've found that by using a tripod and a slow shutter speed (1/30 sec down to 1 or 2 secs), I can hold more shadow detail than on a bright sunny day. Crucially, don't shoot on auto exposure, as the negs, though printable, will be underexposed. If I shoot on auto I override by ⅓ of a stop.

As many people feel vulnerable in front of a camera it's important to make your visualization *before you start shooting*. I decided on a black t-shirt for Nick and an unlit portion of the wall as the background, so that it would end up nearly black on the print. I used an 80–200mm zoom at about 180mm – a long lens flatters most people because its foreshortening properties compact the features. I also shot from chest height; doing so means the subject looks down at the camera and appears powerful and authoritative – the classic angle used on presidents and tycoons.

You can see below that the light changed as the face moved towards or away from the window. To achieve a moody look, I didn't fill in the shadows with a reflector.

SUMMARY

- Don't be put off by low light. Use a tripod and long exposure; it will look great.

- **Camera** Nikon F90x. 80–200mm zoom lens at 180mm.
- **Film** Ilford Delta 3200 rated at ISO 1600.
- **Developer** Film: Kodak T-Max for 11 mins at 20°C/68°F Print: Ilford Multigrade.
- **Exposure** Camera: 1/30 sec at f4. Print: 13 secs at f5.6, grade 3.5; the eye shaded 4 secs. Toner: Gold.
- **Paper** Forte glossy (unglazed) FB.

1. LIGHTING THE FACE
I have included the contacts to show the subtle difference a slight change in the angle of the light source can make to the face. The face appears to be wider when Nick is three-quarters lit; as he turns to the window his face appears narrower. As an experiment, try sitting someone looking directly at camera and then, using a single light source, make a number of exposures: one side lit, one three-quarters front lit, one lit from the front high above the camera, and one from a low level. You will learn how light affects the shape of a face.

2. FINAL PRINT (opposite)
The decisions made were: window light, long lens, low camera angle, black shirt and dark background, low-key moody print, fast film for grainy texture, and gold toning.

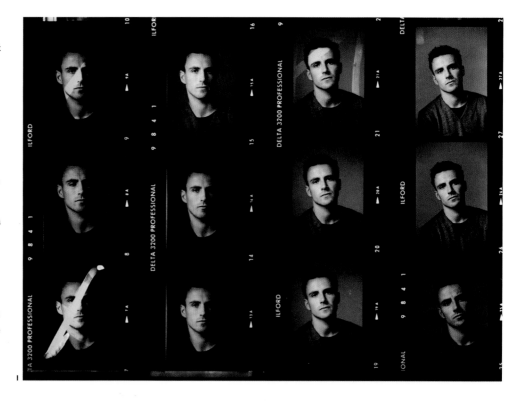

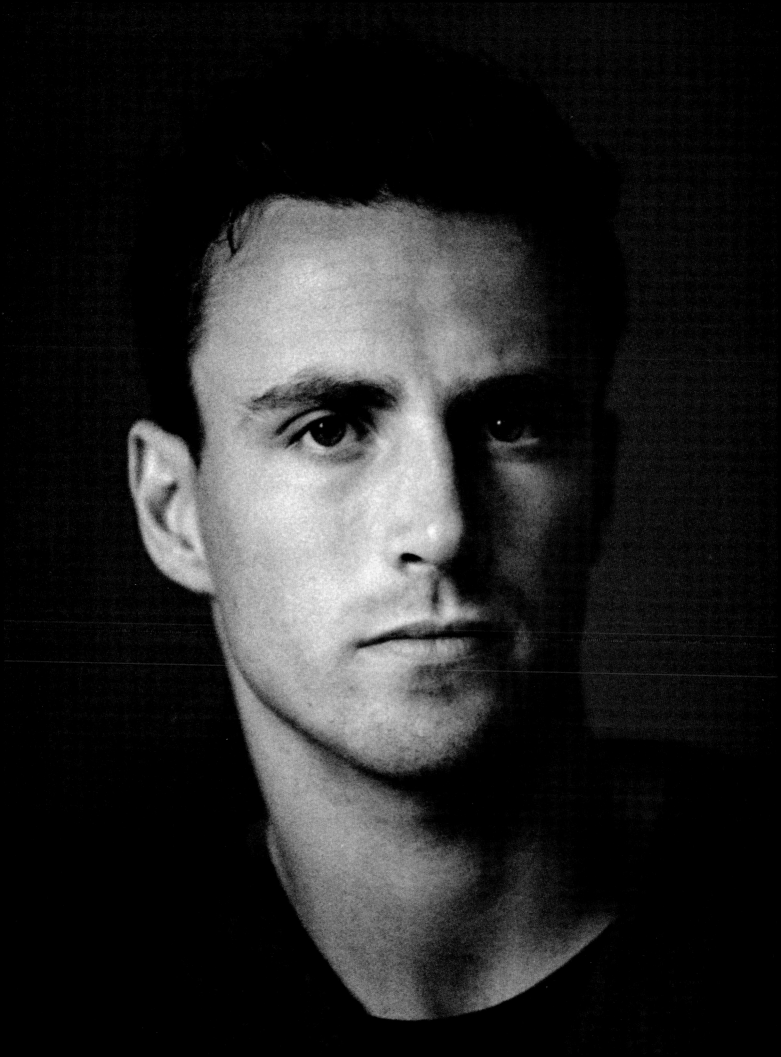

Facial geography: Agnieszka

Agnieszka worked for me for four years. She was convinced that she "didn't take a good photo" – a challenge that I couldn't resist. The beautifully lit, made-up, and heavily retouched images of starlets, supermodels, and celebs, most of whom you wouldn't notice in the street, belie the fact that we are surrounded by beauty. The only difference between the pretty waitress and the celeb is a good photographer.

STRUCTURE

My first step when taking a beauty portrait is to study the structure of the face. From there I can make appropriate decisions on camera angle, lighting, and the tonal look of the print, to enable me to emphasize the good features and hide the not so good. I usually use a orange filter for its cosmetic effect on skin blemishes (it lightens spots). I have selected examples of three sessions that I did with Agnieszka, each separated by about a year. The second and third sessions gave more emphasis to her great eyes and mouth by rethinking the clothes, the hair, the make-up, the lighting, and the camera angle.

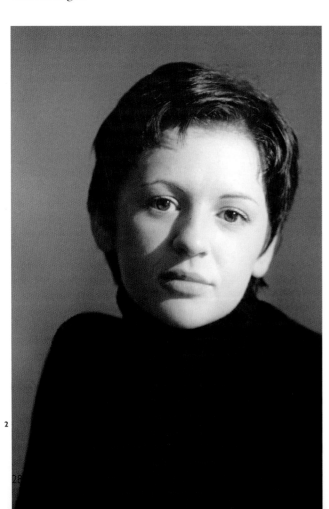

1. HIGH SPOTLIGHT
I used a high spotlight (tungsten). Although we both liked the pic, Agnieszka thought she looked too round faced. The long hair added to that look.

2. CROSS-LIT SPOTLIGHT
One year later and a short haircut. The combination of the black polo neck and the strong cross-lit spotlight has thinned the face. I retouched the sweater to smooth out the lines.

3. DAYLIGHT
This time I used a high-key technique, employing daylight. Agnieszka sat next to a large window (1.8 x 1.2m / 6 x 4ft) and I placed a large silver reflector (1.5 x 0.9m / 5 x 3ft) next to her, opposite the window. The black shirt framed her face well. We have in fact reproduced the lighting used on the portrait of Darcy Bussell. I shot from just above eye height, the high angle having a narrowing effect.

4. FINAL PRINT (opposite)
I have completed the high-key effect by printing light and contrasty. The face looks narrower than in softer print (illustration 3).

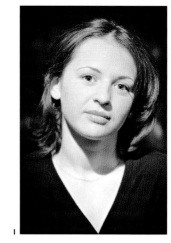

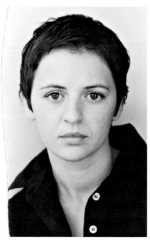

SUMMARY

- Study the face like a still life and decide the camera angle, lens, lighting, background, clothes, hair, and make-up that will best reflect the beauty of your sitter.

- **Camera** Nikon F90x. 80–200mm zoom at 150mm. Orange filter.

- **Film** Ilford HP5+ rated at ISO 320.

- **Developer** Film: Ilford Microphen for 7 mins at 20°C/68°F. Print: Ilford Multigrade.

- **Exposure** Camera: 1/250 sec at f4 (high key); 1/250 sec at f2.8 (spotlight). Print: 15 secs at f5.6, grade 4½, right eye shaded 4 secs (high key); 13 secs at f4, grade 4, area round mouth shaded 4 secs, eyes 2 secs (spotlight).

- **Paper** Ilford Multigrade semi-matt FB.

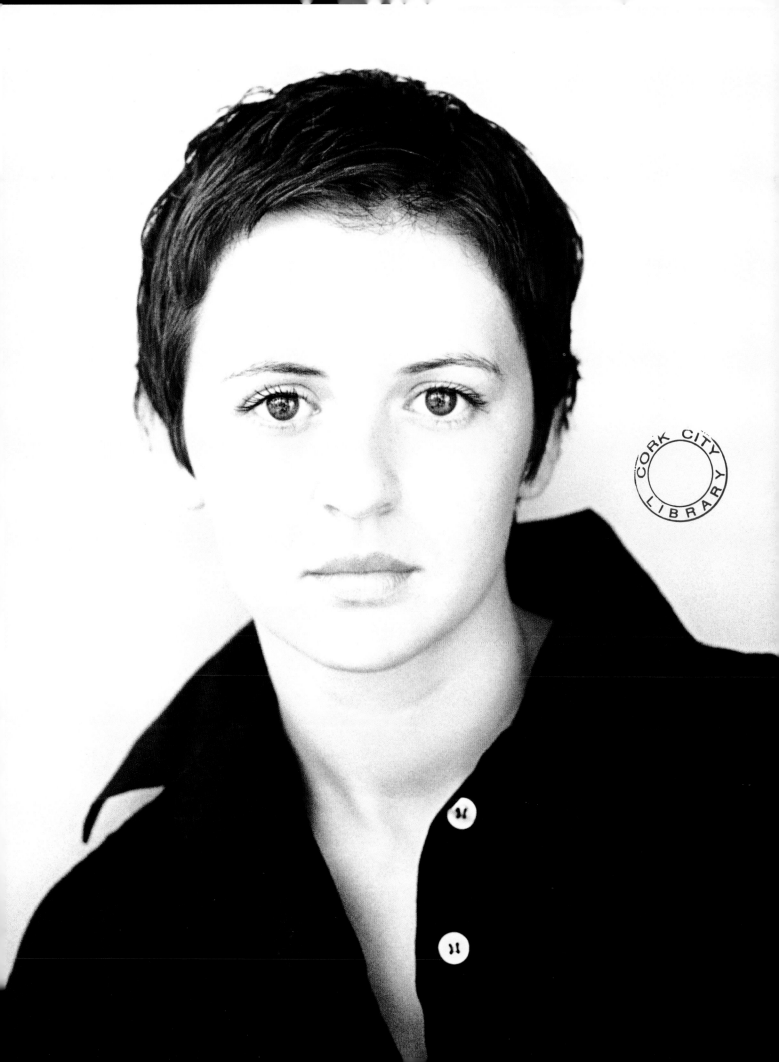

CORK CITY
LIBRARY

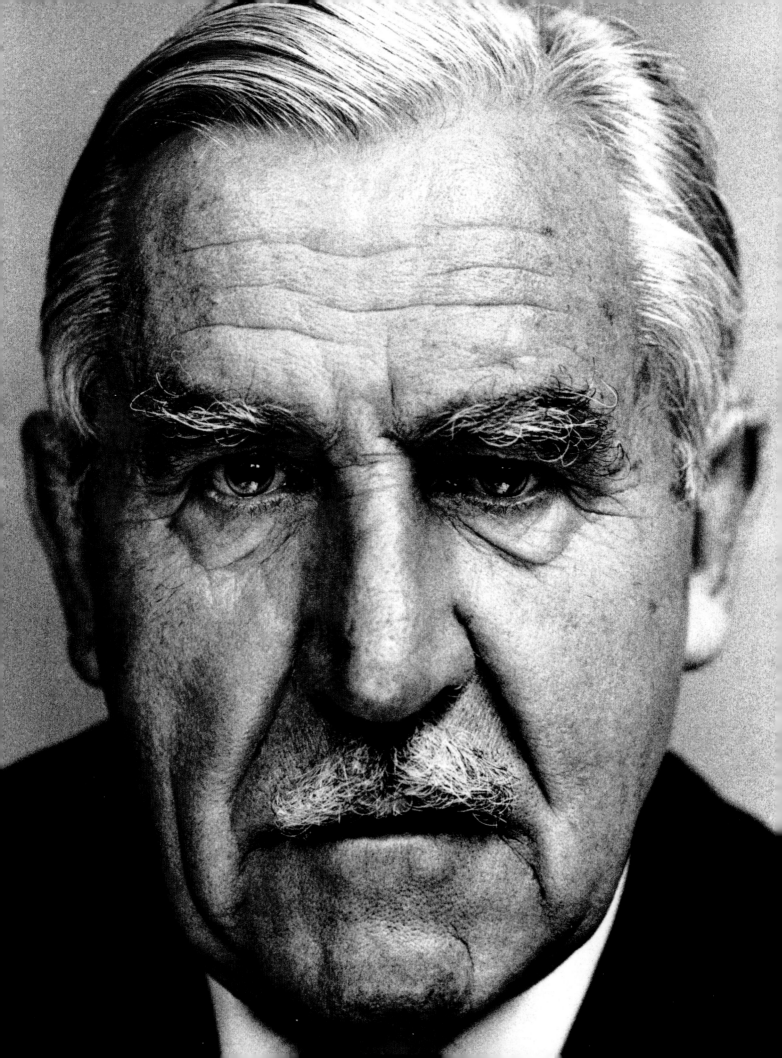

Tight composition: Martin Flett

The late Sir Martin Flett was a senior British civil servant, who on first impression came across as a jolly, if rather elegant, uncle. This was a studio portrait, intended for both work and family, and was arranged with him seated in an office chair behind a desk, allowing him to lean forward – portraits are always more dynamic if the sitter is leaning toward the camera rather than away from it. I used a single 1000 watt tungsten flood lamp bounced into a large umbrella a metre (3 feet) above head height, and three-quarter front lit. On the desk I placed a large silver reflector, which filled the shadows and put a glint into his eye – very important, I think.

CHANGE IN MOOD

I kicked off with nice friendly, family portraits, the mood created by my awful jokes and general banter, which can be embarrassing but serves its purpose of putting the sitter at ease. I left plenty of space around him to make a relaxed composition. I was then called away for a phone call and returned to find Sir Martin alone with his thoughts, and an apparently different man – tougher looking, and more intense. The real Sir Martin perhaps? I went closer in for a very tight framing, which had the effect of clamping his head in, as if there was nowhere to go, and introduced a new tension into the portrait. I let the conversation drop completely, and continued the session in silence. Most viewers of the portraits will probably think that the in main picture he appears tougher just because of the different expression: what they won't realize is that they've also been manipulated (almost subliminally) by the tighter composition.

SUMMARY

- Tight cropping and high contrast can add to the tension in a portrait.

- **Camera** Nikon FE. 135mm lens.
- **Film** Ilford HP5 rated at ISO 600.
- **Developer** Film: Ilford Microphen for 9 mins at 20°C/68°F. Print: Ilford Multigrade.
- **Exposure** Camera: 1/250 sec at f2.8. Print: 13 secs at f4; forehead burned in 4 secs, grade 4½.
- **Paper** Ilford Multigrade semi-matt FB.

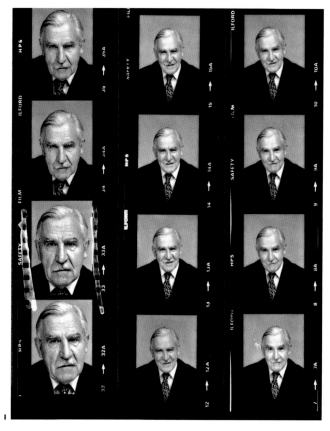

1. CHANGES
The contacts trace the dramatic impact of a change in composition, as well as a change in the mood of the subject and the photographer.

2. RELAXED AND SPACIOUS
The space around the sitter contributes to the relaxed atmosphere of the portrait –this is space you imagine he could move around in. Also note the very different contrasts of this image and the main one; I printed this one on grade 3, making it smooth and light – friendly, you might say.

2

3. FINAL PRINT (opposite)
I printed this portrait on grade 4½, and made it darker also. The increased contrast and density add that final bit of darkroom magic to the decisions made with the camera, and produce the intensity seen in the portrait.

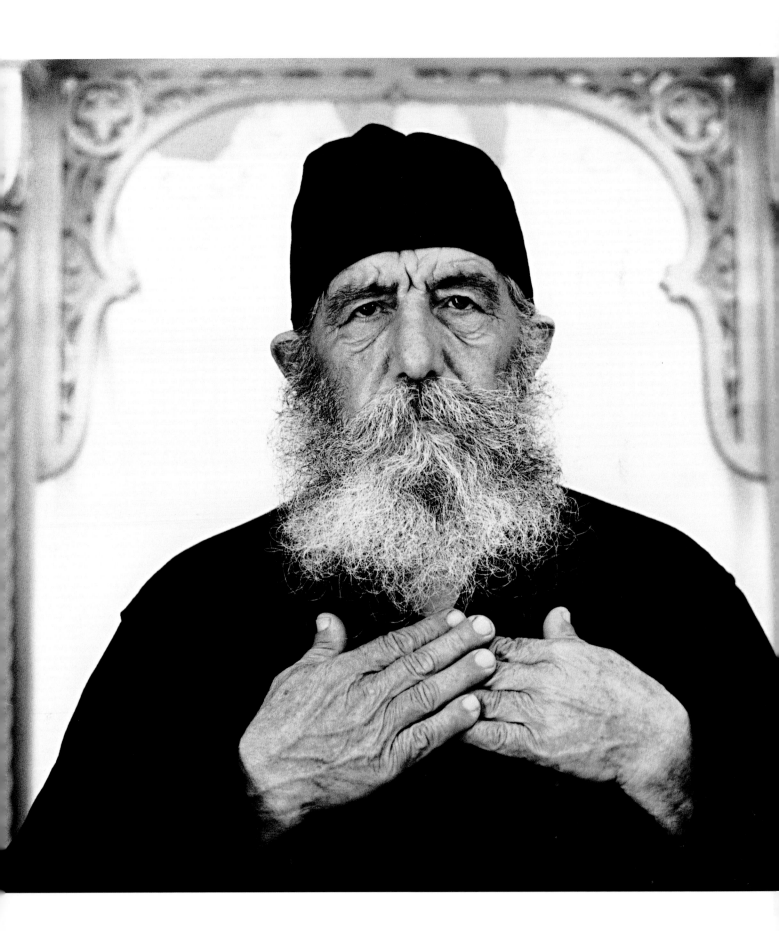

Medium format: A Cretan priest

This portrait of an Greek Orthodox priest is actually a holiday snap. Desperate for some sun, I took a two-week holiday in Agia Roumeli, a small village on the island of Crete that can only be reached by a three-hour cab ride, followed by a two-hour ferry crossing.

GETTING PERMISSION

After a few days on the beach, the photography bug began to bite. The priest and I had been greeting each other in the village for a few days before I plucked up the courage to pop the question. He didn't speak English and I don't speak Greek, but with pointing and miming, techniques honed by nearly 40 years of travel (78 countries so far), he got the message and agreed to a portrait. In fact, he was delighted – he was flattered that I had asked and not just sneaked a shot of him around the village. Bear this in mind when you're in a similar situation; most people say yes if you approach them in a dignified and respectful way.

Our appointment was for later in the day at his tiny chapel (tiny meaning 4 x 3m / 13 x 10ft). The light inside was all indirect. The fierce afternoon sunlight (it was around 2pm) was bouncing off the pavement through the open door; on the other side light was coming through a small window and bouncing off the white ceiling, providing a perfect balance. The creamy marble floor made another reflector. The little light there was had a lovely glowing quality.

THE SESSION

All portrait sessions between strangers start rather awkwardly and the subject is usually shy. My priest however, was a born actor – preaching and acting are closely related professions, after all. I decided on using the Hasselblad, partly because a formal portrait would benefit from the smooth medium format quality, and partly because I needed a tripod anyway (to deal with the low light). I kicked off by placing him in front of the altar – an environmental portrait of a holy man. I needed a 50mm wide-angle lens in the confined space, but changed lenses to a 150mm and went in for a head and shoulders. I observed that his hands, although well manicured, were the powerful hands of a man who knew about hard work; I later learned that he was formerly a shepherd in the mountains. I pointed to the heavens to suggest a devout pose. He thought that was very funny and obliged with the iconic portrait we made together. If you can make your subject laugh you're more than halfway there. I wouldn't pretend that

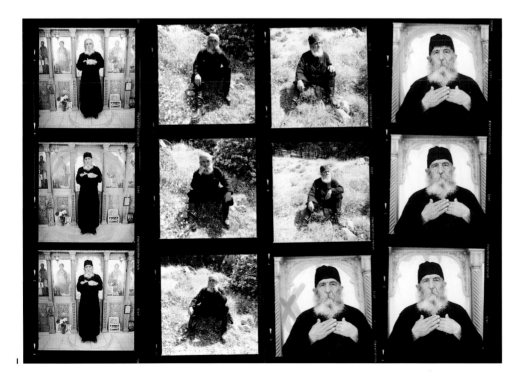

1. DIFFERENT APPROACHES
I don't have room here to show all the contacts, but you can see from these that I took three different approaches to the portrait. Actually, the ones in the field were the last set-up. They show him more as a man of the mountains, but I was after a religious icon, so went for the close-up. You may have preferred one of the other alternatives. It is all subjective.

this is an in-depth portrait that explores the man's character. It is, rather, a Greek icon, a symbol of a powerful influence in Cretan life – the Greek Orthodox Church.

The tonal management was simple. The priest's black habit dominated and the background was nearly white; I just left a frame around the head to add a religious flavour. The hands and face were going to print as a light to mid-grey. This was a perfect black and white situation; the portrait would not have been anywhere near as strong in colour.

THE DARKROOM
I used Ilford HP5+ rated at ISO 320 and developed for 7 mins in Microphen. The negatives are about ½ a stop denser than average – I don't like "'skinny" negs to print portraits from. I printed on Ilford Multigrade semi-matt FB paper. The final print was very easy. The aim when visualizing is to produce a neg that will print almost straight, needing little burning or shading. When you're on a tripod and have the control possibilities that I had here, that should be possible. The trick is to know how you want the final print to look and then go about creating the perfect neg to make it from.

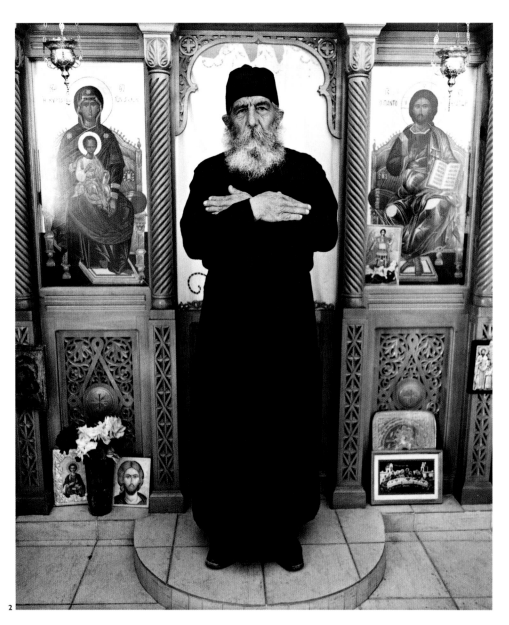

2

2. CENTRED
I like the composition: right in the middle, he's in a little frame within the larger frame of the print. But I'm not getting the most out of my subject. I don't really need all the extra paraphenalia – he is enough in himself.

3. JUST OFF-CENTRE
I don't usually go for centrally placed portraits as I think they're boring, so out of habit I started with this off-centre composition. It felt wrong, however, so I moved him slightly into the middle of the frame. Symmetry is used in art when a feeling of peace is required: the perfect (or near perfect) creates no tension – just the job for my priest. The portrait is much improved by a movement of only a few inches.

4. THE FIRST TEST
My first test with the timings marked on it. I decided to up the contrast from grade 3 to grade 4. I felt that he needed a little more punch, to look more dynamic. His left hand had highlighted slightly so I burned it in to prevent it distracting from the face.

5. FINAL PRINT
A few inches movement to his right has my priest looking serenely devout. For those on digital, all the visualization is the same, but the decision to shoot on high or low resolution is critical. Use a tripod and shoot for the best you can get.

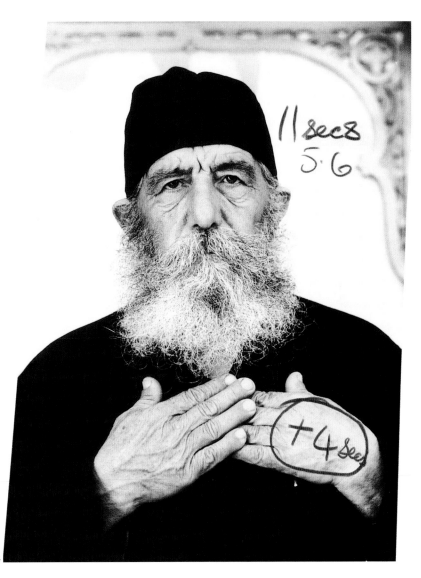

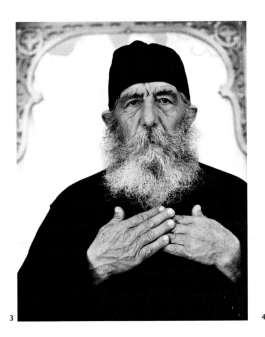

SUMMARY

- Symmetrical composition gives a calm atmosphere

- Don't be afraid to ask people to sit for a portrait. They usually say yes!

- Medium speed ISO 400 films are the perfect choice if you're going for a whisker-sharp, smooth tonal portrait, and they have enough speed to use available light.

- **Camera** Hasselblad 503. 50mm and 150mm lenses. Tripod.

- **Film** Ilford Delta 400 rated at ISO 320.

- **Developer** Film: Ilford Microphen for 7 mins at 20°C/68°F. Print: Ilford Multigrade.

- **Exposure** Camera: 1/30 sec at f5.6. Print: 13 secs at f5.6. Left hand burned in for 4 secs, grade 4.

- **Paper** Ilford Multigrade semi-matt FB.

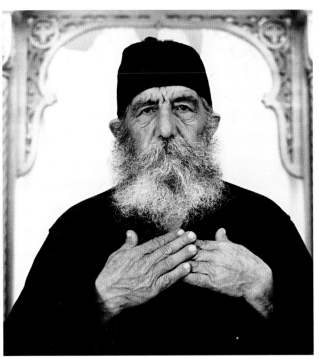

"Snapshot": Mike and Rhella

Mike Ford – art director, painter, writer, and old friend – with his wife Rhella on their wedding day. This is just a snapshot, really, but when I looked at it again with this book in mind, I realized how many decisions had been involved.

RELAXING AND RELOCATING

I shot two rolls. The first produced posed, self-conscious portraits, as I was concentrating so hard on the structure that I was killing the prevailing atmosphere. I warmed up during the second roll, and their facial expressions were the result of us larking about. I moved them from the garden seat to an old horizontal tree trunk. We now had a base that they could lean on and I could build a strong composition. The background was going to be black, which would work very nicely with their monochrome outfits. The leaning pose has made the Golden Triangle composition loved by traditional painters. The hands clasped at the bottom of the frame have further connected the couple. The wind was from the perfect direction, adding to the carefree feeling of the picture.

I used an 80–200mm lens at about 180mm and was wide open on f2.8. The focal length has contributed to the picture by compacting the perspective, making the couple appear closer together, plus it has thrown the background out of focus (assisted by the wide open aperture). Admittedly, I did burn in the background to nearly black later, but the visualization was sensible.

I made a mistake, however, in having Rhella's left shoulder pointing to the camera. She had to turn her head to look at me, inevitably creating wrinkles in her neck. I could have solved this by turning her body more square on to the camera. As it was, I burned her neck in on the print, which largely removed the problem.

AN EXTREME NEGATIVE

The elements in the picture dictated that I was going to end up with a negative where the main areas would be at the extreme ends of the tonal scale. Luckily, I chose the medium speed Ilford HP5+ film (ISO 400), which can reproduce a tremendous range of tones when rated at ISO 320 and matched to Ilford Microphen developer. By underrating the film speed you can reduce the development time, so preventing excessive contrast.

My basic exposure was 20 secs at f5.6. Always make sure the exposure is long enough to allow time for the shading. I shaded Rhella's face for 4 secs because Mike was tilted toward the sky and his face was denser on the neg. I burned in his suit for 6 secs and the background for 5 secs (using my hands). I burned in Rhella's neck using a small hole in a white card for 8 secs.

1. ALL WRONG
First set-up. The heads-together pose looks a bit corny. The long lens (80–200mm at 200mm) has had a foreshortening effect on Mike's leg. He looks tense.

2. RIGHT FEELING

There's a better atmosphere this time, but the tonal management is a mess, as is the composition in general.

3. NEW LOCATION

Getting better. The new location is an improvement, but it's that corny heads-together pose again, and here it has collapsed the Golden Triangle. The expressions look forced too.

4. FINAL PRINT

We have a result. Our larking around has produced expressions and face angles that work well, and Mike's upright position has improved the composition. You need to cajole your subjects into a few more frames sometimes, but perseverance usually succeeds. Besides, if this had been a paid job I'd have had to have come home with a good pic if I wanted to get the fee!

2

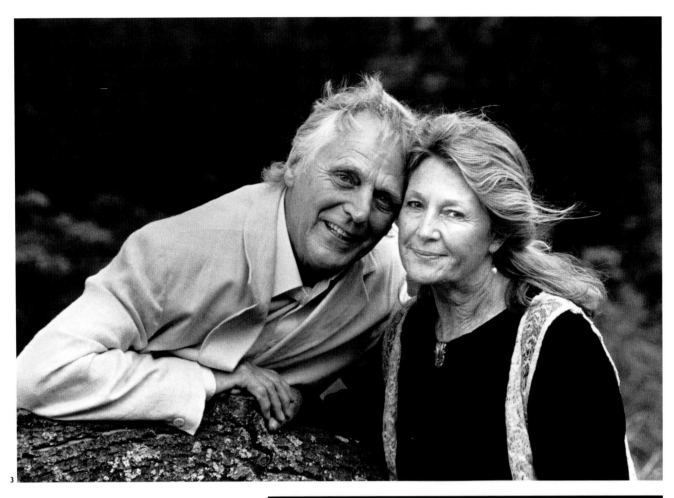

3

SUMMARY

- The atmosphere of the session is your responsibility. You set the mood.

- Couples need to make one single shape inside the frame to seem linked.

- **Camera** Nikon F90x. 80–200mm zoom lens at 180mm.

- **Film** Ilford HP5+ rated at ISO 320.

- **Developer** Film: Ilford Microphen for 8 mins at 20°C/68°F. Print: Ilford Multigrade.

- **Exposure** Camera: 1/500 at f2.8. Print: 20 secs at f5.6. Burned in 8 secs on neck, 5 secs on background; shaded face for 4 secs.

- **Paper** Forte semi-matt FB.

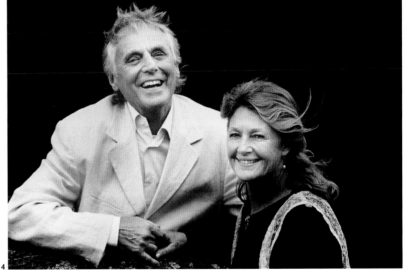

4

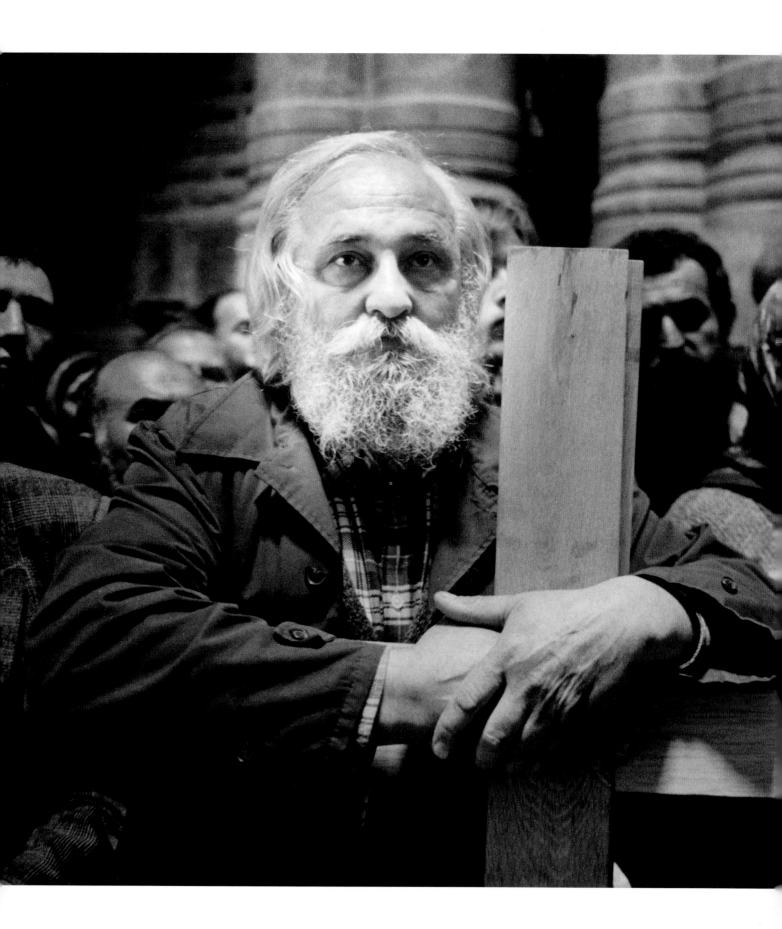

Reportage portrait: Prayer

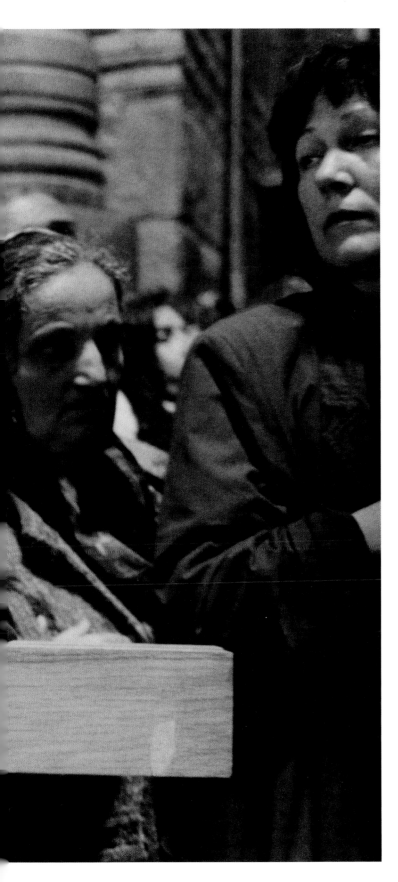

The devout intensity in the face of this pilgrim in the Church of the Holy Sepulchre in Jerusalem made him almost impossible to ignore. He was not really in a state to be asked; I just took the pictures. In my youth I would have been too self-conscious to point my camera in his face, but experience has taught me that if people are very involved they hardly notice you taking a quick picture.

LOW LIGHT

The light in the church was very low, so I used my 50mm f1.2 lens – the large aperture makes available light pictures like this possible. I had Ilford HP5+ loaded, but a fast film like Kodak T-Max or Ilford Delta 3200 would have been preferable, as it would have given me 3 stops more in exposure value. As it was, my exposure was 1/30 sec at f1.2. I could not uprate the ISO because I would have ruined the ten exposures already on the film (taken in bright daylight).

This is a favourite reportage portrait of mine because you can read whatever you like into the man's face. For some, he is a devout Christian; to others, a tortured soul. The supporting cast of pilgrims is important to the portrait too, but they were more prominent in the negative than I had anticipated. I burned them in darker on the final print so that they would add their angst to the atmosphere but not be so prominent that I ended up with a group shot.

A portrait can often tell a story in a stronger way than an action reportage picture. All the great reportage photographers I can think of were also great portraitists. Eugene Smith, Henri Cartier-Bresson, Mary Ellen Mark, Robert Capa, and so many more made some of the most memorable portraits ever seen during the course of their reportage assignments.

A COMPROMISE

A frequent dilemma for the reportage photographer is how much development to give a film that has three or four entirely different lighting conditions on the same roll. You have to compromise, knowing that some negs on the roll are going to difficult to print. I gave this film 10 mins in Microphen at 20°C (68°F). I processed with

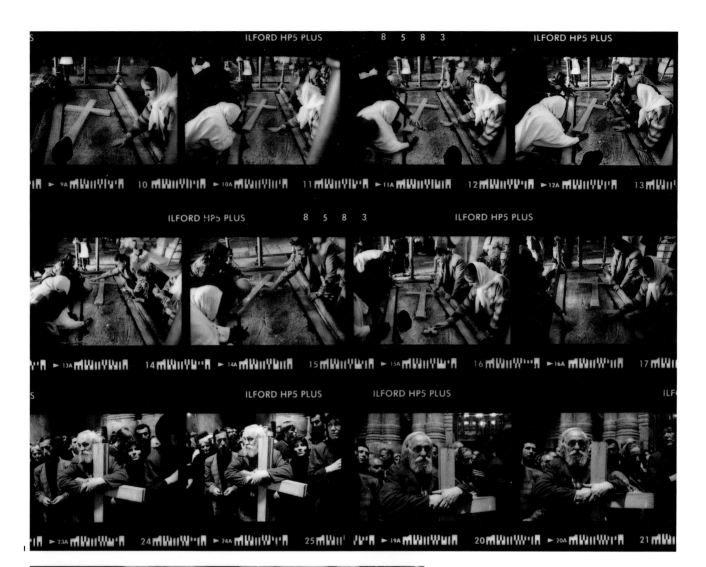

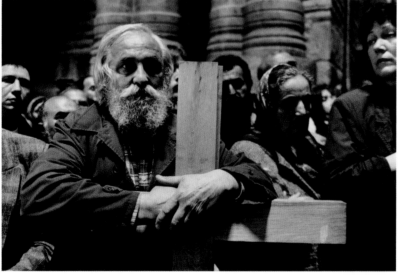

SUMMARY

- In the streets or in a crowd, people will not notice you shooting them.

- If you see a good reportage portrait, shoot. Worry about the neg later.

- **Camera** Nikon F90x. 50mm f1.2 lens.
- **Film** Ilford HP5+, rated at ISO 600.
- **Developer** Film: Ilford Microphen for 10 mins at 20°C/68°F. Print: Agfa Neophen.
- **Exposure** Camera: 1/30 sec at f1.2. Print: 18 secs at f4 on grade 3½; face shaded for 5 secs; cross burned in for 3 secs and background for 4 secs.
- **Paper** Ilford Multigrade glossy RC.

a bias toward the interior pictures, knowing that the outside negs would be a bit dense.

The negative density was acceptable; ideally, I would have preferred an extra ½ stop. I started with a test strip and that led me to make two test prints: one for the man with the cross and one for the other pilgrims. The first print was exposed for 14 secs at f4 on grade 3. That was fine for the star, but the supporting cast was too prominent. My second print was 19 secs at f4. The supporters were now fine but my main man was too dark. I decided to combine the two prints by using the subtractive method. I printed for 18 secs on grade 3½ (I decided to lift the contrast a bit) and shade his face back for 5 secs using a dodger. I then burned in the area above the heads for 3 secs, and the cross and hands for 4 secs.

1. PROGRESSION
I have used some contacts again to demonstrate my progression to the image that I chose. Photography is a searching process for me. Don't expect yourself to find a great picture without shooting plenty of film. Unless you are a genius, it just won't happen.

2. TEST PRINT: BACKGROUND
This is the print test for the supporting cast; the main man is merging with them. While I wanted him to really stand alone as a portrait, I felt that the background figures were very important to the tension of the image.

3. TEST PRINT: PILGRIM
This print was for the main man. He is fine, but the other pilgrims are too prominent, and the cross is too in your face also. I decided to burn that in on the final print.

4. FINAL PRINT
The combination of my tests really amounts to a re-visualization after investigating the neg. This is another case of where the shot is only the starting point. Much of the atmosphere that I felt at the time was created in the printing.

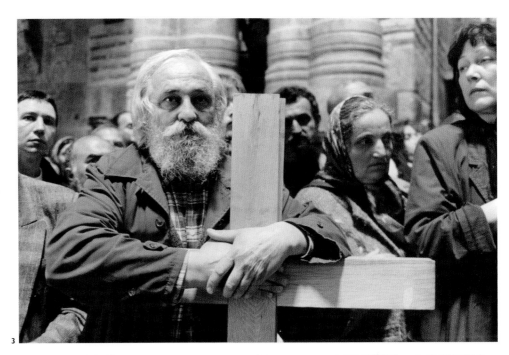

3

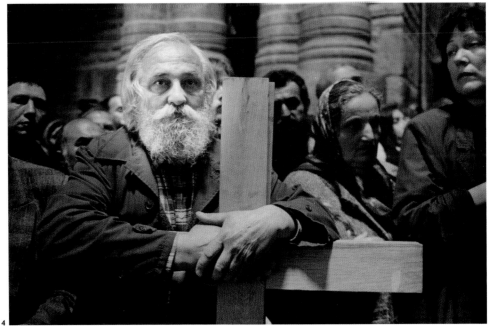

4

Travel portrait: The widow

A travel portrait and a cliché. The old matriarch in black is an image from the Mediterranean that we have seen since photographers began to record their travels. A cliché becomes such for a good reason, however, and I like this because it is a timeless image of Italy, not just a portrait, and the composition works very well.

DAPPLED LIGHT

I was staying at the Costiolu, a beautiful working farm in Sardinia. This lady was the farmer's mother, and agreed to a portrait. While she was getting ready, I found my location and set up ready to go. I decided to use some dappled light for a change; I felt that I was getting a bit stuck on clean, even light and it was time for a different visualization.

Walking to the seat was an effort. To break the tension I suggested that she sit in a precarious swing nearby. She looked at me as if I was mad, then when she realized I was joking, nearly fell off her seat laughing. I formed the composition around the circle of light on the rock behind her.

From 30 exposures, I chose the main picture because I love the hand position. I used the 28–85mm zoom on 28mm; the wide angle elongated the figure slightly without distorting her face. I think the elongation adds a touch of style to the cliché. Due to the considerable contrast between the face and the black dress, this was always going to need plenty of work in the darkroom. I heard later that she said I was crazy but harmless.

1. EARLY TRIES
A sample of the contacts showing the different things I tried on the way to my selected portrait. They are all pretty good but I feel that I found a better solution in the end.

2. CLOSER IN
A closer version. (zoomed in from the same position to 80mm). Not as interesting a picture.

3. FIRST TEST
The first test print – OK on the dress but too light on the rest. I marked up the burning numbers on the print.

4. FINAL PRINT (opposite)
The basic print was 8 secs at f4 on grade 3. I then dialed down to grade 1½ on the multigrade head of the enlarger and burned in the face and rock for 17 secs, and then the surrounding area for 8 secs. Multigrade paper is great for handling extreme contrast negs – you're able to get the right grade for each separate area of the neg on the same print.

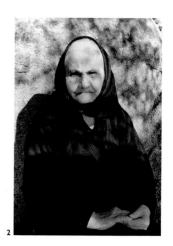

SUMMARY

- The elongating effect of a wide angle can add elegance.

- **Camera** Nikon F90x. 24–85mm zoom lens at 28mm.
- **Film** Ilford HP5+ rated at ISO 320.
- **Developer** Film: Ilford Microphen for 7 mins at 20°C/68°F. Print: Ilford Multigrade.
- **Exposure** Camera: 1/250 sec at f5.6. Print: 8 secs at f4 on grade 3. Burned in for 17 secs, then 8 secs, grade 1½.
- **Paper** Ilford Multigrade semi-matt FB.

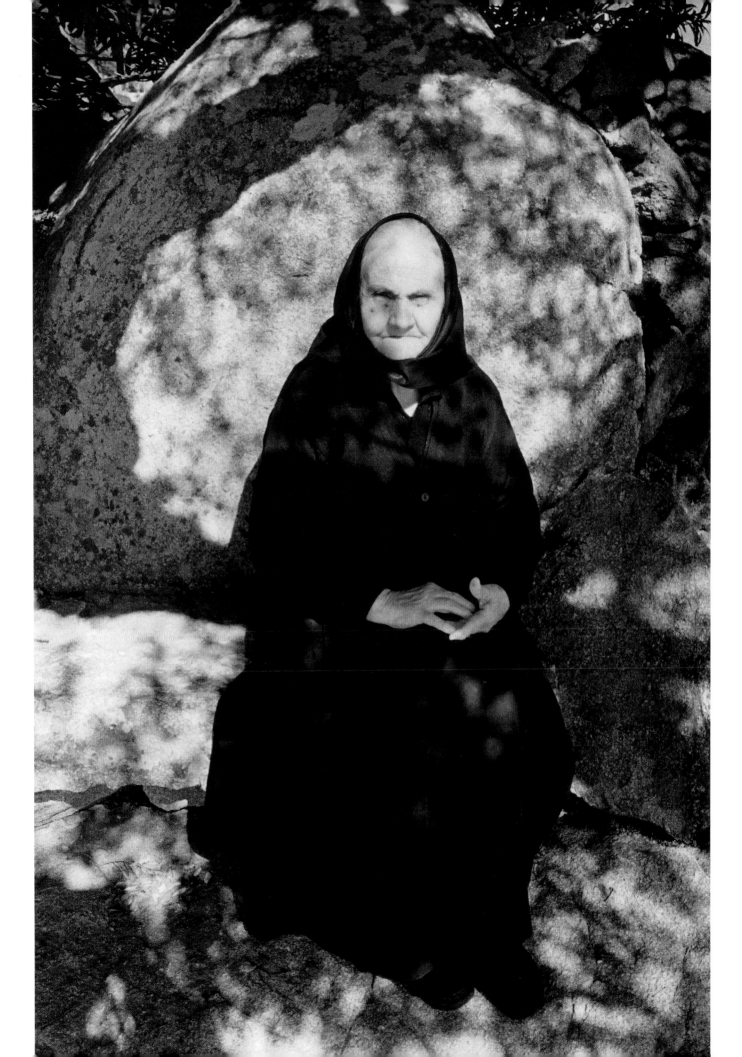

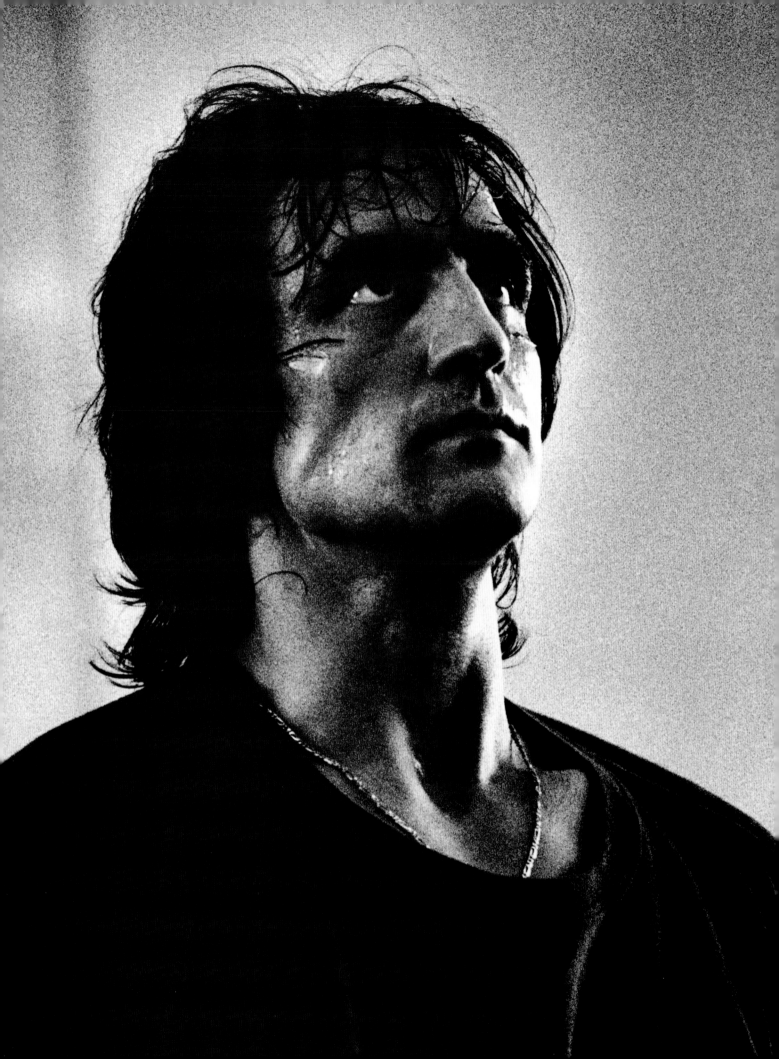

Heroic portrait: Irek Mukhamedov

I was working on a photo story with the Royal Ballet where I was a fly on the wall witness to the creation of a new production – *Cyrano*. The plan was to start on day one of rehearsals and finish with the opening night, a period of nearly six months, working most days. Some way into the assignment I was commissioned to take a portrait of Irek Mukamedov for the Ballet's publicity department, for use in programmes, press releases, posters, and the like. Irek is one of world's great ballet stars, a Russian famous for heroic, larger-than-life performances. Looking more like a middleweight boxer, he is the antithesis of the stereotypical image of a ballet dancer.

REPORTAGE
Early on I took posed portraits during the rehearsal breaks. The results were just too "nice" – they didn't capture the blood, sweat, and tears of ballet dancing, nor the dramatic power of Mukhamedov. So I decided to go reportage with the portrait – to shoot him during the rehearsals. The problems were that he was mostly on the move, there was not much light in the studio, and I needed his head large in the frame. Not to mention that the client needed the picture in two days' time (always the bottom line).

By the time I'd been photographing Irek and the rest of the company for several weeks I'd built up a good working relationship. Or, in other words, he put up with me shooting away at him all day and I did my best not to get under his feet (literally). If I had tried to work this close during the first few days, he would probably have told me to get lost in no uncertain terms.

The first film was OK (again, always shoot lots of film, it's much cheaper than a reshoot), but he hadn't sweated up yet, and his hair looked too groomed. An hour into the rehearsal however, he was really looking the business – with his hair matted with sweat to his face, he looked like a man who works hard for a living.

I shot the final image – or rather, the image that I later chose as the best for the job – from a kneeling position. Many of the propaganda portaits of the great and powerful have been shot looking up from a low camera angle, the intention being to imply that the person in the portrait must be superior to the viewer. The low angle certainly produced drama, but the negative was just the starting point. Some darkroom magic was needed to turn the original image into a compelling portrait.

IN THE DARKROOM
At least 60 per cent of this portrait was created in the darkroom. The work started with the recropping. Although we should always try to create the perfect

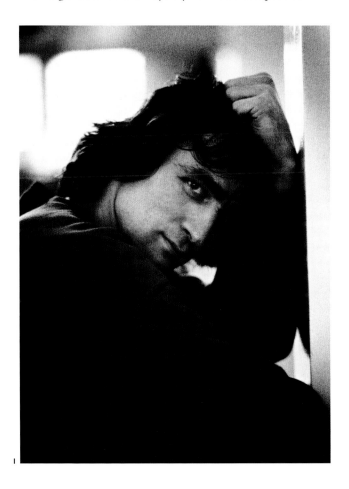

I. POSED
This is my posed portrait of Irek. Although it is an attractive portrait, I felt that it did not capture the the drama of Mukamedov the dancer. It was not gutsy enough.

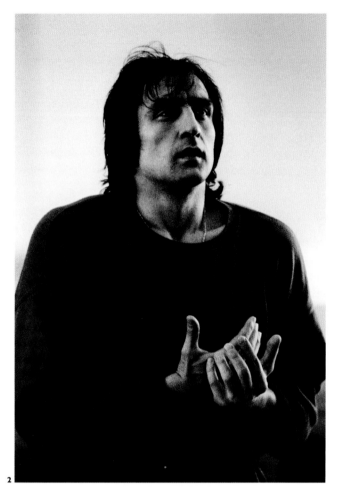

composition in the viewfinder, I do encourage you to take another look at the crop on the baseboard – you can often improve your original effort. The second stage was to increase the contrast to add some guts, or really just to capture the drama that I felt at the shoot. The third stage was to burn in the distracting sweater. Next, I burned in the background, creating the halo effect. Finally, I decided to go for some toning.

TAKING PAINS OVER THE PROCESS

It's important to say that these decisions did not come to me on the first print; they were progressive and I made several prints before I was able to visualize the final version.

You need to expect to use several sheets of paper on a print if you are really serious about improving your printing skills. I used about 16 sheets on this series.

2. TOO GROOMED
This is the first reportage portrait, but the hair looks too neat and he hasn't sweated up enough yet. There's no feeling of the blood, sweat, and tears of ballet.

3. STARTING POINT
This is the image that I chose as the starting point and this is the first print that I made. We have potential, but it will need a real darkroom turbocharge to make the grade. His head is too small in the frame and the tone is too flat. The folds in his sweater distract the eye from his face, so I would need to burn them in. Some tone needs to be added to the background to hold the portrait on the page.

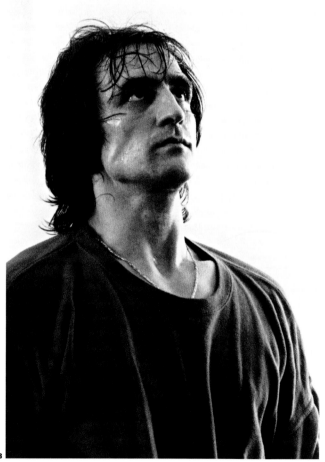

4. HALO

I pulled the head up bigger and increased the contrast to 4½. My basic exposure was 13 secs at f5.6. Using my fist to shade his face, I burned in the background and the sweater for 30 secs on f4. The background was actually darker than I had intended, producing a halo effect around the head. But it looked theatrical so I went with it. The increased contrast and the dark sweater were a big improvement and Saint Irek was now among us!

5. BLEACH BACK

I decided to try some toning as a poster idea. My first thought was to do a simple bleach back. This is the first stage of a traditional sepia toning process. The bleach back strips away the highlights and increases the contrast. This gave a gritty looking print with a yellow/brownish tone that I find sympathetic to the subject.

6. SEPIA TONING

I used a sepia toner with a tone additive that enabled me to produce this rather chocolatey brown – darker than the usual sepia tone.

7. SEPIA AND GOLD TONING

First, I sepia-toned this image, then followed it up by gold toning the print. The result is a glowing orangey brown tone. This is a matter of personal taste, and there is an almost infinite variety of tonal effects that can be produced. These examples just show what I did for this particular assignment. Different types of paper produce a different tonal result using exactly the same chemicals and method.

8. PALETTE KIT

This tone was the result of experimenting with a palette kit. The kit allows you to create just about every colour in the spectrum. This print was toned in the red palette. Toning kits are remarkably easy to use and help to preserve a happy family life – they don't smell out the whole house!

4

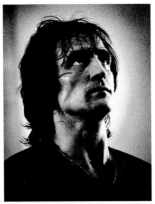

5

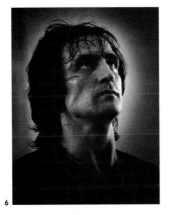

6

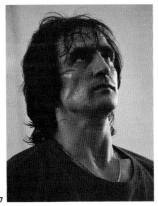

7

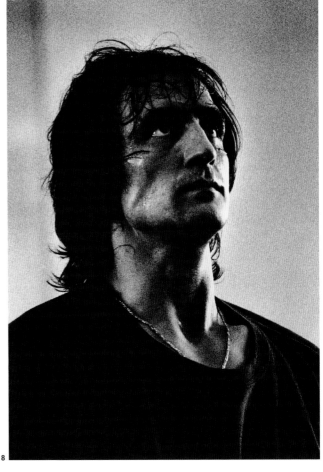

8

SUMMARY

- Using a low camera angle eliminates messy background features and gives the subject a "heroic" look.

- Experiment with different tonal effects according to your brief. Use some darkroom "turbocharge" to achieve theatrical effects if they are appropriate.

- **Camera** Nikon F90x. 80–200mm zoom lens.

- **Film** Ilford HP5+ rated at ISO 1200.

- **Developer** Film: Ilford Microphen for 11½ mins at 20°C/68°F. Print: Ilford Multigrade.

- **Exposure** Camera: 1/250 sec at f2.8 Print: 13 secs at f5.6, grade 4½. Background and sweater burned in for 30 secs at f4. Bleach back and toning.

- **Paper** Ilford Multigrade semi-matt FB.

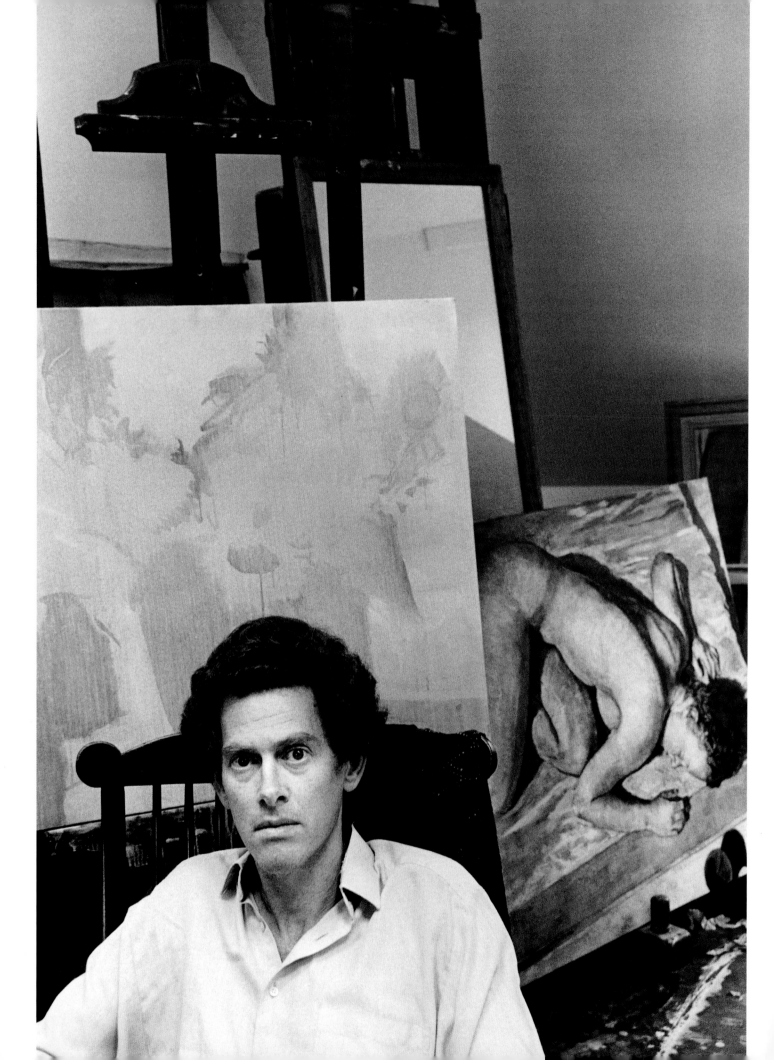

Sitter and environment: Henry Korda

This case study is all about exploring space and tonal management inside the viewfinder. Henry Korda is an eminent painter and an old friend of mine, so we didn't have to spend time on the getting to know each other preliminaries – this is a good reason for budding portraitists to practise on old friends. The portrait was for his new exhibition catalogue, and my visualization was to produce a composition sympathetic to his paintings.

I started shooting on a Hasselblad (6 x 6cm format). The studio light was almost perfect; I just needed to add a silver reflector on the floor to bounce some fill light into the eyes. The 6 x 6 portraits were good but rather predictable "painter in studio" pictures, so I switched to the Nikon and a 24–85mm zoom lens – I needed to free myself up – and with the hand-held camera I explored a variety of compositional possibilities.

PLACING THE SITTER

I think photographers are often guilty of taking the easy option when it comes to composing portraits (me included); we just place our subject in the centre of the frame and work on the facial expressions. The composition of the portrait – where we place the subject in the viewfinder – also contributes to the tension or mood of the portrait and shows the personality of the subject, not just the smile or frown.

The mood, and therefore Henry's expressions, changed as we chatted along during the session. It's essential to get sufficient control of your technique to be relaxed enough to chat along – something that takes lots of practice. Henry has very piercing eyes and they were the feature that I was after; the task was to capture them within an interesting composition. I've realized that most of my portraits end up as rather serious interpretations of the personalities of my subjects. I think it must be that I feel they're more dignified that way. Having said that, I also love a wholehearted smile, if it's real.

If you check out the contacts and the small images I've included you'll see that some work and some don't, but

I. COMPOSING
You can see from the contacts that I was experimenting with space, with where to place my artist in the frame, as well as playing with the relationship of the subject with the paintings and easels in the background, which in compositional terms are just an assembly of grey rectangles of varying density.

2. THE ORIGINAL SET-UP
The scene when I entered the studio. We moved the paintings around to make a more graphic composition. The neutral work behind his head was important to position him within the frame of the picture without distracting. The nude juxtaposes well with that frame and adds some interesting information about the artist.

we may not agree on which is which – it's all subjective, and we all have different tastes in composition, thank God! The frame that I chose follows the classical painters' Golden Section, or law of thirds; Henry chose this one as well because he felt the composition to be similar to his paintings.

THIN NEGATIVES

I made a test 35mm roll and one for the 6 x 6cm shots and developed them. I found that the films both needed an extra 2 minutes of development time as the negatives were rather thin. The print needed only slight manipulation as the studio light had made a neg with an excellent tonal range. The shirt needed some burning in so that the whites didn't distract attention from the face. The top left needed some burning also, and I shaded the nude a little.

I decided to print on coldtone paper, hence the bluish cool look. I hoped it would look similarly "cool" stylewise.

The basic exposure was 13 secs at f4 on Ilford semi-matt coldtone FB, grade 3. The shirt had an extra 5 secs at grade 1½. The nude was shaded for 3 secs and the top left burned in for 4 secs.

3. UNCONVENTIONAL
This composition contradicts all the conventional laws for portraiture; we both rather liked it although we weren't sure why exactly. Though it's too central I think that the slight elongation created by the zoom at 28mm makes it quite interesting.

4. TOO STATIC
This is the Hasselblad pic – not bad, but rather static, and the positioning of the pallets and paintings looks a bit contrived. It does have that smooth, fine-grain quality that we get with medium format though. It was a straight print, needing no shading or burning in because the lighting was so even.

3

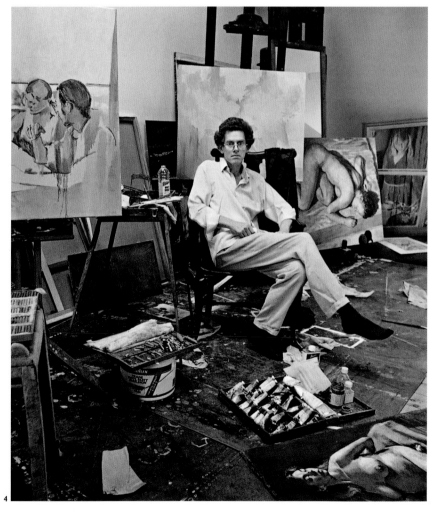

4

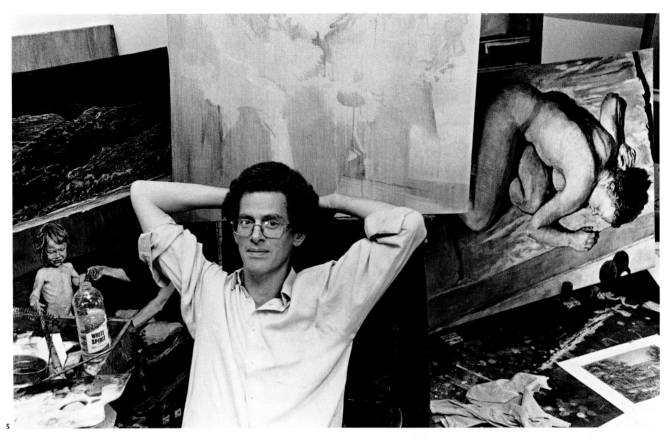

5

5. DISTRACTING

I tried a horizontal shape but it's not a very elegant solution; it looks messy and I don't like the white shirt forming a distracting hole in the picture. In retrospect, this image needed to be cropped just below the armpits with more space above the head.

6. FINAL PRINT

My choice as a portrait of my friend, the artist. It works for me both as an example of my work and an interpretation of his. I trust that this case study demonstrates that portraiture is a bit of a journey; you need to work at it to get an interesting result, and you sometimes need to push yourself to do better.

SUMMARY

- The composition of every portrait has a profound effect on the interpretation of the subject's personality.

- Shoot a roll to test your exposure/development combo.

- **Camera** Nikon F90x. 24–85mm zoom lens at 35mm.

- **Film** Ilford Delta 400 rated at ISO 320.

- **Developer** Film: Ilford Microphen for 9 mins at 20°C/68°F. Print: Ilford Multigrade.

- **Exposure** Camera: 1/250 sec at f4. Print: 12 secs at f4.

- **Paper** Ilford Multigrade coldtone semi-matt FB.

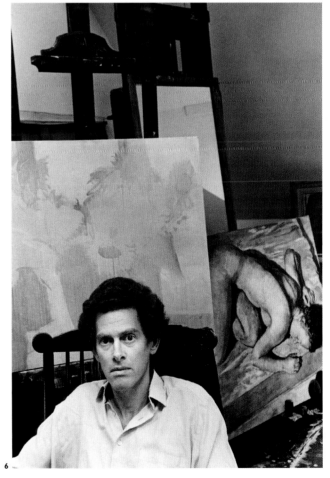

6

Group portrait: A football team

I have great respect for colleagues who make their living taking school, team, and other group portraits – it's not easy! My son Matt is coach of the Northern Steele under-14 girls' soccer team from western Pennsylvania, USA. I had no trouble getting smiles out of them, as they had just won several trophies.

The medium-format Hasselblad 6 x 6cm, camera was ideal for this, as the larger negative it produces allows a smoother, sharper print of each individual face. The overcast day was ideal for groups because it did not create any shadows. I stood up on a small bank, which meant that I could look down and get good separation between them, and also that they had to look up, which helped with lighting on the faces. Including the goalposts tells us which sport is involved. I shot on a 150mm lens rather than the medium format standard 80mm to compact the perspective and make them

appear closer together as a team. The hardest part of group photography is getting everyone looking nice, so you need to take lots of pictures. It's a situation that the photographer must dominate to get everybody's attention; a tripod allows you to have a free hand to orchestrate your band.

SUMMARY

■ **Camera** Hasselblad 503. 150mm lens.

■ **Film** Ilford Delta 400 rated at ISO 320.

■ **Developer** Film: Ilford Microphen for 8 mins at 20°C/68f. Print: Ilford Multigrade.

■ **Exposure** Camera: 1/250 sec at f8. Print: 14 secs at f5.6, plus 4 secs burn in on the sky, grade 3.

■ **Paper** Ilford Multigrade semi-matt RC.

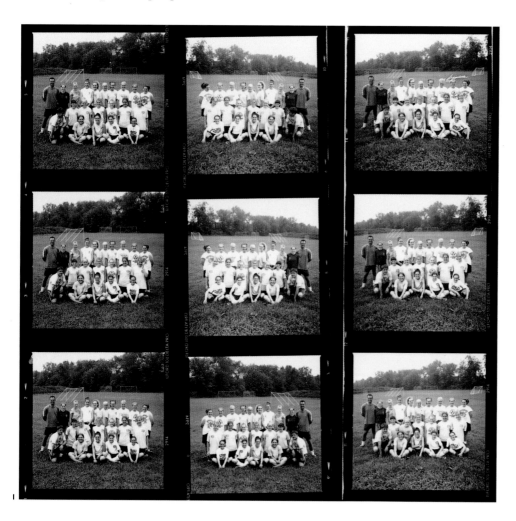

1. MOSTLY MISSES
You can see how many misses I had – some looking away, some not smiling, etc. I should really have shot another roll to make sure. That, of course, is not easy when everybody wants to go home. The photographer must be in charge, however. They would have stayed if I had insisted.

2. FINAL PRINT (opposite)
Matt (bottom left) is the only one not smiling, of course, but all the girls are on song. The print was almost a straight one – I just burned in the trees and sky for 4 secs. I could have made a more dramatic print by burning in around the group, but in the end I decided to keep the it smooth and simple.

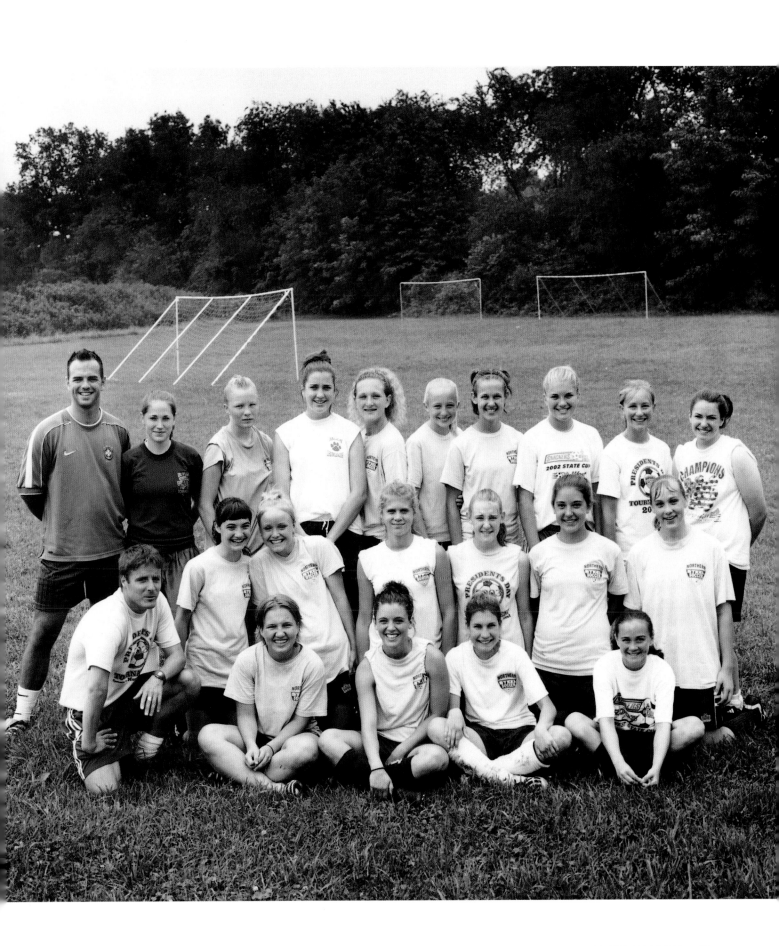

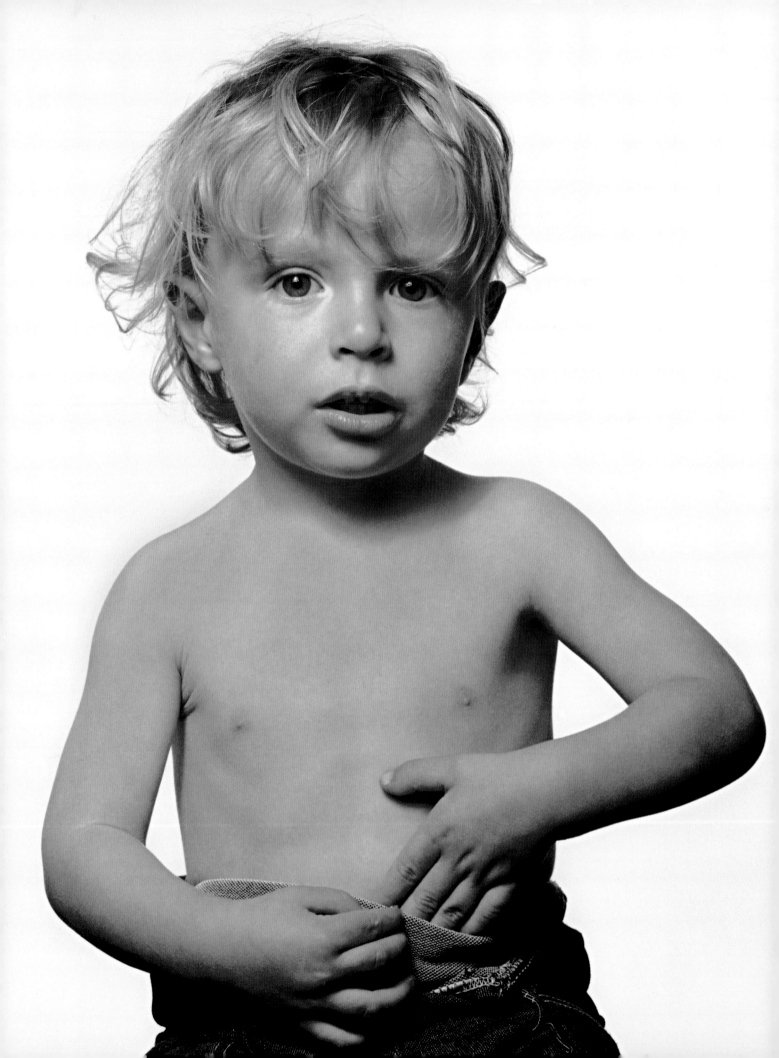

Child portrait: Nick

Here is my definitive portrait of a little boy, ungroomed and certainly not dressed up. He is in fact my older son Nick, who makes an earlier appearance on p. 26. The studio was still set up from a previous shoot, white background and all, when he toddled in; I popped him on the stool and shot off a roll on the Hasselblad. The light came from a studio flash unit (Bowens 500), bounced off a large white umbrella (2m/6ft diameter). Draped over the umbrella was a sheet of fine, white, translucent fibreglass, to further soften the light, which was coming from a couple of metres above head height, almost directly over the camera. He was very relaxed with the situation, as he was often in the studio.

The open, smooth tonal range that medium format brings is sympathetic to the subject. Because his hair is tousled and he's half dressed he makes a beautiful image of the innocence and vulnerability of childhood. I do think it a pity that we tend to spruce kids up for the big portrait and lose the magic. The low camera angle added some strength – I don't like the obvious symbolism of looking down on a child. The important thing to remember is that small children get bored very easily, so you *must* be ready before you start. And if they don't want to know, stop; if you push them they'll associate the portrait with bad experiences and be put off for ever.

SUMMARY

■ **Camera** Hasselblad. 105 mm lens.

■ **Film** Ilford HP5 rated at ISO 320.

■ **Developer** Film: Ilford Microphen for 7 mins at 20°C/68°F. Print: Agfa Neophen.

■ **Exposure** Camera f16 synched to flash. Print: 14 secs at f5.6, grade 3½. Slight flash in.

■ **Paper** Ilford Multigrade warmtone semi-matt FB.

1. CONTACTS
As you can see I've cropped the print from the original square image, though I wouldn't do that to most of the other images. I shot on a long (250mm) lens so that I was far enough away for him not to feel shut in. The short duration of the flash is very useful in freezing the movement of children (this flash was going off at 1/800 sec); otherwise you end up telling them to keep still all the time, and you don't want that.

2. FINAL PRINT (opposite)
The negative was very easy to print, and needed no extra burning or shading, although I gave it a brief flash in. I have printed it on several different contrasts over the years and they all look OK, whether hard or soft. This one on grade 3½ works best for me – bright but not too hard for a wee chap.

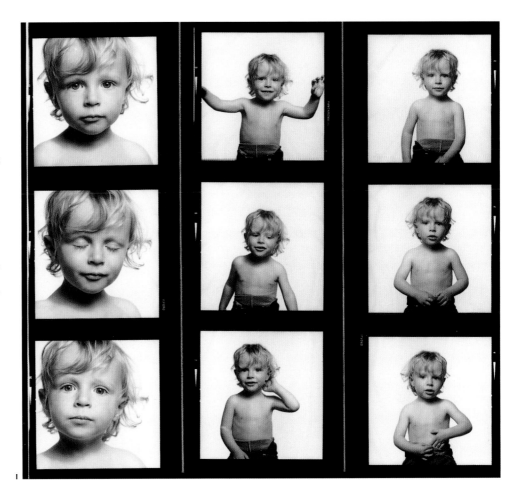

Flash fill with daylight: Dog and hills

This portrait of a farm sheepdog is an example of backlight with a fill-in flash. That's as good a reason as I can come up with to publish this picture – I just really like it. I'd been taking some indoor pictures of a farmhouse kitchen using flash because it was very dark. On the way back to the car, I thought I'd finish the roll on a landscape with the local village in the background. As you can see, it wasn't working until the dog decided to sit in. He was snow white and three-quarters backlit, and I moved to where I could frame his head in the tree. I was using a red filter and still had the flash gun on the camera; I shot a frame without flash, then switched on and got another away before he moved off. The flash made a subtle but very important contribution to the picture by capturing the whiteness of his coat.

DEDICATED FLASH GUNS

Dedicated flash guns, produced by most manufacturers, have made subtle fill really easy; I set the flash to ⅓ of a stop fill. The red filter did its usual job on the background, darkening the green foliage and the blue sky. Combined, the manipulation of the existing tonal balance with the red filter and flash produced my best ever dog in landscape picture – well, OK, my only dog in landscape picture.

This was shot on Ilford HP5+ rated at ISO 600 and developed in Kodak Xtol for 12 mins. The negative printed almost straight; I only shaded the trees slightly to prevent them printing black. I cropped the print at the top just because it looked better for the dog.

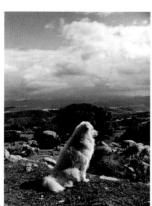

1. BAD LANDSCAPE
The "end of the roll landscape" that wasn't working. It's just a mess, really. There are none of the required elements for a landscape present: no focal point, no foreground that leads the eye into the picture. I guess the sky is OK!

2. LANDSCAPE WITH DOG
The dog without flash – a nice pic, but I think you'll agree that the dog's coat lacks the glow of the next pic. We now have some solid structure in the picture; just a squirt of flash to add.

3. FINAL PRINT (opposite)
Here he is in all his glory. I would have experimented with different amounts of flash, but he wasn't up for that. I don't like flash to look like flash, so I only add in a little bit unless I want to alter the tonal balance drastically.

SUMMARY

- **Camera** Nikon F90x. 24–85mm lens at 60mm. Red filter. Nikon SB-26 flashgun. Tripod.
- **Film** Ilford HP5+ rated at ISO 600.
- **Developer** Film: Kodak Xtol for 12 mins at 20°C/68°F. Print: Ilford Multigrade.
- **Exposure** Camera: 1/500 sec at f8, plus ⅓ flash fill-in. Print: 12 secs at f4, grade 3. Trees shaded 3 secs.
- **Paper** Ilford Multigrade warmtone semi-matt FB.

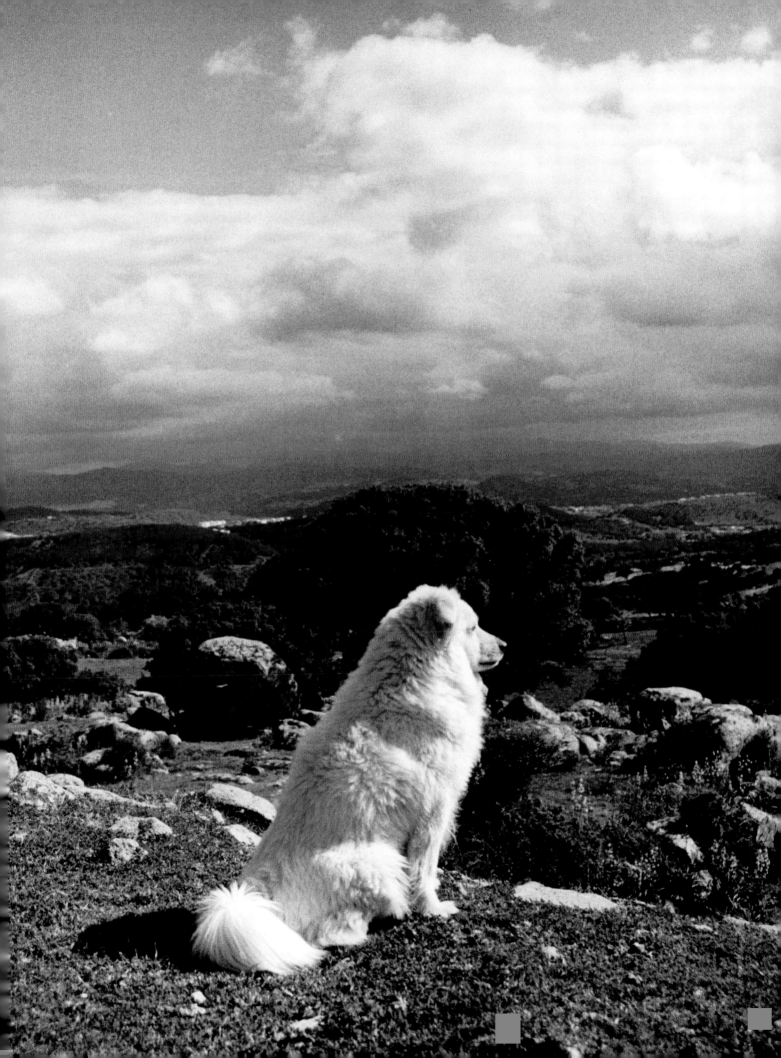

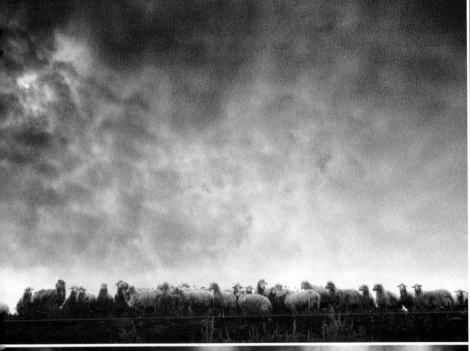

Landscapes

I think that of all the great photographic themes, Landscape is the one that the beginner finds the most difficult. How do you turn that pretty scene into a strong black and white composition? The eye can scan around a huge area and reconstruct all the elements in the brain as an attractive image. The camera can't do that. And then you hear the old cry of "I don't understand. It looked much nicer than the photograph." We are on the right track when we understand that when with landscapes *less is more*. I have chosen examples for case studies that I hope will be helpful whether you are learning to visualize a landscape in perfect light or on on a horrible day. But the truth must be told – if you aspire to be a good landscape photographer, it takes hard work and dedication. It can get cold and wet out there, and your clothing, boots, sandwiches, and mobile phone can prove as important as your camera.

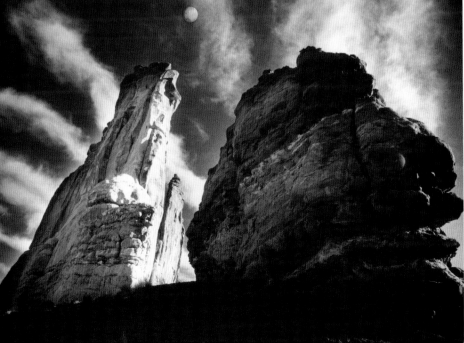

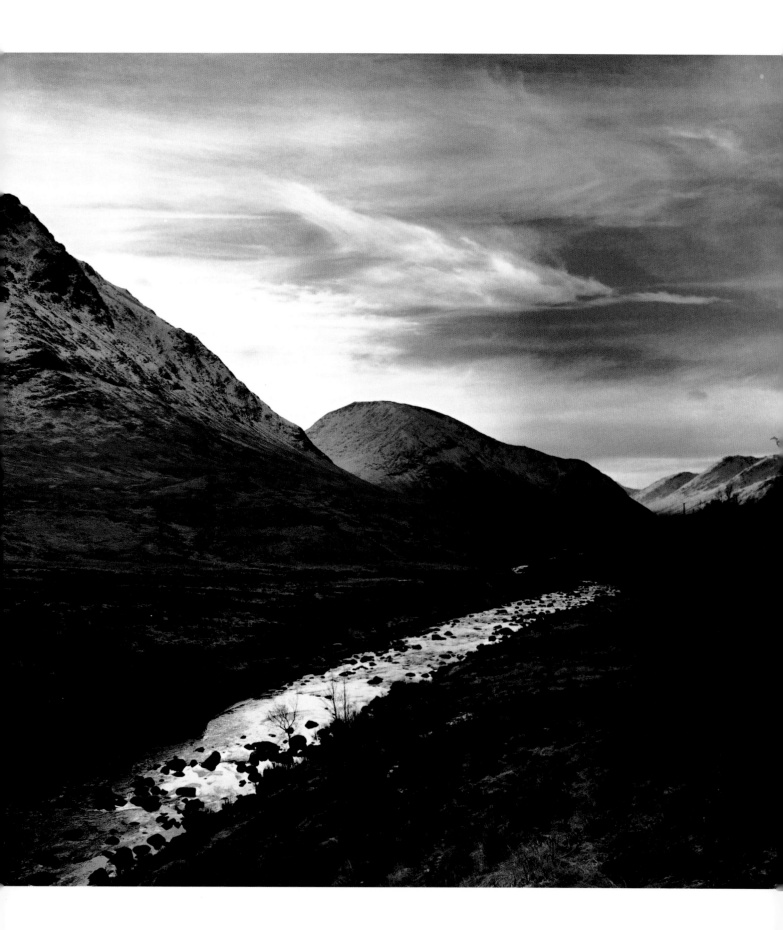

Classic landscape: A Scottish burn

At first glance this shot of Glencoe in the western highlands of Scotland is a typical landscape with mountains, a river (in this case a burn), and a big sky. Indeed, that's all it is – I've reduced this massive glen down to a graphic design. The highlands landscape tends to be spare anyway – or minimalist in today's parlance – there are few trees, and at the time of year this picture was taken (December), the heather had died off, waiting for the spring.

TONES OF GREY

The time of day was 8.30am, and the sun had yet to reach the mountainsides to give me the detail and form that a tourist brochure would include. The light worked a treat, as it gave me definition between the mountains, and threw all that rather uninteresting foreground into shadow. The burn was reflecting the sky, and I visualized it as a great highlight slashed across the picture. Learning to see the scene before me not as lovely mountains, majestic trees, pretty farmhouse, and so on, but as shapes made up of different tones of grey, was the development that led to an improvement in my landscapes. It's the tonal arrangement or composition that dictates the success or otherwise of a landscape. The colour snap below was taken with the sun diffused by cloud cover. I waited 20 minutes until the cloud dispersed to give me

some contrast and add some much needed separation between the mountains. As you can see, the sky was only a pale blue and wasn't going to appear very dark, even with a red filter, so some burning in was going to be needed. I looked at the scene through the 35mm Nikon first and made a few exposures, but quickly changed to the Hasselblad. The 6 x 6cm format works better on this composition for me; compare the shape with the 35mm colour image.

The bottom line is that I have selected a small portion of the vast glen and then reduced it to a few tones of grey. I've managed the tones to make the bright highlight of the burn cut across the dark foreground, leading the eye through to the mountains in the background. That was the camera visualization; I planned to add the drama in the darkroom.

BRACKETING AND TESTING

I exposed Ilford Delta 400 with a bracketed exposure. When you're set up on a tripod at a landscape it makes sense to do this to be absolutely sure you end up with a perfect negative. Processed in Microphen, the negs had more detail than I ended up using. As with the rock stacks in the next case study, I made one for the sky and a print for the land to discover the potential of each. I

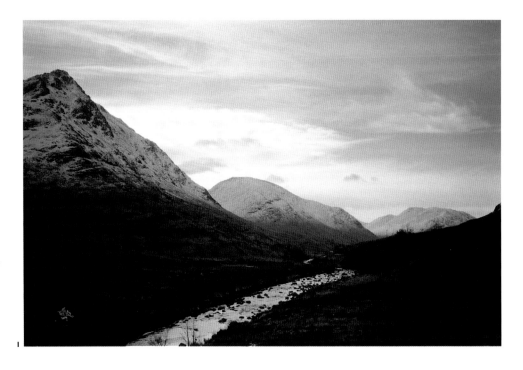

I. REAL LIFE
I took the colour picture to show how incredibly different the final black and white print looks compared to real life. The camera can lie after all! That could not have happened if the important elements had not been present.

I didn't think the dead heather looked very inspiring so decided to go dark, leaving just a little detail, though not completely black. The sky was a bit light for my taste. I made two more prints; the first held too much foreground detail and my choice of grade 3 was a little too soft. The second print was on grade 4 with a basic exposure of 15 secs at f5.6. I shaded the burn back for 4 secs using a ruler. The sky was burned in for 20 secs on grade 5, to get as much separation for the clouds as possible. I printed on Forte warmtone semi-matt FB.

FARMER'S SOLUTION

As the prints dried, they lost their sparkle: a common problem. I ran them through a weak mix of Farmer's Solution and bleached them back very slightly (15 secs). The bleach has restored life into the print.

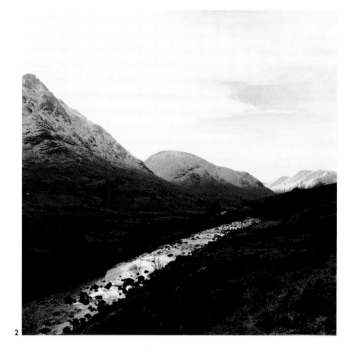

2

2. TEST PRINT: LAND
Note how pale the sky has reproduced, even with the red filter. It was going to need lots more exposure; I exposed this one for 12 secs.

3. TEST PRINT: SKY
It looks OK, but I thought it needed just a little detail in the foreground. This print had 27 secs. It is only subtly different from the final one. In fact, I'm still unsure whether or not this darker look works better than my final version. It's just a question of personal taste, really – neither one is a "better" print than the other.

3

4. ATTEMPTED SOLUTION
The first attempt at a solution. I made the basic exposure too short – there's too much detail that isn't interesting to the eye.

5. FINAL PRINT
The final print ended up as a rather melodramatic interpretation of the scene in front of me, but let's call it artistic licence.

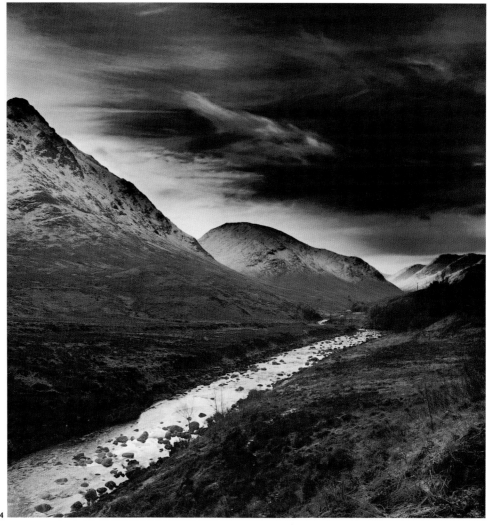

4

SUMMARY

- Bracket your landscapes exposures for a good neg.

- Try to see the landscape in terms of shapes and tones, not as a pretty scene. This is the key to visualization.

- ■ **Camera** Hasselblad 503. 80mm lens. Red filter. Tripod.

- ■ **Film** Ilford Delta 400, rated at ISO 320.

- ■ **Developer** Film: Kodak Xtol for 11 mins at 20°C/68°F. Print: Agfa Neophen warmtone.

- ■ **Exposure** Meter reading was 1/125 sec at f1. Bracket was: 1/125 sec at f8; 1/125 sec at f8/11; 1/125 sec at f11; 1/125 sec at f11/16; 1/125 sec at f16. Print: Basic exposure 15 secs at f5.6, grade 4; shading 5 secs, burning in 20 secs.

- ■ **Paper** Forte warmtone semi-matt FB.

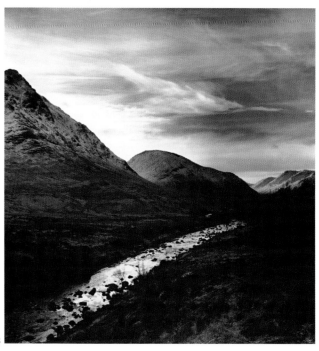

5

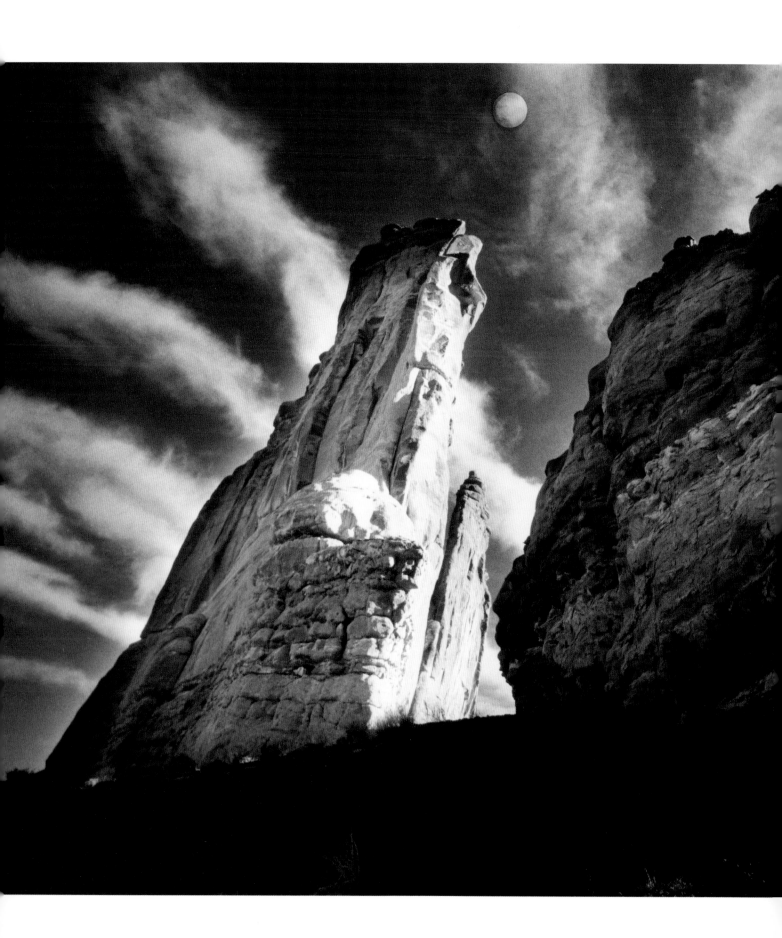

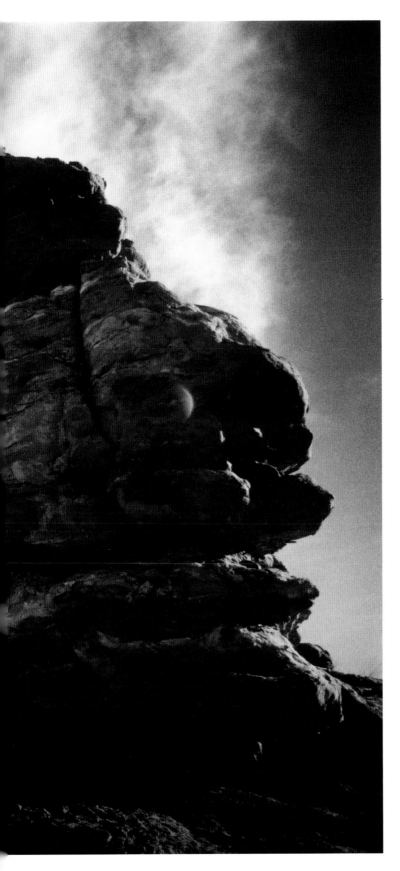

The Four Corners of the USA is one of my favourite parts of the world, a vast area so named because it's where Colorado, New Mexico, Arizona, and Utah meet in what looks on the map like a crossroads. I'm sure it was the images of my childhood – predominantly of America rather than Australia, where I was born and raised – that influenced my feelings for this extraordinary country. I do feel that our visual memories from childhood contribute considerably to our creative lives as adults, influencing our style as photographers without us even being aware of it. Apart from that, I challenge anyone to go there and not be completely knocked out. Landscape photography is primarily about travel – going somewhere that inspires your photographic muse. In fact, don't even start practising in a place that's pleasant but not really exciting, as you'll just be disappointed and lose confidence. When you come across great natural sculptures like these in Colorado National Park, you're in with a chance of making a good landscape picture.

THE MAGIC INGREDIENT

The magic ingredient that makes a dramatic landscape is light. I make no apology for labouring this point, as it can't be overstated. Time of day and weather are the main influences on light quality. I travel with a compass, as it tells you where the light will be at different times of day, and you can plan to return to a location when it's more exciting. As far as weather's concerned, I often have most success on stormy days: they start off most unpromisingly, and just when you think it'll never clear a shaft of light suddenly breaks through, and presto – you have a landscape. This picture came at the end of such a day. I was fed up and ready for a Jack Daniel's, when the weather cleared and I was in business. Light changes quickly, so you need to be ready to shoot fast while you can. I always travel with my cameras loaded and one on the tripod, with filters in my pocket.

EXTREME WIDE ANGLE

I used an 18mm lens for this shot, and it's the optics that have dominated the composition: the extreme wide angle has distorted the perspective, dramatizing the shapes of the rocks and exaggerating the "stretched" look of the clouds. The finger-shaped cloud formation

was the main attraction really, so a red filter was needed to emphasize it by darkening the blue sky. The light was going down but put glowing highlights on the "tower rock", and I was getting a fine fill to the shadow side as the sun bounced back from the rocks behind me. I used Kodak T-Max 100 rated at ISO 100. I set my auto exposure at +7 to make sure that the increased contrast of the filter didn't leave me short of shadow detail.

IN THE DARKROOM

The second stage visualization in the darkroom holds the key to this image. The neg held sufficient detail to print the shadow areas as dark monoliths or as beautifully detailed rock formations. I first made a light print to see how much detail was available, and a second print for the sky, which made the shadow areas dark and foreboding. The answer seemed to be a combination of the two.

1. THE IMPACT OF LENSES
The two strips demonstrate the difference between using a long lens (top), and the distorting effects of looking up at your subject from close in (bottom).

2. TEST PRINT: SHADOW
The print for shadow detail. Whether you finally decide to use it all or not, this is the quality of neg that you should aim for – then you have the luxury of making a creative decision in the darkroom rather than being stuck with only one way to print the image. I printed on grade 2½ for a smooth tonal range.

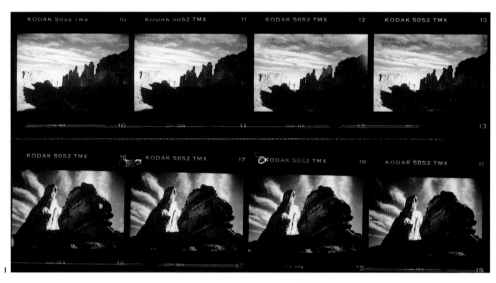

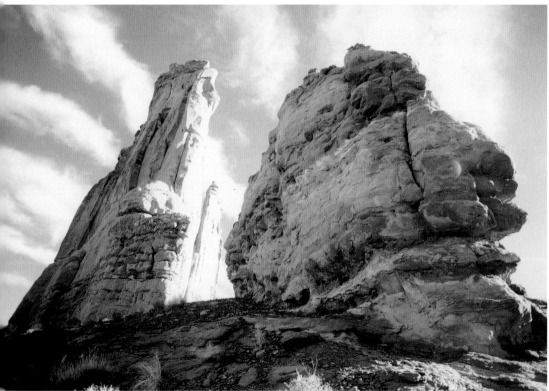

3. CLOUDS (opposite top)
The print to check out the clouds and what it would look like dark. I preferred the dark look, but contrasted the two shapes by making the tower lighter than the foreground. Printed on grade 3.

4. THE FINAL PRINT
I bumped up the contrast to grade 4, exposing for the sky and shading the rocks. I wanted detail in the foreground rock while keeping it dark and moody. Then I shaded back the tower so it could retain the glow of the late sun and made the foreground black to make it less distracting. I added a moon – a coin – and divided the exposure into two parts. I first exposed for 5 secs, shading the foreground, and then removed the coin and re-exposed for 8 secs while I shaded the tower (with dodgers). I finally burned in the foreground for 8 secs. The cloud printed through the moon to look real, but it still needed some retouching.

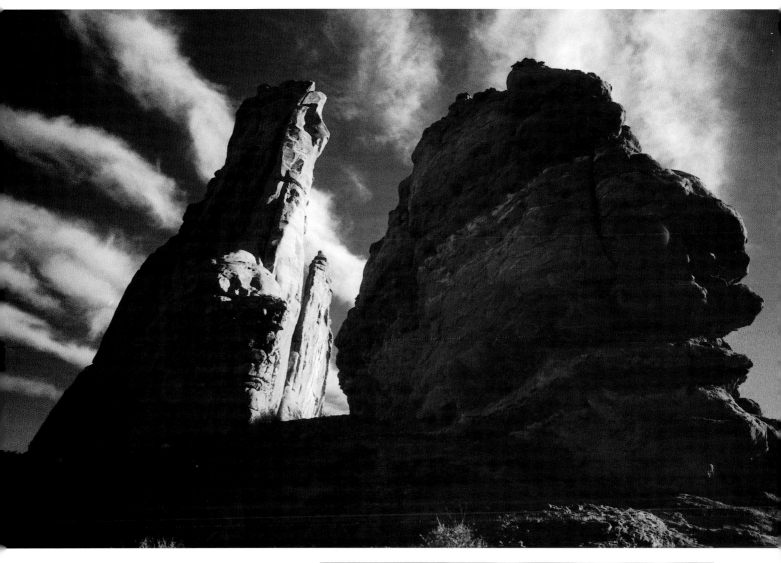

SUMMARY

- **Camera** Nikon F90x. 18mm lens. Red filter. Tripod.

- **Film** Kodak T-Max 100.

- **Developer** Film: T-Max for 7 mins at 20°C/68°F. Print: Agfa Neophen warmtone.

- **Exposure** Camera: 1/250 sec at f11. Print: 13 secs, grade 4; shaded foreground 5 secs and 8 secs; burned in 8 secs.

- **Paper** Forte warmtone glossy (unglazed) FB.

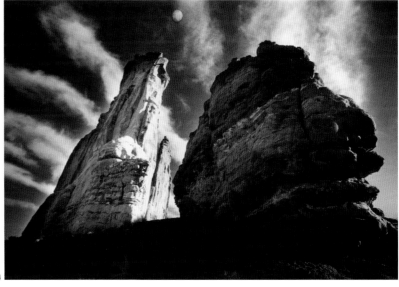

4

Skyscape: Sardinian sheep

This rather strange image is my alternative landscape. I was in Sardinia shooting some case studies for this book. As I was driving along, I saw these sheep fleetingly out of the corner of my eye. A mile or so further on, I realized that the sheep were lined up very graphically in front of an intensely dramatic sky. I turned back; I always regret it later if I don't.

UNEVEN EXPOSURE

The problem tonally was the big difference in exposure value between the sky and the sheep. The sun was diffused by cloud, but still backlighting the sheep, and I knew from experience that I'd have trouble holding much detail in the sky. I used a neutral density graduated filter to cut the light value of the sky by half (1 stop), and left the sheep to expose as they were. Despite evening out the exposure, I knew the sky would need some burning in during printing, and I'd have trouble doing this around the heads of the sheep. Here's an occasion where a computer could be very useful: it's easy to put tone back into fiddly spaces with the spotting brushes in Photoshop. In this instance, however, I was determined to print in the darkroom, and used a cotton bud covered with graphite from a 2B pencil to spot in some grey tone – a trick that my photographer pal Graeme Harris showed me.

The composition was pretty obvious, really: presented with a dramatic sky and a row of sheep, the natural thing to do was put the sheep across the bottom of the frame and leave a big sky at the top. My sole technical contribution was the use of an 18mm lens, which stretched the sky and elongated the sheep to add more graphic impact. I reckon it works well, and I like the moody atmosphere of the final print. Simple pictures sometimes require complex solutions in black and white. I shot a few frames on Ilford FP4+, then switched to Kodak T-Max 3200P. I used a red filter to darken the blue sky at the top.

ADDING AND SUBTRACTING

Having already cut the exposure value of the sky with a filter, I gave it my normal development in T-Max. I concentrated on the detail in the sheep and left the sky to look after itself. As I visualized, the sheep were well exposed and the sky needed some burning in. I tried

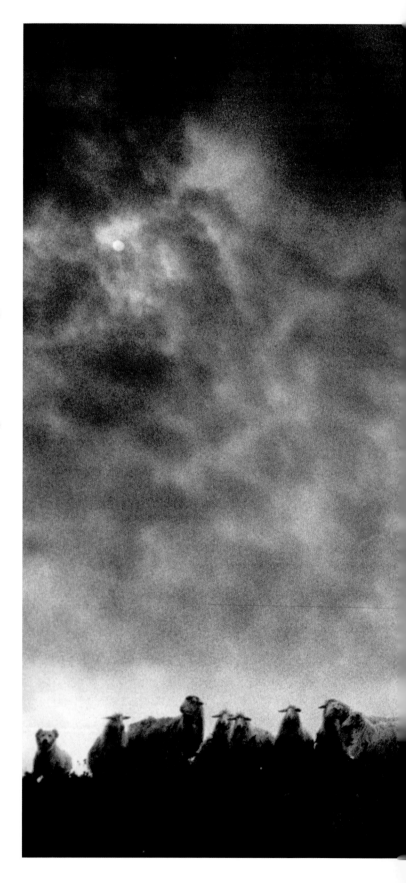

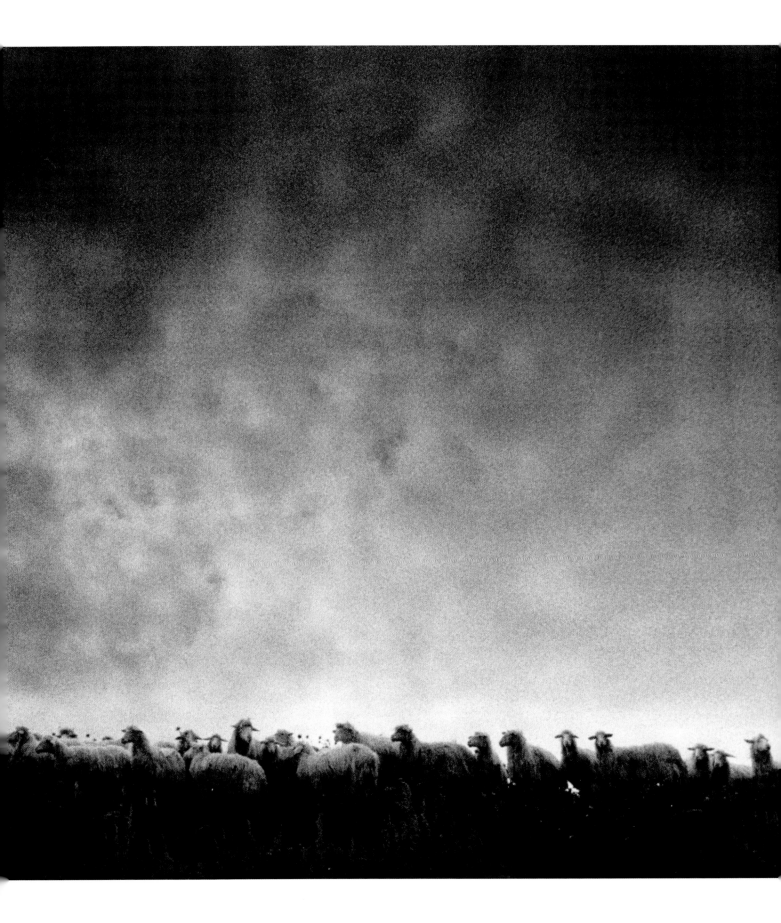

the two basic printing methods, additive and subtractive. I first tried a basic exposure for the sheep and then added burning in for the sky. Next, I tried an exposure for the sky and subtracted tone from the sheep by shading the light with my hand. I calculated the exposure using my test strip. The additive method worked better. If you're having trouble with a neg using one method, try the other. The first exposure was 8 secs at f4 on grade 3, and then using the great feature of variable contrast papers, I set the enlarger's multigrade head to 5 and burned in the sky for a further 9 secs. Grade 5 milked the ultimate contrast out of the sky, adding more drama, and the grainy look of T-Max added a gutsy texture.

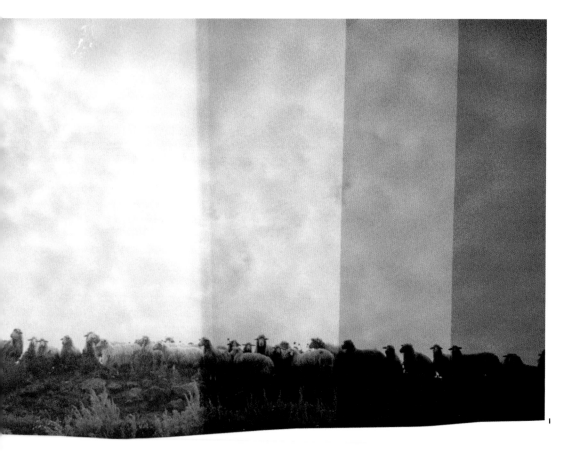

1. TEST STRIP
This is just a sheet of paper torn in half. I don't often make these as I print so often I can go pretty close on a test print. Because this image had an even density right across the neg and the exposure was very tricky, I made a four-step strip using a piece of card as the mask. From left to right the exposures are 6 secs, 9 secs, 12 secs, and 15 secs at f4 using Forte glossy (unglazed) FB paper.

2. TEST PRINT: SHEEP
Based on the strip, I made a test print, exposing for the sheep – 7 secs at f4. That was good for the sheep, but too light for the sky, as I visualized back in Sardinia. Contrast was grade 3.

3. TEST PRINT: SKY
A second test, exposed for the sky. I gave it 14 secs at f4. I dialled up to grade 4 to increase the drama by adding contrast.

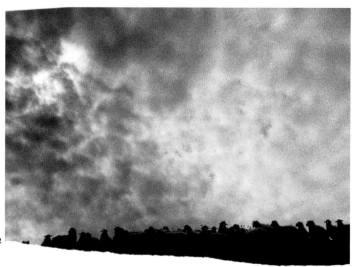

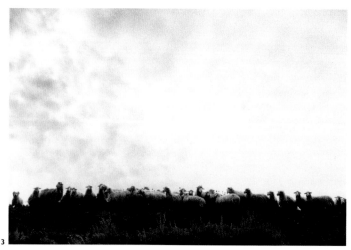

4. COMBINED EXPOSURES
I combined the two exposures, starting with 7 secs on grade 3. Then, with the sheep shaded with my hand, I added another 7 secs at grade 5 – having decided that the sky could use even more contrast. Although I liked the halo effect around the sheep, this print has too much, I feel.

5. FINAL PRINT
For my final effort I added 2 more secs to the sky and burned in a bit around the sheep by making a hole with my hands. You can do the same thing by making a small hole in a large card and exposing through that. I finally used the trick of spotting carbon from a pencil via a cotton bud.

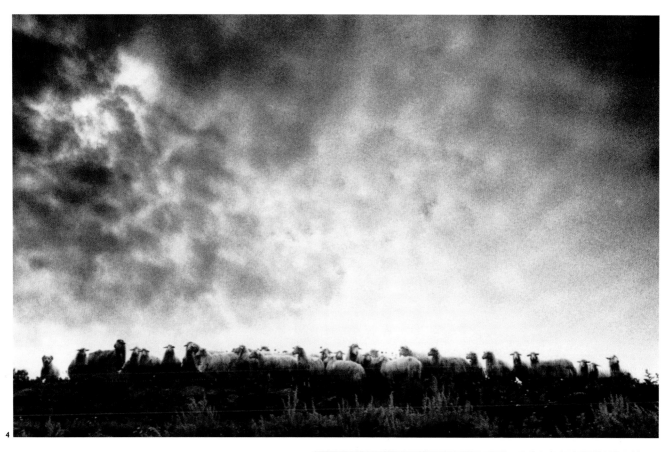

4

SUMMARY

- Graduated filters balance out tonal extremes.

- **Camera** Nikon F90x. 18mm lens.

- **Film** Kodak T-Max 3200P.

- **Developer** Film: Kodak T-Max for 12 mins at 20°C/68°F. Print: Agfa Neophen.

- **Exposure** Camera: 1/1000 sec at f8. Print: 8 secs at f4 at grade 3. Sky burned in 9 secs at grade 5.

- **Paper** Forte glossy (unglazed) FB.

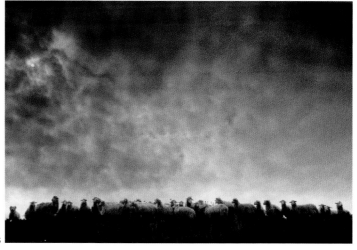

5

Right place, wrong time: A landscape saved

The right place at the wrong time – surely the most common frustration of the landscape photographer. Eilean Donan castle in the western highlands of Scotland has been used as a location for many movies; set in a loch and surrounded by mountains, it's a wonderfully romantic setting for black and white landscape photography too. But, and we're talking a big but here, the weather was appalling when I was there. The light was dull, and there wasn't much of it. To add to the misery, it started to rain and a big storm was on its way – great! Unfortunately, I didn't have the luxury of waiting to see what tomorrow would bring, so decided to have a go at it anyway.

USE THE CONDITIONS

I had to go with the conditions as they were and try to use them to my advantage. I tried to think positive, to try to clear my head of all feelings of disappointment that I experienced at first. Going with the flow, I decided to add some grain by using T-Max 3200 film and pushing up the speed to ISO 4800 in the development. I thought that grain could add to the atmosphere by making it look even more murky than it already was. I found a camera position that put the castle in profile and across the water. I used the foreshortening properties of a 300mm telephoto lens to pull the mountains in the background up closer behind the castle.

As part of this quest to try to turn the rather boring scene before me into a dramatic landscape, I visualized having to burn in the top of the sky. Another idea was to produce a denser than usual (or "thick") negative. Dense negs tend to clog up with grain, something that it's usually best to avoid, but here could work to my advantage. Such negs are also usually flat (low contrast), so as the scene was already very flatly lit I was probably going to have to print on grade 5 to wring any guts out of the picture.

Driving away from the location, I comforted myself with the thought that if I'd made a decent job of this picture it would after all be an honest interpretation of the way the castle looks for most of the year. The highlands aren't famous for sunny weather. All things

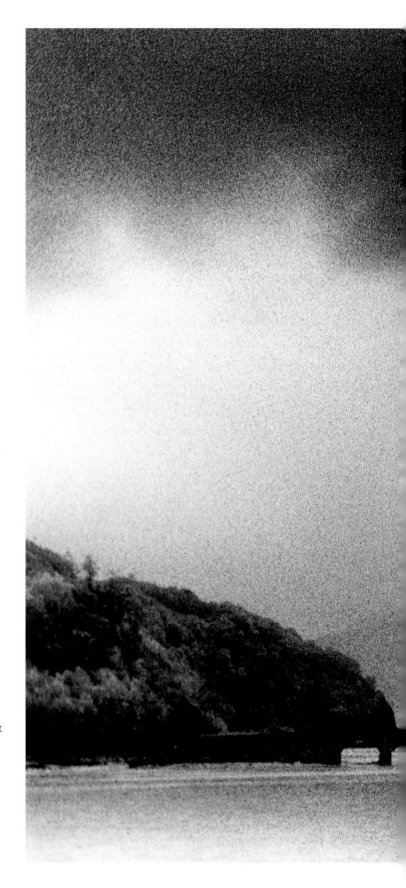

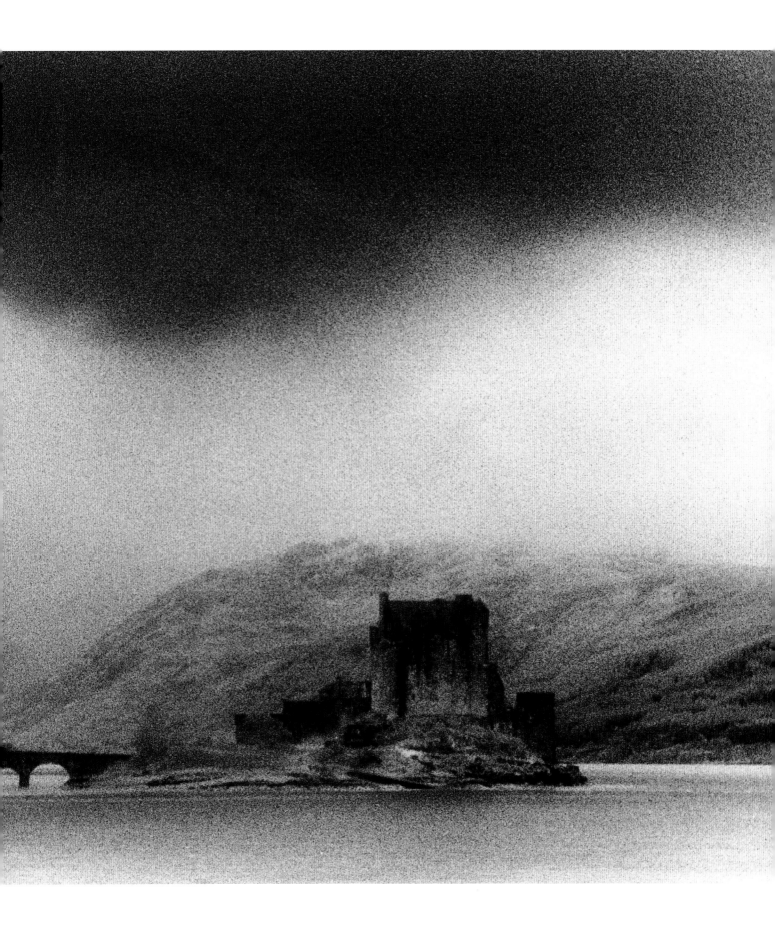

considered, it isn't a classic, but it is rather nice – a real life landscape from a situation that we all come across on our travels.

I do think that we get too hung up on trying imitate famous photographers such as Ansel Adams instead concentrating on developing our own style. Of course, the masters play a key role in inspiring most of to become photographers, and there is much we can learn from their work, but we are all fascinated by different things and should as far as possible follow our own instincts while sticking to the basic principles.

INFRA RED
In fact, this picture ended up looking much like an infrared picture, with its slight glow, extreme grain and black sky. It is worth keeping a roll of infra red in the bag for really difficult conditions.

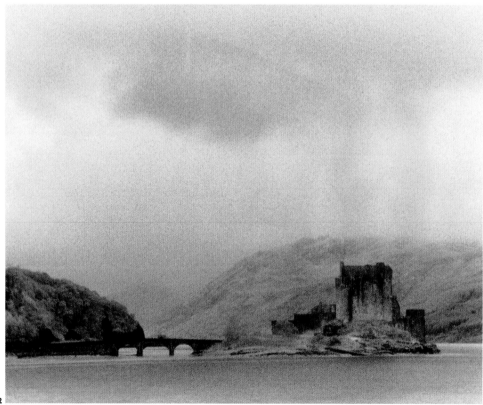

I. OVERDEVELOPED NEG
Confession time. I made real mess of the development. In going after a dense neg, I overdeveloped and ended up with something more suitable for viewing a solar eclipse than making a print. No excuse – I should have made a test clip first (about 15cm off the beginning of the film). I was trying to hurry and made the neg very difficult to print, as you can see from the two I've published.

2. THE FIRST TEST
This needed 45 secs at f2.8 to expose. It's about as interesting as the scene itself – not very – but a good exposure guide and a basis to work on.

3. GETTING CLOSER
This is certainly more dramatic and getting closer to my visualization in Scotland. It's a little too dark and has lost separation between the castle and the mountains. I gave a basic exposure of 65 secs, grade 5, and then burned in those high clouds for 40 secs using my hands.

4. FINAL PRINT
This is looking pretty good. I've cut the exposure by 20 per cent, and shaded the mountains with a dodger for 10 secs to separate them from the castle. I decided at this point to try a bleach back, which would add some extra contrast by stripping the highlights, as well as adding a touch of sepia-like tone. I made another two prints at the density of illustration 3, and bleached in a weak mix of Farmer's Solution.

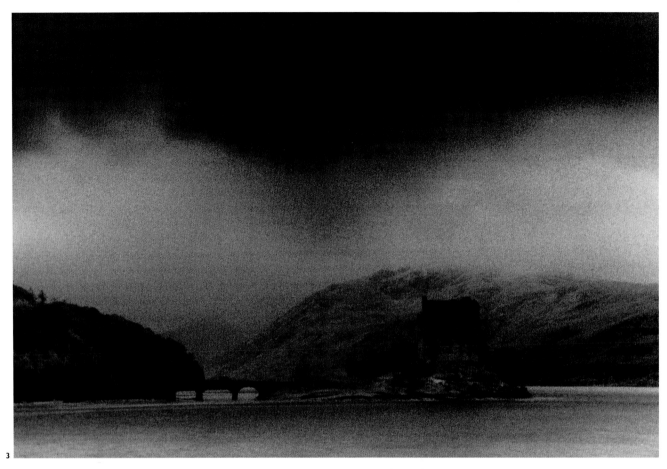

3

SUMMARY

- ● Take up the challenge when faced with disappointing weather. It is interesting to see if you can use your technique to pull off a good pic.

- ■ **Camera** Nikon F90x. 300mm lens. Red filter. Tripod.

- ■ **Film** Kodak T-Max 3200P rated at ISO 4800.

- ■ **Developer** Film: Kodak T-Max for 14 mins at 20°C/68°F. Print: Kodak T-Max.

- ■ **Exposure** Camera: 1/1000 sec at f8. Print: 65 secs, grade 5. 40 secs burn in on clouds; 10 secs shading mountains. Bleached in Farmer's Solution 2 mins.

- ■ **Paper** Forte warmtone glossy (unglazed) FB.

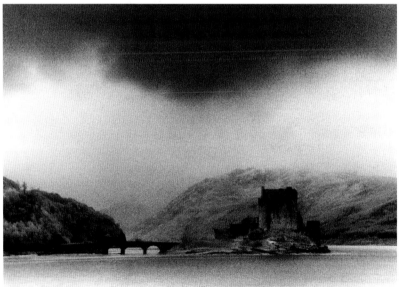

4

Nostalgia: An old farm

When planning a trip, I make sure the places I'm going to stay in have some photographic potential. This picture was only possible because I spent the night at a charming little farm in central Sardinia. I spotted this landscape on a stroll around the place and snapped it first on a compact to show how it looked in colour. It looked more American than Italian somehow, like a scene from an old black and white movie.

SEPARATION

I chose a slow film (Ilford FP4+ rated at ISO 100), for maximum sharpness and fine grain, and settled on an orange filter so as not to lose separation by making the sky too dark. I decided to lie on the ground, partly to get separation for the swing and to look up the road rather than down on it, but also because the sky was stronger from there. I used the 24–85mm zoom at 24mm, and shot both vertical and horizontal frames. I prefer the latter – I like the road and the rickety fence flowing off over the hill. The 35mm format gives us different compositional options by just turning the camera in the hand.

The tonal arrangement was interesting. The mid-morning sun was lighting the tops of the trees and making silhouettes of the tree trunks; later in the afternoon, in different light, there was no picture at all. Again, light is the key ingredient in landscape photography; our ability to visualize its effect on a scene in black and white determines whether we take good pictures or not. Treat every disappointing shoot as a valuable lesson rather than a failure and you'll quickly improve.

TONING

Holding the subtle clouds and fence in the print was always going to be tricky. After the first good print I decided to try a tone, thinking it might add to the nostalgic feeling I got from the farm. I went for the copper Fotospeed kit. The FP4+, slightly underrated and developed for 8 mins in Microphen, gave me an excellent quality neg, with all the tonal range present at the location. I chose Forte warmtone semi-matt FB paper, and went for all the tonal range in the neg. Test prints showed that some burning in was needed on the fence and clouds between the swing and the central

trees, as well as a little extra on the road, and some shading was required on the fence and trees to the right. I prefer to print on a higher contrast and then burn in the highlights (grade 3½), rather than go down by a grade or half, which here would have eliminated the need to burn in but would have lost the higher grade's sparkle. It's a more difficult technique, but the resulting prints have more impact. The basic exposure was 18 secs at f5.6 (stopped down enough to allow shading for 5 secs). I burned in the clouds and fence for 6 secs and the road for 4, with the contrast set at grade 2. For prints to tone I increased exposures by 20 per cent; toning reduces the density of the print, so you need to start off with one darker than you require ultimately.

1. VERTICAL APPROACH

The vertical response to the situation. It works OK as a picture in its own right but lacks the flow and the nostalgia of the horizontal. There is less of a story to it.

2. "REALITY"

A colour snap to show how it was in the real world – and for you to see what the elements were that attracted me to make a black and white picture from a perfectly good colour one.

3. PRE-TONING

The black and white print that I made before I got carried away with the copper toning. You may prefer it – it is certainly the classic solution. This is definitely a subjective area.

4. FINAL PRINT

This is the final result, starting with a print that was 20 per cent darker than the one above (illustration 3). I did try toning with a print the same as that one, but it went too light. One man's nostalgic image can be another's cornball – over to you.

SUMMARY

● Toning can romanticize a landscape.

■ **Camera** Nikon F90x. 24–85mm zoom lens at 24mm. Orange filter.

■ **Film** Ilford FP4+ 125, rated ISO 100.

■ **Developer** Film: Microphen for 8 mins at 20°C/68°C. Print: Agfa Neophen.

■ **Exposure** Camera: 1/250 sec at f8. Print: 18 secs at f5.6, grade 3½. Shaded 5 secs and burned in 6 secs and 4 secs.

■ **Paper** Forte warmtone semi-matt FB.

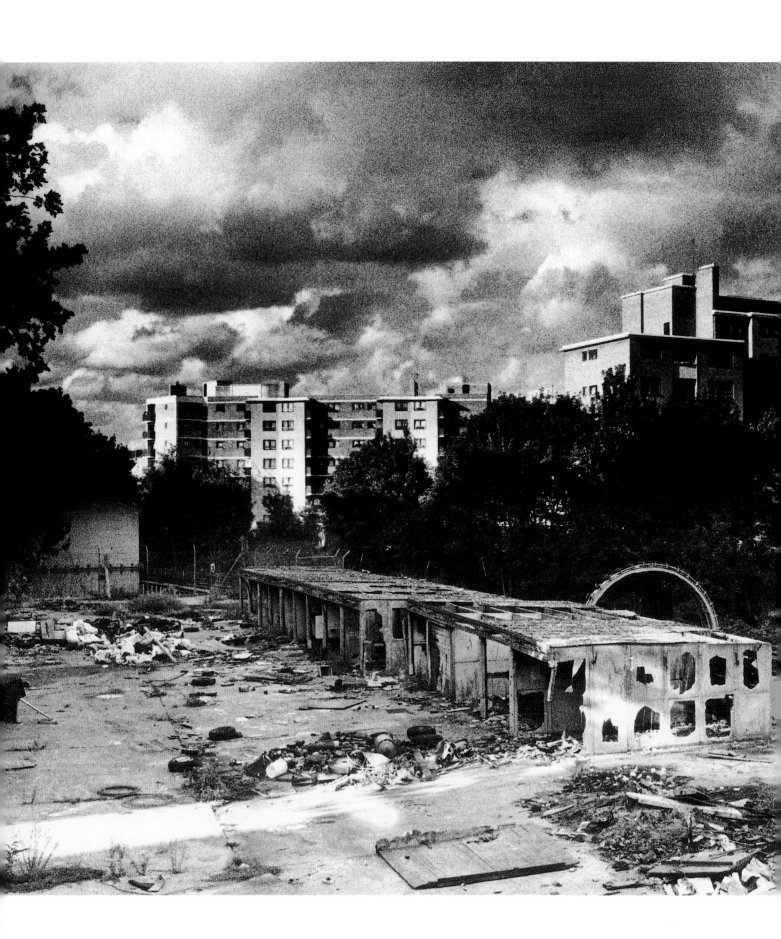

An urban landscape: East End

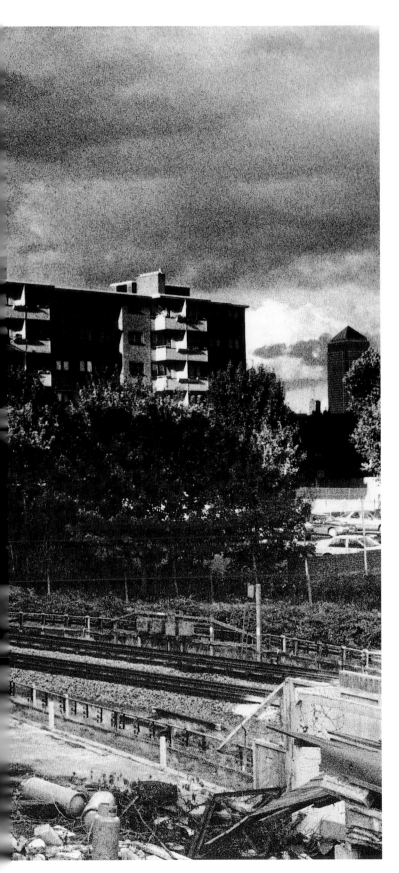

This is a cityscape, or urban landscape. It's a reportage picture, really, taken to illustrate a story about decaying infrastructure in big cities. Often in reportage a portrait or still life can tell a story to greater effect than your usual "human condition" picture. In this case, a landscape did the job for me: the abandoned railway station and a run down housing estate functioned as symbols of a problem. I include the picture here to illustrate the landscape techniques I used. There's a foreground that leads the eye further into the picture, a middle ground that separates the estate from the mess, high-rise estates in the background taking the place of a mountain range, and finally a big sky. Other pictures I took at the same time had people in them, but this empty one more effectively communicates the desolate feeling I was after.

READING THE LIGHT

The light had the potential to provide some drama, with strong highlights and moody shadows. There was a difference of several stops between the light values for the sky and the railway station, but that was never going to be problem: I just needed to expose for the station area and burn in the sky later. If you learn to read light in relation to how it will look on film – what sort of negative it will produce – you're well on the way to being a good black and white photographer. You'll be able to decide which film to use and what exposure and development it will need, and have a good idea as to how a final print will look.

CAPTURING A FEELING

My film choice was a reportage one rather than a tonal one: T-Max 3200 rated at ISO 1600. I wanted its grain to add a rough edge to the picture. It was another case of trying to capture a feeling rather than just faithfully reproducing a location. The light was throwing an intense highlight off one end of the station and making a hole right through the middle of the scene, so I used a polarizing filter to cut the reflection and add some contrast to the sky. I started from ground level, but it all looked boring. Then my assistant spotted a footbridge behind us; from that elevation the picture came to life – the composition was both more interesting and more descriptive. This urban landscape contains some very un-photogenic elements but the final print has a sort of

shabby beauty to it. I should add that since these pictures were taken, London's East End has been enjoying a period of revival and regeneration.

The negative came out of the marriage of Kodak T-Max 3200P film and T-Max developer (9 minutes at 20°C/ 68°F). As always when confronted with a neg of extreme tonal range, I made two test prints, one for the foreground shadow and another for the area above the treeline (prints 2 and 3). The exposure difference was big – about three stops – but the burning in was easy with the trees as a defining line. The basic exposure was 8 secs at f5.6, grade 3½, and then I opened the aperture to f4 (doubling the amount of light) and exposed again for the buildings and sky with 13 secs on grade 5 (shading the foreground with my hands). The burned-in sky contributes to the gloom.

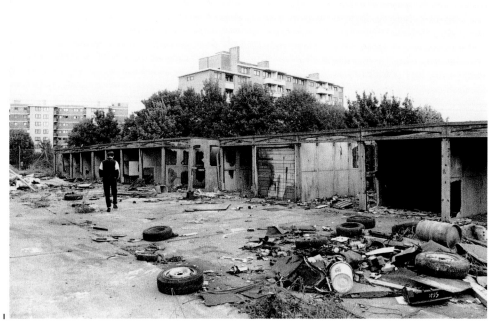

1. JOURNALISTIC IMAGE
The first camera angle made a boring picture. Not bad from a journalistic point of view, with plenty of rubbish and general decay in evidence, but not an interesting photograph.

2. FIRST PRINT
A much better camera angle. This is the first print: 10 secs at f5.6. The foreground is too dark and the sky is almost completely white, though the choice of contrast (3½) is working well.

3. SECOND TRY (opposite top)
The second print, exposed for 25 secs, showing that the sky is still not fulfilling its potential. The foreground is nearly black, giving the appearance of two separate prints combined together. This is only possible because all the tonal range is present in the negative.

4. FINAL PRINT
The combination works very well. I've boosted the contrast of the sky to grade 5 and increased the exposure by 30 per cent while reducing the foreground by 20 per cent. Just as you need to learn to read daylight, you also need to learn to read the potential of your negs, so that you can find the most from each picture.

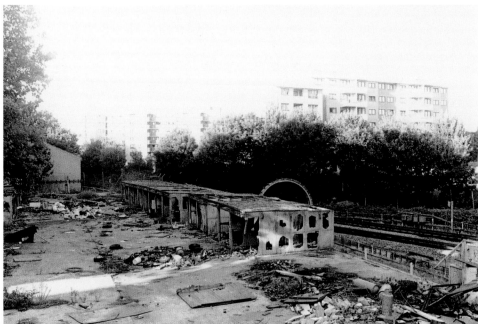

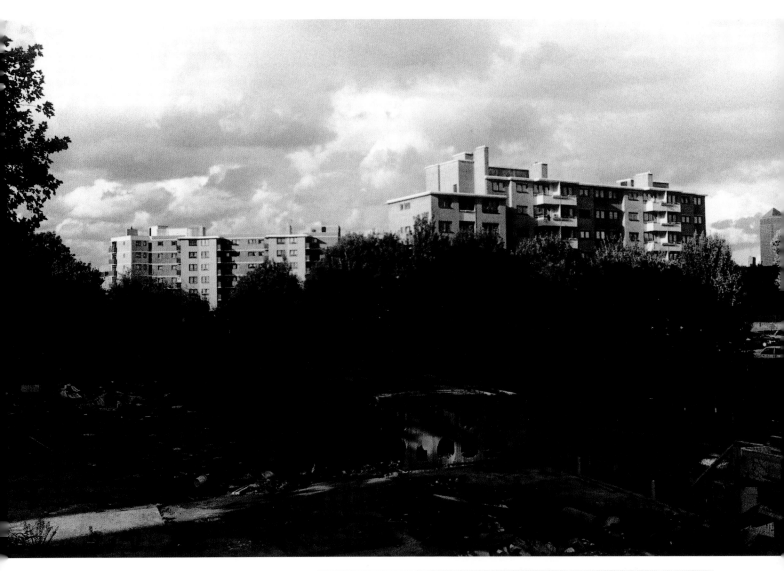

SUMMARY

- Make sure you get enough exposure into the shadow areas. You can always burn in the highlights later.

- **Camera** Nikon F4. 28–70mm zoom lens at 35mm. Polarizing filter. Tripod.

- **Film** Kodak T-Max 3200P rated ISO 1600.

- **Developer** Film: Kodak T-Max for 9 mins at 20°C/68°F. Print: Ilford Multigrade.

- **Exposure** Camera: 1/1000 sec at f11. Print: 8 secs at f5.6 for foreground, grade 3½, with a further 13 secs at f4, grade 5, above the trees.

- **Paper** Ilford Multigrade satin RC.

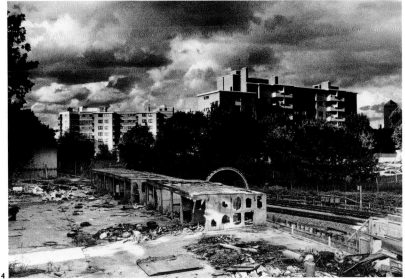

4

Still life
and Nudes

I have been taking nudes on and off for years but I have only become interested in still life quite recently. I hope what I am learning as I go along will work for you also. I have grouped the two themes together because I believe that the same disciplines are required for both. The nude is, after all, a series of cylindrical shapes and needs to be lit with that in mind, and still life is the ultimate theme for teaching oneself the discipline of attention to the most minute detail. Without that concentration, I believe that the subtle eroticism that is essential to a good nude will be lost. If you can take a good nude and a good still life then you are a very competent photographer in my opinion.

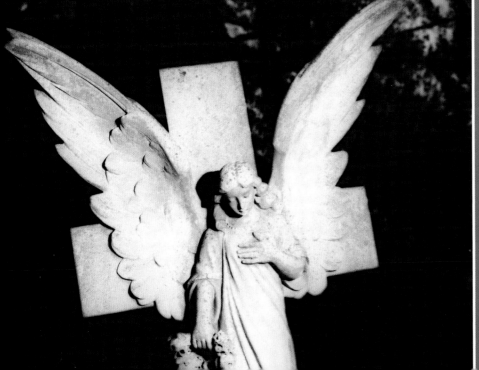

Graphical composition: Shadow play

The waiter whose first job of the morning was to arrange these tables and chairs outside his café had no idea that he was setting up some still life pictures for me to find a few hours later. In fact, he probably saw me taking the pictures there at about 11am and thought me quite mad. The tools of one man's trade can often also be the tools of another, quite different trade.

This found still life uses elements that photographers have been attracted to since it all started – the combination of shapes into patterns, and the repetition of those patterns in the form of shadows. It's really the essence of photography – the positive and the negative.

WANDERING

I love to wander around village streets when travelling, photographing whatever takes my fancy; some pictures work, and some don't. I don't get stressed by the ones that don't work, but I get pleasure from those that do. I think this "street photography" is great training for the eye – a way of learning to find the patterns around us and visualize them into black and white. Still life is the best subject matter to go for when doing this, because you only have form and light to deal with, without the complication of movement and people. I played with the chairs and their shadows, using my zoom lens at different focal lengths to alter perspective – an opportunity to experiment denied to traditional still life painters. When I go on my walkabouts I take only one camera with my trusty 24–85mm zoom, plus a few rolls of film, and orange and red filters. More than that and it becomes a test of endurance rather than an enjoyable pastime.

A medium speed film suits street walking: the ISO 400 range will give a good printable negative in varying lighting conditions. I used Ilford HP5+ rated at ISO 600. The hard morning sun produced a very contrasty neg that was ideal for my visualization of a minimalist picture containing very few tones – like a drawing. I printed on grade 4½ for 10 secs at f5.6, burning in the right-hand corner for 3 secs. I made a slight bleach back in weak Farmer's Solution (20 secs) to clean up the highlights.

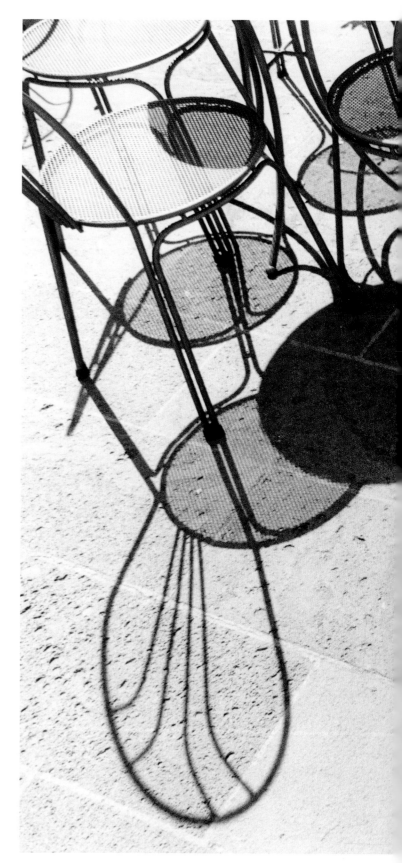

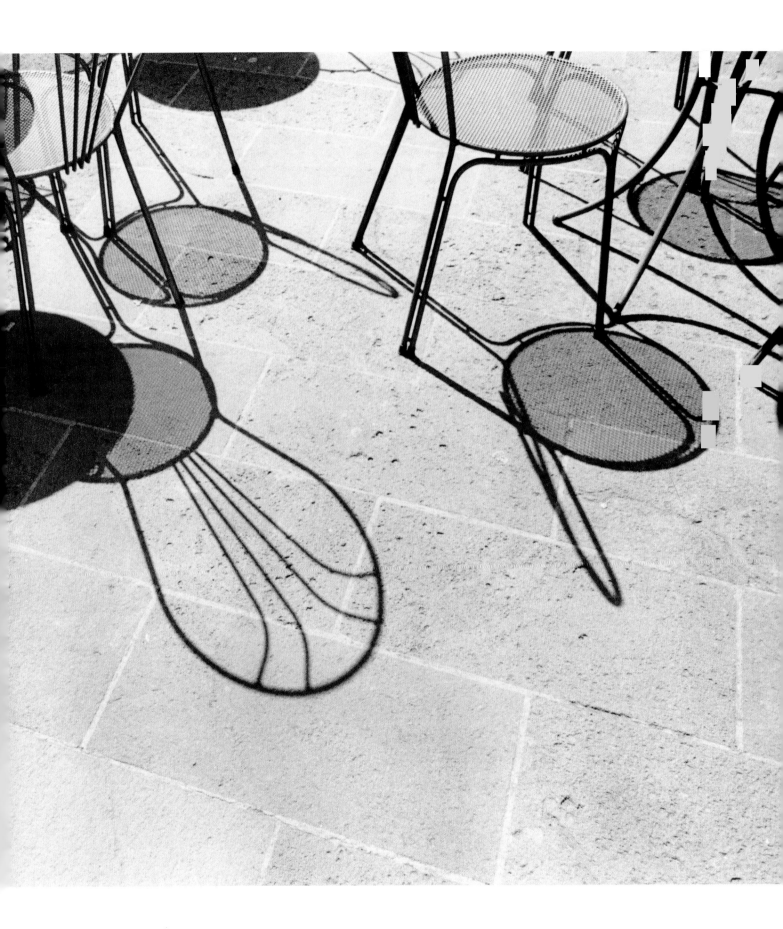

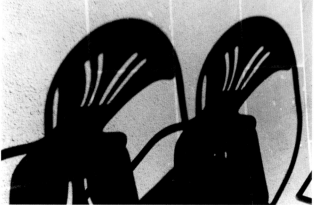

SUMMARY

- For street photography one camera and a small zoom should be enough — if your kit is too heavy, all your energy will go into just carrying it.

- Look for the alternative images — shadows, reflections, and details.

- ■ **Camera** Nikon F90x. 24–85mm zoom lens. Red filter.

- ■ **Film** Ilford HP5+ rated at ISO 600.

- ■ **Developer** Film: Ilford Microphen for 8 mins at 20°C/68°F. Print: Agfa Neophen warmtone.

- ■ **Exposure** Camera: 1/500 sec at f11. Print: 10 secs at f4 grade 4½ Corner burned in 3 secs. Bleached back 20 secs in weak Farmer's Solution.

- ■ **Paper** Ilford Multigrade satin RC.

1. WALKABOUT
You can see from these contacts that my picture taking on these walkabouts is pretty random, though it's usually a special light that attracts me to a still life. Shadows are an ever-present subject in hot climates.

2. SIMPLICITY
A simpler still life, just using the shadows. The zoom at 80mm has allowed me to pick this out, making a more abstract composition than the main picture. The short zoom is perfect for street photography.

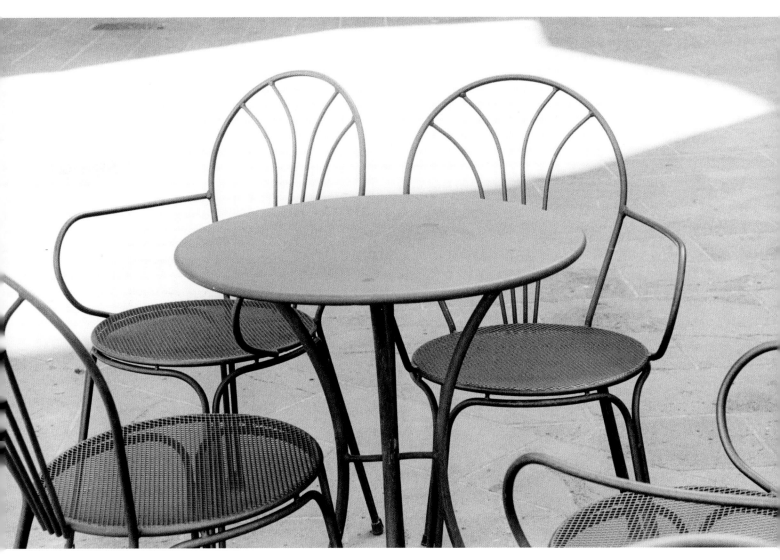

3. 85MM VIEW (above)
The incredible potential for perspective control that is possible with a zoom is evident here. The difference between the composition made by the 85mm used in this picture and the 24mm used the main picture (repeated below) is very exciting to me.

4. FINAL PRINT
This is the picture I chose. The paving was a pinkish colour so I used a red filter to remove some detail. Looking back, I regret not having taken more pictures of the chairs as they worked out really well.

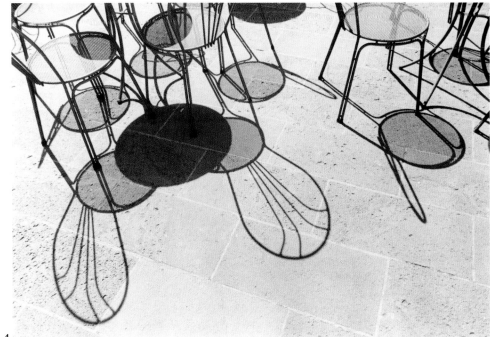

4

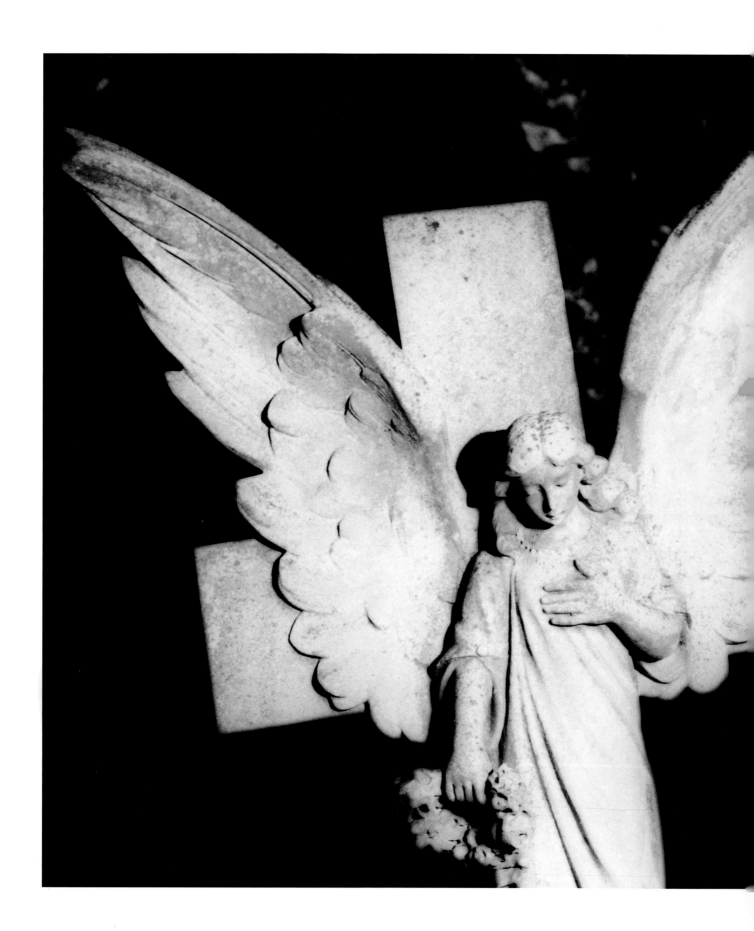

Tonal management: Angel

A FANTASY IMAGE

The angel picture is an example of my using flash in daylight to drastically manipulate the existing tonal relationships. I was trying to create my own fantasy image instead of taking a faithful portrait of the gravestone in situ.

The starting point came when I happened across the angel in a cemetery in London. Its mixture of the sweet and the macabre had a strong effect on me. As you can see from the pictures overleaf, the setting was cluttered and the light was dull and uninspiring. I took a few pics as I first saw her and then decided to make drastic changes to the tonal balance – a chance to play God with the light. I came in closer and put her at an angle, hoping to add a feeling of movement. I used a dedicated flash gun on an extension. The tripod allowed me to have a free hand to hold the flash away from the camera. I tried lighting her from several different angles. My visualization was to light the headstone entirely with flash and underexpose the background to separate the angel from the mess behind her, creating a dark, eerie atmosphere. I was trying to create my own fantasy image instead of taking a faithful picture of the gravestone in situ. I used the flash on auto and experimented with different exposures for the background. I set the camera's auto on –1 stop, then –2 stops, and finally –3 stops.

DARKROOM MANIPULATION

In the darkroom I had an ideal negative for my purposes, but when I saw the image on the baseboard, I decided to flip it and see how she looked facing the other way – definitely more interesting, I thought. The final piece of manipulation was to add a soft focus filter over the lens during exposure. I feel that the filter has given a dreamy quality to the picture. It is a reminder to me to consider the possibilities of a second stage visualization in the darkroom, or in Photoshop. But either way, of course, you need that original image to have the properties that you can work with.

I had quite a variety of negs on the one roll due to my exposure experiments. It was obvious that the last exposure (–3 stops on auto) was the one that was going

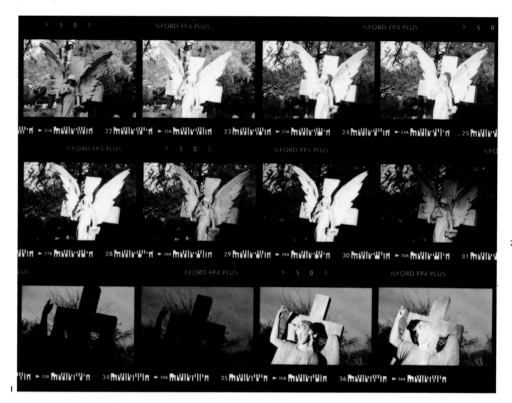

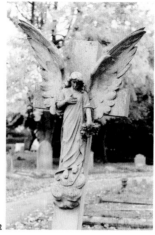

1. THE CONTACTS
Here are the contacts – misses and all. You can see the different lighting angles attempted and the variations in background density. Also, there are a couple where I missed the angel with the flash completely. I don't know what I was doing there!

2. ORIGINAL VIEW
The angel in the graveyard as I first saw her. A pleasant enough pic, but rather ordinary. Note how bright the surrounding areas were before I used the flash.

3. UNDEREXPOSED
This is with the camera set on -2 stops. The angel is the right way around and she is lit from the other side.

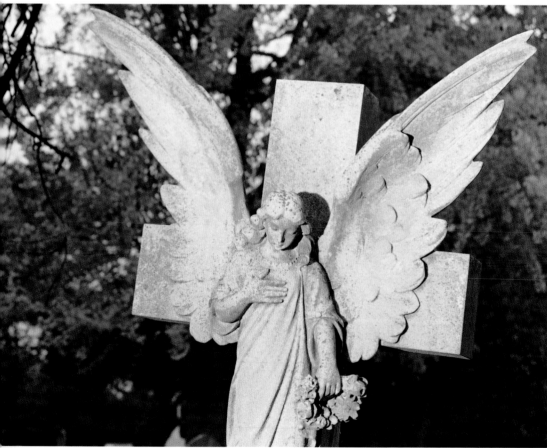

to make a print that was closest to my original visualization; the -1 and -2 stop exposures still left too much detail in the background. After I flipped the neg I printed straight on grade 3 for 12 secs – the right hand side had caught more flash and so needed burning in a touch (3 secs), and the background needed to go darker still, so some burning was required there also (5 secs). The resulting print looked pretty good. It was at that late stage that I decided to added the soft focus, so I used the same exposure with the filter over the front of the lens.

The flashgun is underused as a creative tool. As a substitute for low light it tends to kill the atmosphere that attracted you in the first place, but for an extreme visualization like this, it is perfect.

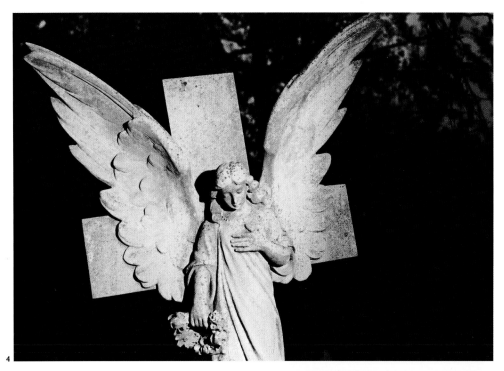

4. FLIPPED AND FLASHED
A flipped negative has changed the look of the pic, and she is now standing out well from the dark background.

5. FILTERED
I added the soft focus filter. I would suggest that you look at some of your old negs with a second stage in mind – a flip, some diffusion, or a change of crop. One often sees a picture differently – with the eyes of a printmaker rather than a photographer.

SUMMARY

- ● Flash can manipulate tonal balance.

- ■ **Camera** Nikon F90x. 24–85mm zoom at 70mm. Nikon SB-26 flash gun. Tripod.

- ■ **Film** Ilford HP5+ rated at ISO 600.

- ■ **Developer** Film: Kodak Xtol for 8 mins at 20°C. Print: Ilford Multigrade.

- ■ **Exposure** Camera: c.1/2000 sec at f2.8 (auto -3 stops). Print: 12 secs at grade 3. Left wing burned in for 3 secs, background for 5 secs. Soft focus filter.

- ■ **Paper** Ilford Multigrade semi-matt FB.

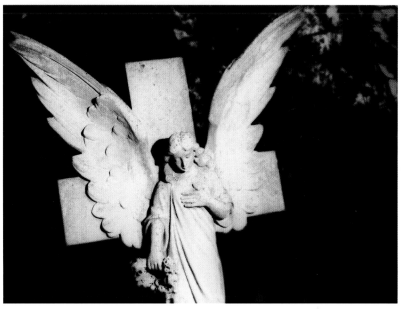

Low-key window light: Pots

I brought these bowls back from a trip to Kenya some years ago. I have always appreciated their simple beauty. They are made with basic tools from trees and the roots of trees. I have often thought of using them in a photograph, but it only recently occurred to me to put them together in this way.

LIGHT AND FORM

Although the pictures are still lifes of African artifacts, they are not descriptive in a catalogue sort of way. Instead, I have used them to make pictures that please me. The images are inspired by the exercises in light and form that Edward Steichen, Edward Weston, and André Kertész experimented with way back in the 1920s and 30s. My pictures are an exercise in relating round shapes to each other using crosslight from a window to pick out the circles with highlights that come out of deep shadow areas. They are low-key images. I have tried to make a single form out of several separate objects.

A SIMPLE SET-UP

These are set up, studio-style still life pics, but as you can see from the colour pic of the set-up, you do not need a big studio with expensive equipment to make still life photographs – my sitting room and the window light work great for me.

I set the bowls up on a black tabletop that would print dark but retain a little wood texture, hoping to enhance and not distract from the objects. My first composition was built up using the larger bowl as a starting point. The little pot made a repeat shape inside and the large seed worked fine as another round item inside the first two. The jug needed to be partly inside the circle theme that I had established, so that the objects made a single form. I shot from a high angle, after experimenting first with low ones. I liked the way that the bowls appeared to be almost hovering in space but connected to the jug. The side light from the window brings the magic to these pictures. I could not have lit as well with my studio lights.

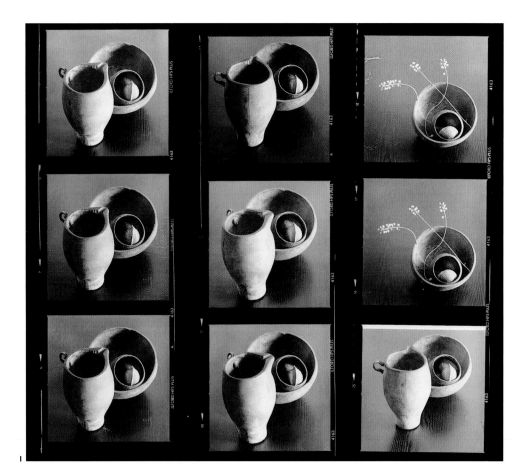

1. CONTACTS
The contacts show the amount of tonal range I could have used, and also note the slight differences in the position of the jug – the final frame was a difficult choice – you may well have chosen differently to me.

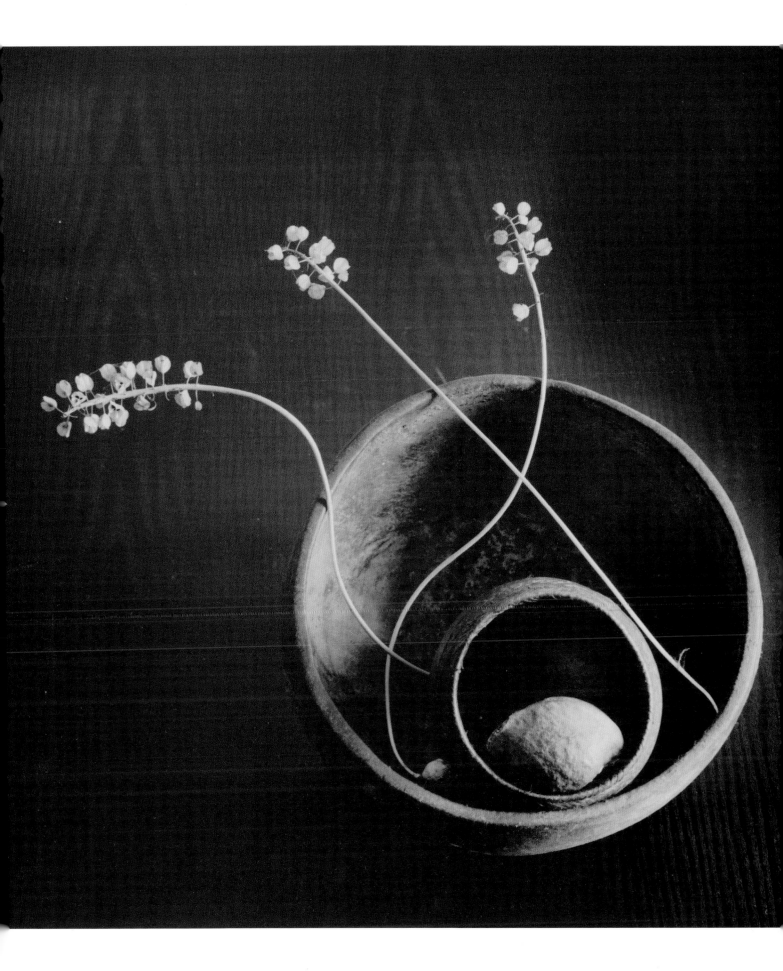

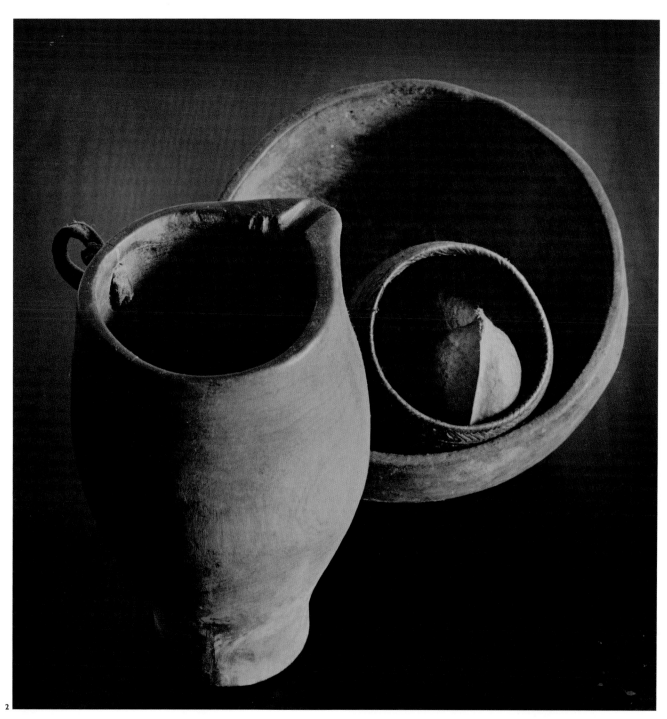

2

2. HARMONY

The four objects shot as one form. If, like me, you are just getting into still life, I think it is a good idea to select objects that harmonize with each other – not in their function, but in their form and tone and texture. Give yourself a fighting chance, in other words.

3. THE SET-UP

I wanted to show you the set-up – most of us can find this amount of space and a window somewhere, even if it is at a friend's place. Now, that suggestion could lead to the end of a beautiful friendship!

4. DISTRACTIONS

The main picture as a first print. I find the background distracting and the highlights too bright. The flashing in has held the highlights but blended them in more subtly. Again, we are in an area of personal taste here.

5. FINAL PRINT

This picture works primarily because of the big circle placed in the corner of a square. The dark square is not dead space because the plants are reaching out and breaking it up.

These compositions are greatly influenced by the square format I was using. The main picture is playing with the fine highlights of the plants; tracing and cutting through the circles as you would use a pencil in a drawing. By placing the bowls in right hand corner I feel that the flowers have created a sense of movement, as if they are escaping from the still life. I used a 150mm lens that has flattened the perspective, and to keep the tones low key, I flashed the print during development.

IN THE DARKROOM

Ilford FP4+ developed in Microphen gave me a sharp neg with a greater tonal range than I actually used in the prints. The black desktop collected more light than I had expected, so was going to have to burn that background area in on both prints. I decided not to use the detail available to me inside the bowls as it distracted from the effect of the circles, which after all was the compositional visualization of the picture. I gave the first print 14 secs on grade 3. I burned in all around the objects for 7 secs. I flashed in too – I like the sombre feel it has produced. The second print ended up as 15 secs at f5.6, grade 3. Everything but the bowls was burned in for 8 secs. I flashed this print also.

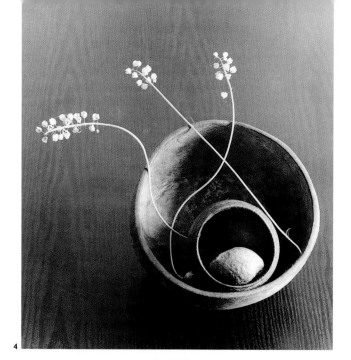

4

5

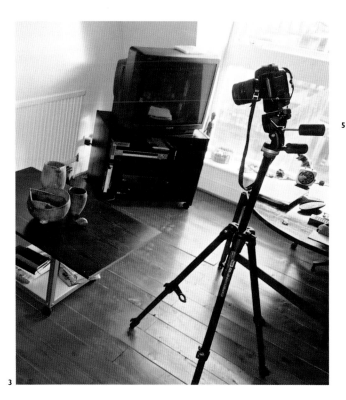

3

SUMMARY

- Window light is a wonderful, free still life lightsource.

- Collect props that you like to inspire your still life.

- **Camera** Hasselblad 503. Lens 105mm. Tripod.

- **Film** Ilford FP4+, rated at ISO 100.

- **Developer** Film: Ilford Microphen for 8 mins at 20°C/ 68°F. Print: Ilford Multigrade.

- **Exposure** Camera: 1/8 sec at f16. Print: 15 secs at f5.6 grade 3. Burned in 8 secs. Additional flash in.

- **Paper** Ilford Multigrade semi-matt FB.

Reportage: A man's hands

Tom Campbell is a professional gardener whose hobby is… gardening. I was on a visit to his allotment, where he grows for fun, and from where he supplies vegetables to his friends. I ran into him as he was leaving the allotment, handlebars weighed down with veg. He pulled the squash out of a bag and I spotted this shot. What drew me to the picture was the contrast between Tom's hands, the dirt of the allotment still on them, and the smooth sculptural form of the squash. The dark shirt was a bonus, giving a contrasting background for the still life. All I had to do was to turn the squash slightly off centre and make sure that the hands formed a symmetrical bowl in front of the shirt. The overcast light had a great quality for the subject.

I used the 24–85mm zoom at 30 mm. The wide angle has stretched the the perspective to good effect without looking distorted. I shot with the aperture wide open (f2.8). The resulting fall-off in depth of focus works very well to concentrate the eye on the hands and squash.

1. ORIGINAL VIEW
Tom as I first saw him on my visit to the allotment. He pulled the squash out of the bag almost exactly as he is holding it in the picture. I grabbed my camera and we made the shot.

2. MUDDY TONES
The first print on grade 2½. I felt that the tones were all merging together too much – a bit muddy, as it were. I needed to make the hands darker to get more emphasis on the vegetable.

3. TOO DARK
Grade 4, but a little extreme – it's too dark and the squash needs to stand out of the hands more. Hence the final solution.

4. FINAL PRINT (opposite)
This final print combines the strong hands of the soil theme with an elegant still life of the squash. I'm pleased with this final image. It reminds me to carry a camera with me always. I have got out of the habit lately, so I must have missed a lot of good pictures.

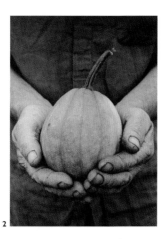

2

1

SUMMARY

- **Camera** Nikon F90x. 24–85 zoom at 30mm.

- **Film** Ilford HP5+ rated at ISO 600.

- **Developer** Film: Ilford Microphen for 9 mins at 20°C/68°F. Print: Agfa Neophen warmtone.

- **Exposure** Camera: 1/250 sec at f2.8. Print: 12 secs at f5.6. Shaded 4 secs on squash, burned in 3 secs. Grade 4. Bleached back 30 secs in weak Farmer's Solution.

- **Paper** Forte warmtone semi-matt FB grade 4.

3

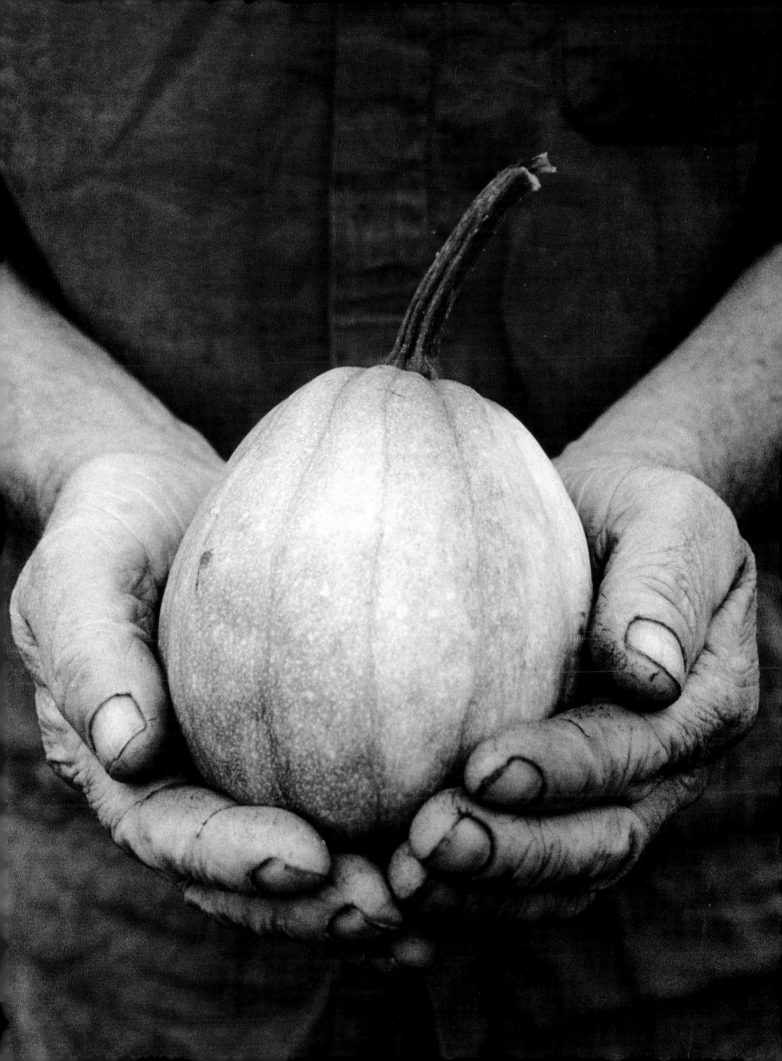

Minimalism: A woman's hands

A feminine version of the hands and still life theme. I came across these Easter pastries at a craft fair in Sardinia. I first shot one in the hand of a man, but I thought they looked feminine and asked an old lady to hold one for me instead. She agreed, and after removing her distracting apron, came up with the idea of using the lace cuffs. Her hands were surprisingly young looking and beautifully groomed, like those of a professional hand model. My first picture was descriptive but not elegant. I wasn't getting the most out of the subject, so we made the pastry run vertically, and positioned her hands so that they repeated the shape it made. The lace cuffs were an inspiration – they're so sympathetic to the composition that they really make the picture.

It was bright sunny light, but under a canopy, so it was all bounced – perfect! I shot on Ilford HP5+ at ISO 600 and used my 24–85mm zoom (a fantastic travel lens) at 35mm, creating a slight elongation of the hands. This picture is all about attention to detail – I effectively reorganized the tonal composition. It's amazing the co-operation people will give when they see you really care about the picture, and therefore about the object that they care about also.

2

1. PORTRAIT NO-GO
My model earlier in the day. Note the apron and no cuffs. She was not too keen on a portrait but really got into the spirit when we took the still life.

2. CRAB-LIKE
The first shot. The pastry has a crab-like appearance at that angle. I find that I have to slow myself right down and make myself *really* look at the subject. My natural instinct is to shoot quickly.

3

3. ALMOST THERE
A change of position for the pastry and the hands, and we now have a vastly improved picture. This needed only a slight burning-in on the pastry to hold some detail.

4. FINAL PRINT (opposite)
I made test prints on grades 3 and 4. The tones of this print are crucial to the feeling of the picture. Too much contrast made the hands look almost masculine; too little and the print seemed flat.

SUMMARY
- Attention to detail is crucial.
- If you are enthusiastic the people around will help out.

- **Camera** Nikon F90x. 24–85mm zoom lens at 35mm.
- **Film** Ilford HP5+ rated at ISO 600.
- **Developer** Film: Ilford Microphen for 9 mins at 20°C/68°F. Print: Agfa Neophen warmtone.
- **Exposure** Camera: 1/125 sec at f5.6. Print: 12 secs at f4, grade 3.
- **Paper** Ilford warmtone semi-matt FB.

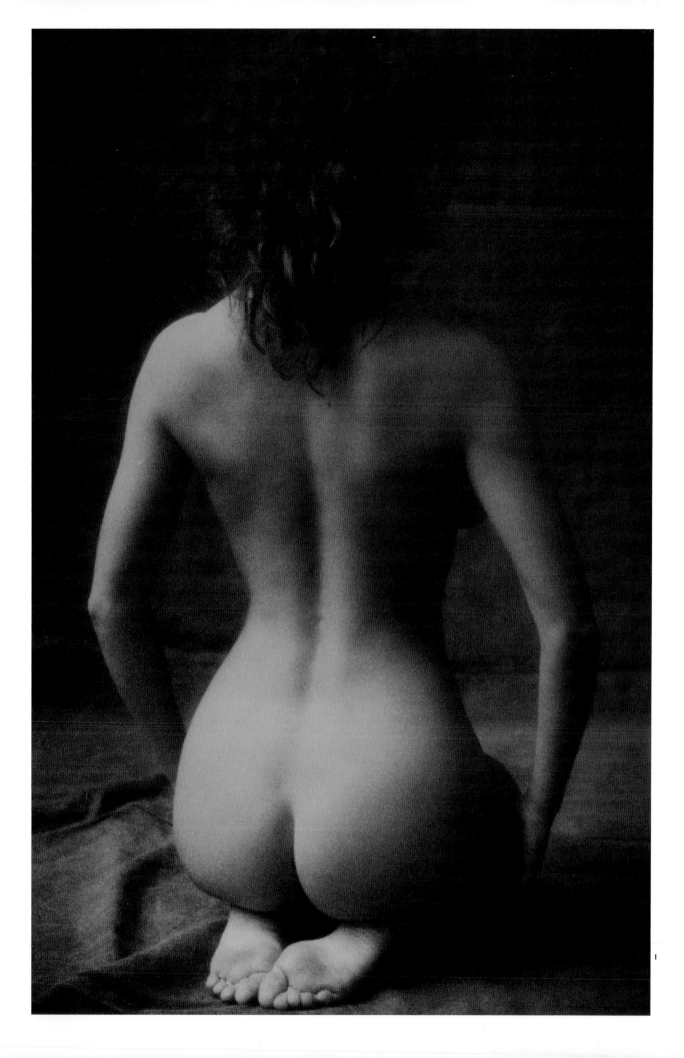

Sculpting with light: Nudes

Life class is still considered an essential subject at most art schools. Students learn to draw form and volume. The same applies to photography. Nudes are difficult to light. We have grouped them with still life in this chapter, and that is appropriate. To take nudes a stage further than those awful group sessions that some camera clubs arrange – one model confronted by a herd of snappers (really gross!) – to art pictures requires the same attention to detail and lighting as still life.

The single figure nudes here were shot originally in colour; it was only recently that I decided to make internegatives of the transparencies to give them a new life as black and white prints. The originals were shot on fast film and heavily filtered, using a warming (81d) and a soft focus filter (Hasselblad No 1 Softa). All the pictures were shot in my daylight studio. It has diffused north light from above and the side. The soft filter has smoothed the skin tones.

MAKING INTERNEGATIVES

I made the internegs using the enlarger. Film replaces paper, but otherwise it's the same process as making a print. To avoid an increase in contrast, which often occurs in internegs, I overexposed the film and compensated by underdeveloping the negative. Less development equals less contrast.

I made the internegatives on 5 x 4in film. It is easier to see what you are doing with a larger image on the baseboard, and also you can give individual processing to each interneg. With one side of a double dark slide loaded with white card – to frame up and focus on – I used an exposure meter (incident reading) to get my exposure. I then made several tests to find the ideal exposure/development combination. The exposure ended up as 2 secs at f16, and the development as 5 mins in Microphen. I used Ilford HP5+ film.

I have made many different types of prints from the internegs, but I have chosen some dark-toned ones for the book. The warmth of the toning is sympathetic with skin tones, I feel. Forte's warmtone paper responds very well to selenium toner. It turns an almost sepia colour. Selenium does not require bleaching, but make sure your prints are well washed (at least 45 mins at 20°C/68°F) or you risk staining. *Remember*, selenium is extremely dangerous. Make sure you have very good

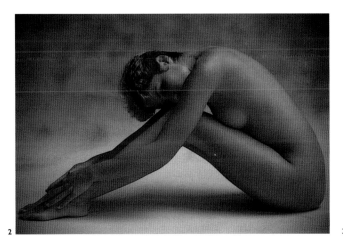

2. ORIGINAL
The original colour version. I am not saying that the black and white is better, I just personally prefer it. It is worth going through youre old transparencies, you will find some that would convert really well to black and white.

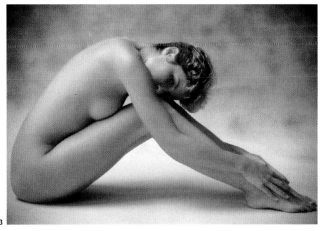

3. INTERNEG
The soft interneg. Make sure your transparencies are clean before you start. You don't want all the marks and dust reproduced onto your new neg. I washed each neg first.

ventilation, and don't work with your head right over the dish.

THE COUPLE

The two nudes of the couple were shot as general illustrations for a section on relationships in a health book. I concentrated on blending the two models into attractive compositions. The vertical image is the stronger – the arms have framed a picture within the picture. Note the radical compositional changes that we can make on 35mm format by just turning the camera in the hands from horizontal to vertical. The eye is drawn to the girl's breast; I shaded it slightly in the print to make sure it was the focal point.

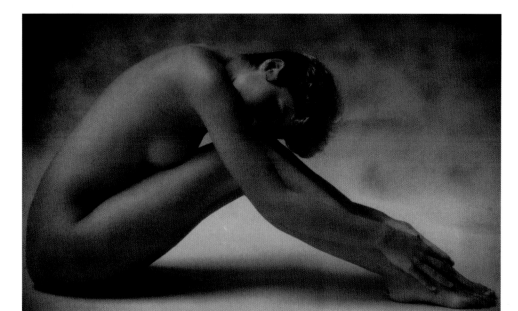

4

4. THE PRINT
The print from the first interneg. I was fortunate to have a model who could work well with her body. That is half the battle with nude pictures.

5. SECOND CHOICE
I shot horizontal and vertical to give the designer some choice with the layouts. But I don't find this composition as interesting as the vertical one.

6. FIRST CHOICE
This picture has more going for it. The two arms make the picture a more affectionate interpretation and the framing of the breast is more interesting from a compositional point of view.

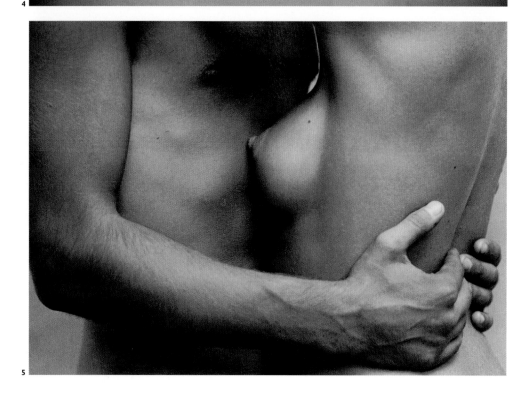

5

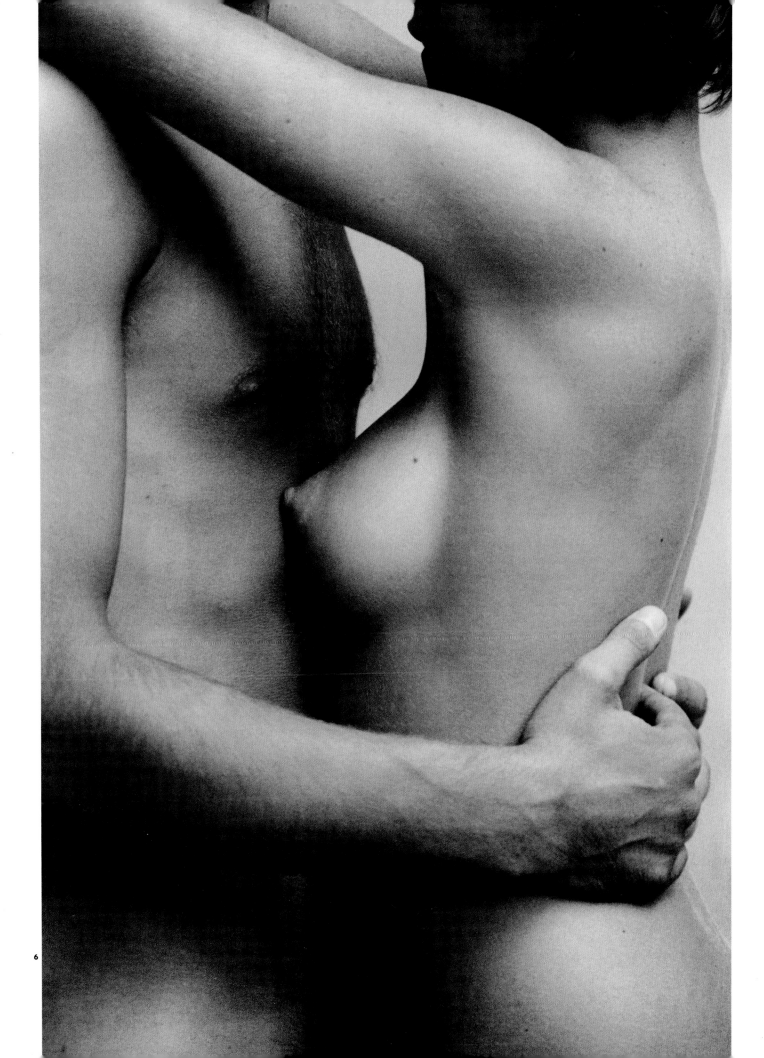

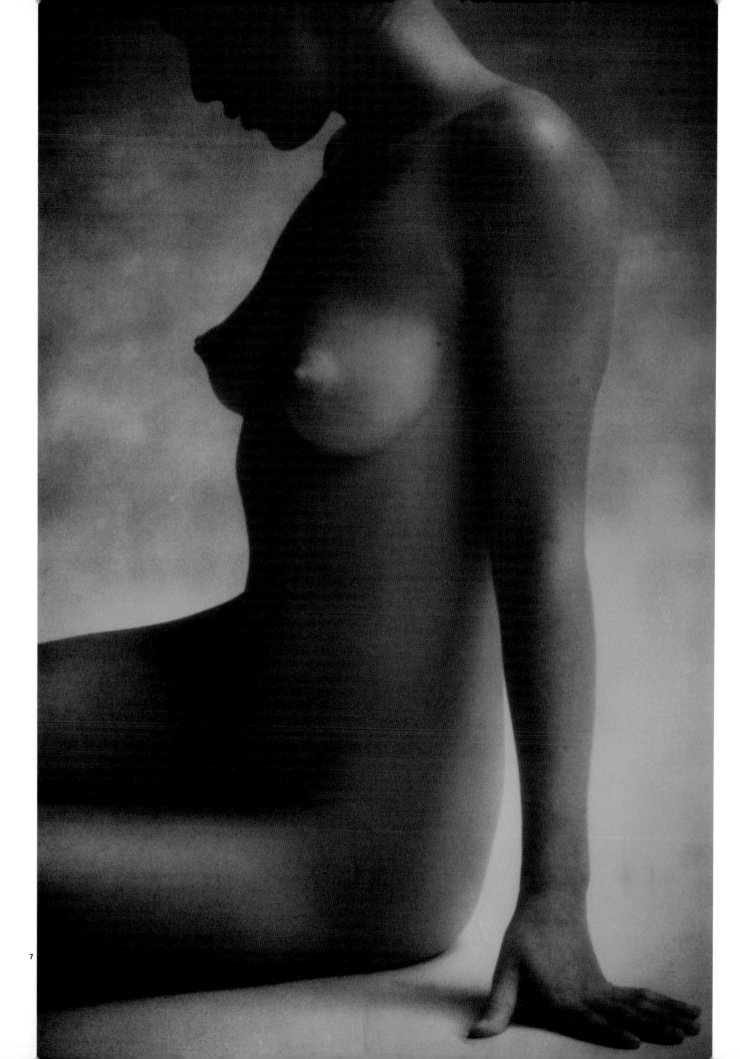

7

8

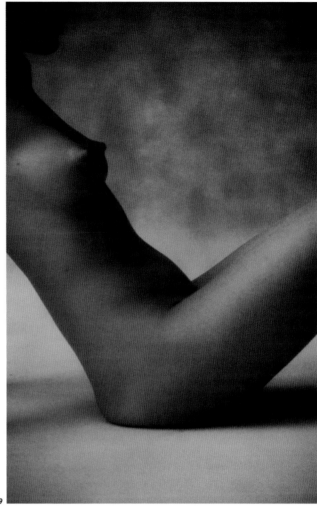

9

SUMMARY

- Light from the side or above. Front lighting kills curves.

- A slight softening smooths out skin blemishes.

- **Camera** Nikon F4. 80–200mm zoom used between 100 and 160mm. Hasselblad No 1 Softa filter.

- **Film** 3M 1000 rated at ISO 2000 (colour). Internegs on Ilford HP5+. Couple shot on Ilford HP5.

- **Developer** Film: E6 processing (colour). Microphen (b&w). Print: Ilford Multigrade with Kodak selenium toner.

- **Exposure** Colour: 1/250 sec at f8; internegs 2 secs at f16. Couple: 1/250 sec at f5.6; print 14 secs at f4, grade 3, with the breast shaded 3 secs.

- **Paper** Ilford Multigrade warmtone semi-matt FB.

7. SHADED PROFILE
Almost a silhouette, with just a few drops of light. I used the face because it was such a feminine profile. I printed for 12 secs at f5.6, grade 2½. I shaded the breast for 3 secs and burned in around the head for 4 secs.

8. MYSTERY
Nothing to say, really – it is what it is – printed dark to add some mystery. Not in your face obvious.

9. SHAPE AND FORM
This nude becomes more sculptural without the arms. Here, I am just using the female nude for its shape and form – the erotic element has been minimized.

High key: Flowers

I had this white orchid in my house – a present from a friend – and it seemed to be crying out for a high-key treatment. White on white was the visualization.

I believe you shouldn't waste time struggling to make pics of things that can only look half decent no matter how well you photograph them. Put all your creative energy into something that you really like. My white orchid was such an object for me. I simply set it in front of a white muslin window blind in my kitchen, to create diffused backlight. The room has white walls, which provided a lovely soft shadowless fill back into the flower.

TORCH AND BAKING TRAY

The dark stamen area looked a little bit dead, so I shone some light from a small torch, just picking out the stamens. I hand held the torch. The light it added is very subtle but has really lifted the picture. I took my exposure reading with the spot meter on the camera. A general reading on auto would have produced a thin (underexposed) negative, caused by the brightness of the backlight in comparison with that falling on the flower. I used my 80–200mm lens. A zoom is very convenient for this kind of situation because you can frame very accurately without moving the tripod.

I then decided to try a single bloom. For this, I just sat the orchid on my light box and then reflected light back in by holding a small reflector over the top. Actually, I used a small silver baking tray (30cm/1ft square); they make great still life reflectors. I used my 28–85mm zoom, which has a macro facility that I used with the lens set at 65mm. The angle and composition turn the flower into an almost abstract image: it could be an orchid or a butterfly – well, to me, anyway! The original white-on-white visualization ended up as light grey on white, but I have retained the delicate light tones of the orchid.

DETAILS

I did not get the reflector in quite the right place, resulting in an uneven neg that printed darker on the petals on the right than on the left. I had become carried away with the overall look at the expense of the details, which are after all the most important quality a still life

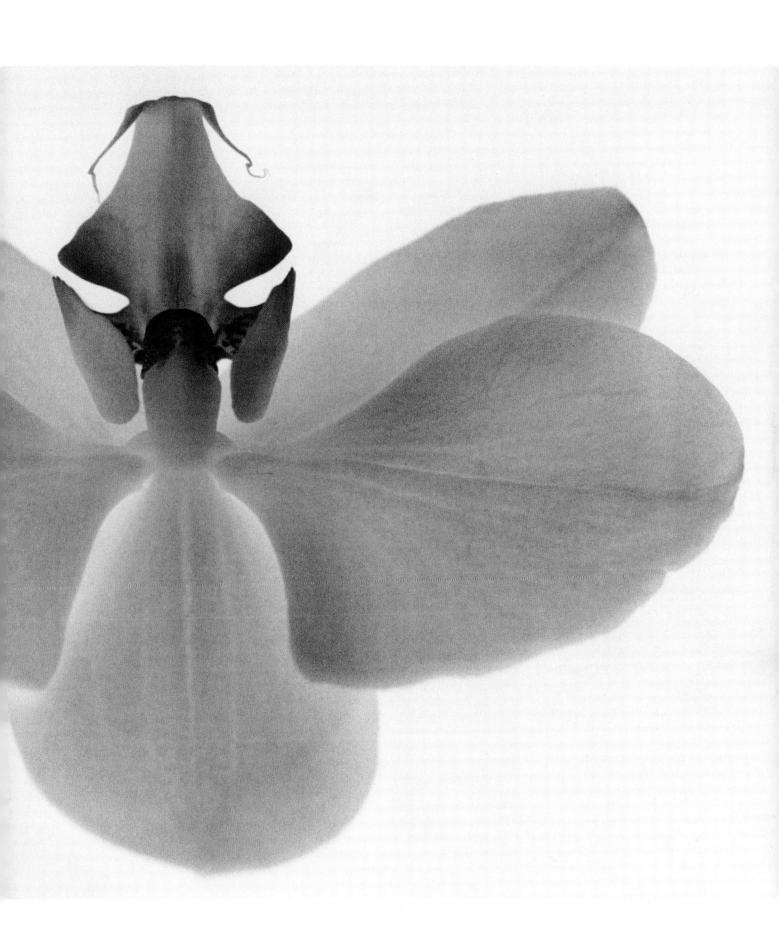

photograph needs. So, the main job in the printing was to even up the density while still keeping a small difference between the left petal and the right petals. My first test print was 12 secs at f5.6 on grade 3½. I decided to increase the contrast to 4½ and I shaded the right hand side by 3 secs and the stamens for 3 secs with a dodger. I burned in the edges of the print for 3 secs, using my fist to shade the flower. I don't like a completely white edge; the picture looks like it could flow off the page.

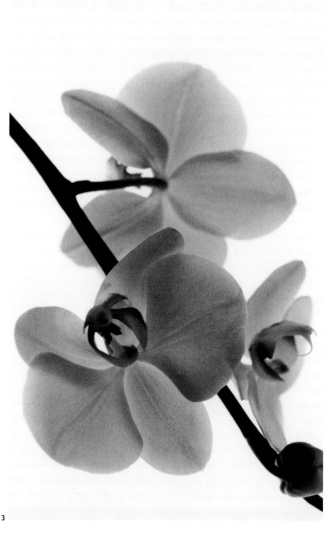

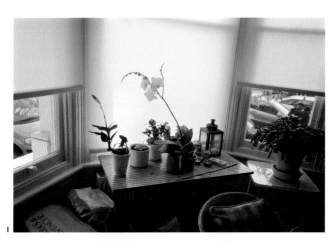

SUMMARY

- Try using a diffuser over your window as a backlight.
- A small torch is a useful additional lightsource.
- If the composition feels almost too simple, you're there.

- **Camera** Nikon F90x. 28–85mm zoom lens and 80–200mm zoom lens.
- **Film** Ilford FP4+.
- **Developer** Film: Ilford Microphen for 7 mins at 20°C/ 68°F. Print: Ilford Multigrade.
- **Exposure** Camera: 1/125 sec at f4 (first setup); 1/15 sec at f11 (stopped down for depth of focus in the flower).
- **Paper** Ilford Multigrade semi-matt RC.

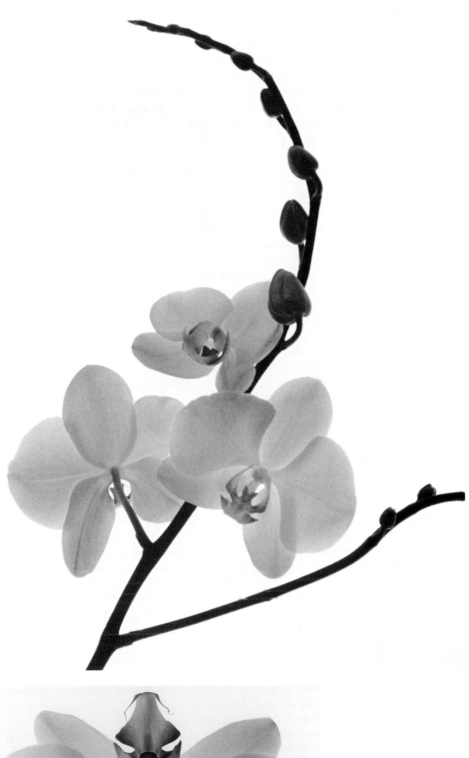

1. KITCHEN STUDIO
I have included the colour snap to demonstrate that you don't need a great studio in order to make a decent still life. This is one end of my kitchen. A white translucent blind like mine is a very useful piece of equipment.

2. BRACKETING
A set of contacts to underline that when you are set up on an object that is not going to move or change, you should take a bracket of exposures to make sure you get a good printable neg. But don't be lazy: think about the neg that you need and make as accurate an exposure as you can. As I mentioned earlier, I used the spot meter.

3. OTHER COMPOSITIONS
I tried several alternative compositions (I shot three rolls). This is an example of one that didn't work – it is very clumpy, a mess, to be honest.

4. JAPANESE
I do like this picture from the first set-up. I felt at the time that it had a Japanese look to it. The diagonal stem cutting through the frame is in a pleasing position, and the bottom stem cut off by the frame works well for me. The juxtaposition of the front and back of orchid displays its all over beauty. The print was an almost straight one from the neg – something you should get with the control that is possible over still life – 12 secs at f5.6, grade 4½. I just burned the edges in for 3 seconds.

4

5. FINAL PRINT
By comparing this picture with the one above from the first set-up you can see how extraordinarily different an object can be made to look. More than any other theme in photography, still life teaches us to really examine what is in front of us. Any tiny blemish that we don't see will destroy our picture.

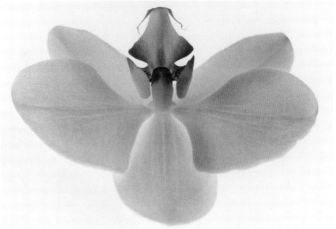

5

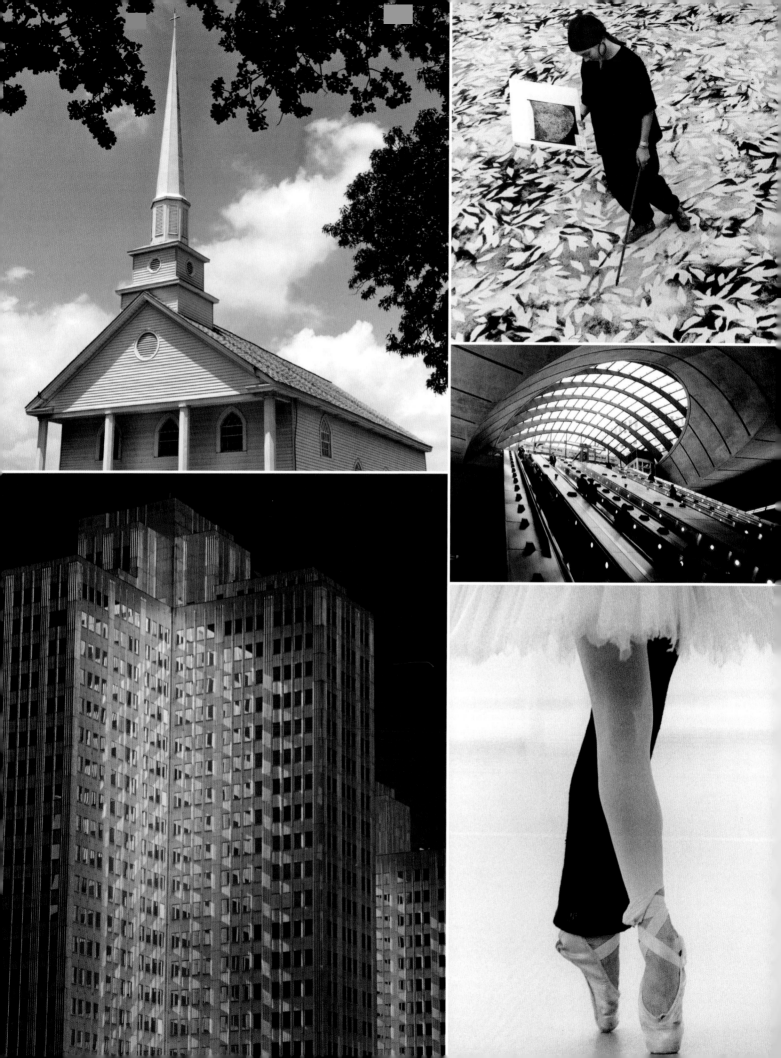

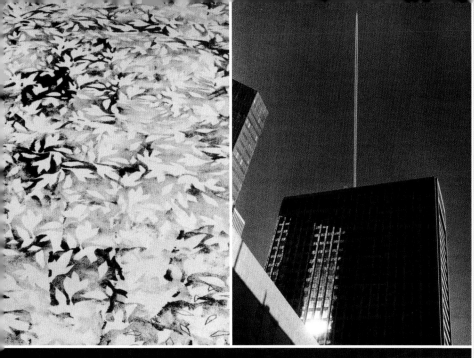

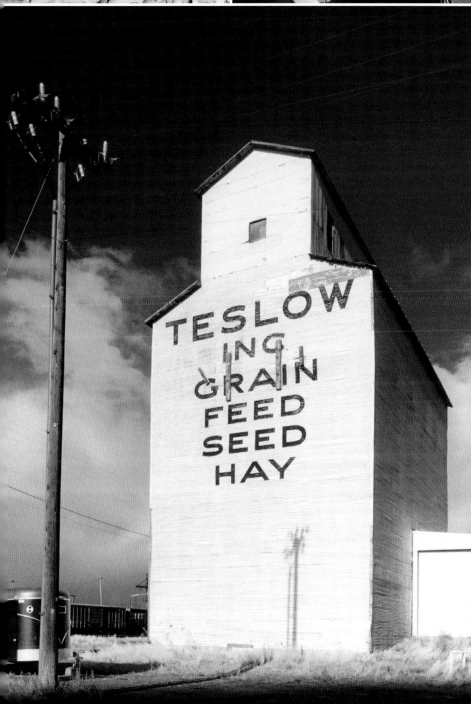

Architecture and the Arts

When you are asked to photograph anything that has been the work of an artist, you are in the area of interpreting somebody else's work rather than starting out to create something entirely of your own. Whether we are talking buildings or ballet, we have to sublimate our own egos somewhat and try to do justice to the art that is in front of us. That should not be a problem for a reasonably sensitive, observant soul. Most of the great architectural photographers were first trained as architects. If you have a passion for any of the Arts, you have a wonderful subject to photograph. Be brave and ask the local theatre company or sculptor if you can photograph their work. You've nothing to lose!

Filtration: A glass building

There are pictures of office buildings like this to be found on nearly every city block; the thing that makes these special is my knowledge of filtration. I was able to visualize what a red filter would do to a glass and steel building with strong mid-morning light hitting it like a huge spotlight. The sky was a deep blue and it was going to photograph black, for sure, as were the windows. It's a day for night picture, really, using the technique employed by cinematographers to simulate night in old westerns. The giveaway that these were taken in daylight is the black windows – at night there would have been lights on. These two interpretations are the results of playing with the different compositional possibilities offered by the lenses in my camera bag.

The verticals appear almost correct, as if I had used a perspective control lens. If you can get far enough away from a building to use a telephoto lens you can keep things pretty straight. Vertical distortion is caused by pointing the camera up at a building – if the camera is on the same plane it will not occur.

SUMMARY

- **Camera** Nikon F90. 24mm and 80–200mm zoom at 200mm. Red filter. Tripod.

- **Film** Ilford FP4+.

- **Developer** Film: Kodak Xtol for 8 mins at 20°C/68°F. Print: Agfa Neophen warmtone.

- **Exposure** Camera: 1/500 sec at f8. Print: 10 secs at f8, grade 4; highlights on vertical shaded 4 secs.

1. PROGRESSION
The contacts show the progression of the shoot that ended up producing the two prints.

2. WIDE-ANGLE LENS
This is the opposite optical approach to the Silo picture on page 134. This time I've used the exaggerated perspective of the wide-angle lens (24mm) for graphic effect, instead of correcting the verticals with a PC lens. Note the reflection of the sun, like a giant spotlight.

3. TELEPHOTO LENS (opposite)
A change to a long lens (80–200mm used at 200mm); note how much more compressed the building appears. I've concentrated on the reflections more than the shape of the building.

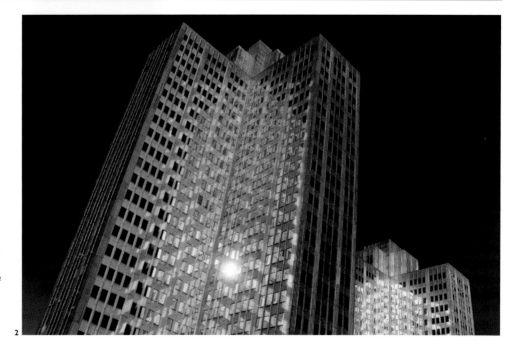

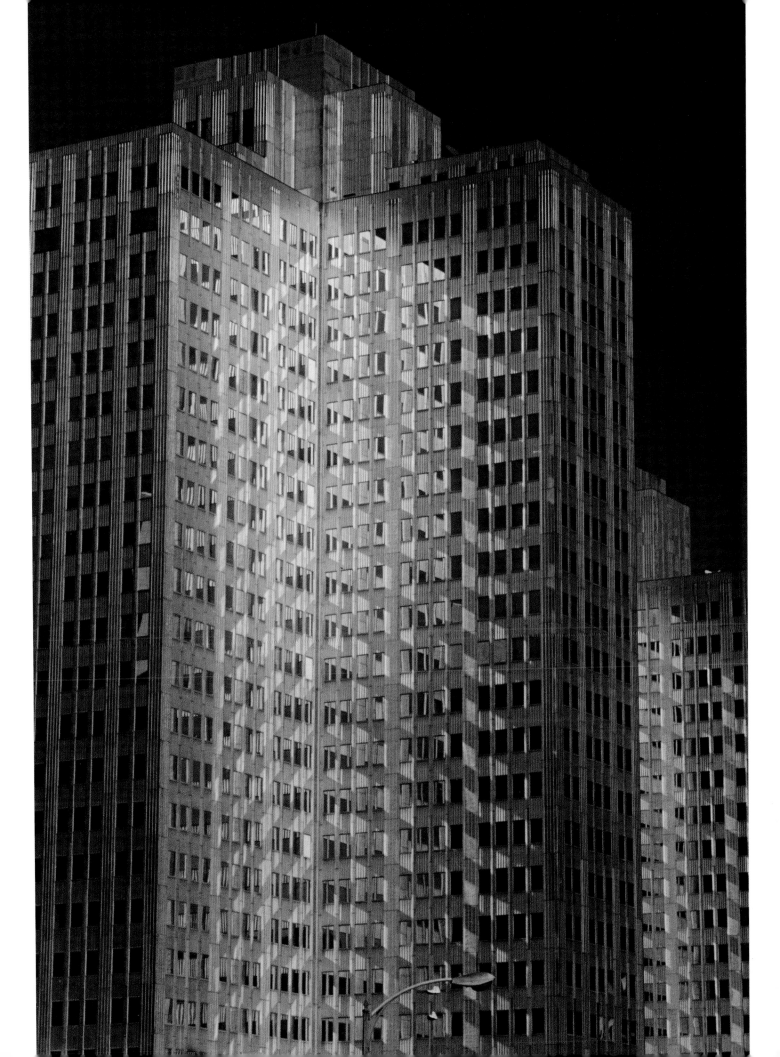

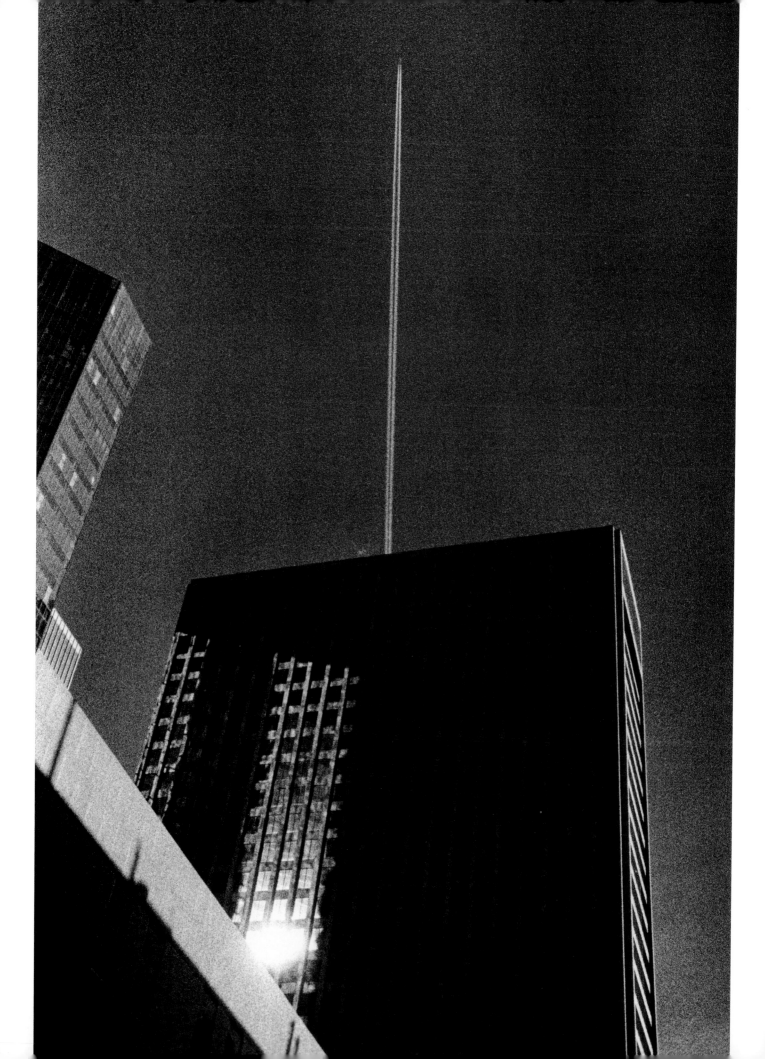

Abstraction: Skyscrapers

PATTERNS

Still walking the streets of Pittsburgh on the same day as the last case study, I added another element to the buildings to create urban patterns. Or, more accurately, I was looking for patterns that were already there, and used my technique to turn them into interesting black and white photographs. As photographers we don't really have to create anything – we just have to pick out patterns from the infinite number that are already there in the world around us. The art of photography is thus the art of selection, and that requires the discipline of observation. Many people wander through their day without observing anything other than the most obvious, but observational powers can be learned and developed. As photographers we need to be working at that constantly, no matter how experienced we may be.

Cities are great locations for practising abstract or semi-abstract composition. These pictures are patterns on a large scale: by reducing the buildings to blocks of grey of various densities in my mind's eye, I'm just playing a game with graphics – like drawing. I used the red filter to alter the existing tonal arrangements, reducing the range for dramatic effect. I shot three rolls of Kodak

T-Max 3200, rated at ISO 1600, (using grain as another graphic tool) during a four-hour walk. A large proportion of the shots are pretty boring, to be honest. The ones that really work are those with an extra element that I was able to add into existing patterns. The main picture (opposite) came from observing the jet and its trail against the dark blue sky, and knowing it would look great when converted to black by the red filter. I made sure I kept the trail at a vertical angle, splitting the black sky with a white line. I was lucky that the plane was there, but the trick was to recognize its potential, and to have the black and white technique to capture it on film, completing the pattern.

GRAPHIC LINES

I decided to push the graphic look all the way by printing on grade 5, eliminating most of the middle tones and ending up with what look almost like line drawings. I love charcoal drawings, and no doubt this was at the back of my mind. If I had been trying to take an architectural picture rather than just using the architectural elements to make my own graphic design, I would have held more detail in the building – it was available in the negative.

I. SUNLIGHT
A selection of contacts, showing how influential the strong sunlight was to my visualization of the whole shoot. It would be interesting to try the same exercise on an overcast day and see the difference in the pictures; it would be unrecognizable as the same place.

2. REFLECTION

This picture also works for me. This time it's the burning reflection of the skyscraper placed in the middle of the empty street sign makes the picture special. It's all about observation – really looking at what's around you.

3. CLICHE

This picture is one of the boring ones, for my money: the naked tree in front of the high rise is a tired cliché. It's the first picture I tried, and I hadn't yet got my eye in, but it's important to make a start somewhere.

4. FINAL PRINT

The black sky, created by a red filter, the contrasting white jet trail, carefully kept vertical to cut the frame, and the starkly graphic grade 5 printing have all combined to make a strong image.

2

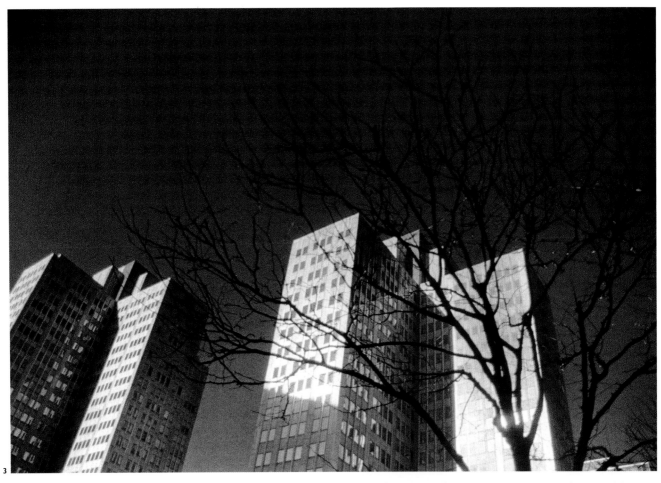

3

SUMMARY

- All technical decisions are, or should be, creative decisions.

- Understanding what a red filter would do to the sky and the highlights and shadows created by the contrast light made these pictures.

■ **Camera** Nikon F90x. 24–85mm zoom lens. Red filter.

■ **Film** Kodak T-Max 3200P rated at ISO 1600.

■ **Developer** Film: Kodak T-Max at 20°C/68°F. Print: Ilford PQ Universal.

■ **Exposure** Camera: 1/1000 sec at f11 for all the pics. Prints: main – 8 secs at f 5.6, grade 5, right side burned in 3 secs; second – 9 secs at f5.6, highlight burned in 8 secs; third – straight print for 8 secs at f5.6, grade 5.

■ **Paper** Ilford Multigrade satin RC.

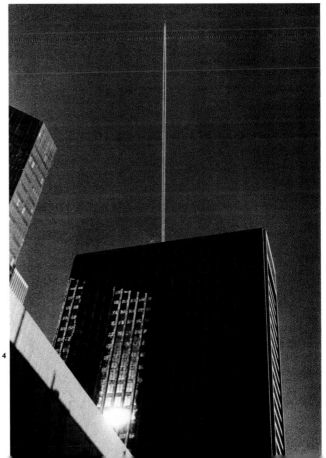

4

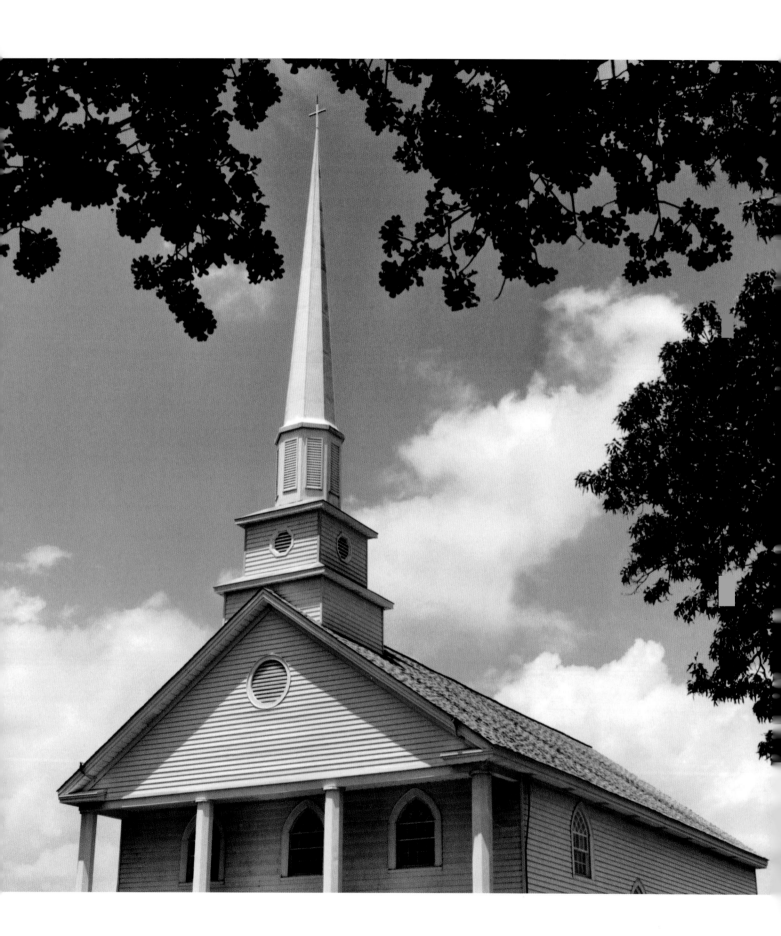

Homage to Edward Weston: Virginian church

THE F64 GROUP

This picture is in homage to Edward Weston, as well as Ansel Adams, Paul Strand, and all the other great photographers who made superb images of their country in the period between 1920 and the early 50s. The group f64, founded by Weston, Adams, and Willard Van Dyke documented America. They were radicals, who rejected the painterly style of the pictorialists and declared photography to be a legitimate art form and not merely a poor man's painting. They aimed for sharp, simple, unsentimental images of nature and manmade structures.

Those images are still very much in my head, and when I travel in America I constantly see an Edward Weston or an Ansel Adams picture in front of me. Sometimes I just have to take a picture too, almost as a gesture of solidarity with the old masters, to whom we photographers of the new century owe so much. I don't pretend to be in the same league as those guys, but the steps taken to get to the final print of this picture make a useful case study.

Clapperboard churches are dotted all over the USA. There are many architectural variations, but they are all basically the same design. In Virginia, where I found this one while travelling down to Georgia, they are also symbols of the very religious communities of that part of the country, known as the Bible Belt.

It was a very hot and humid day in late June. The sun was almost overhead at around midday when I started taking my first picture. The square format of the Hasselblad suited the shape of the church, and the smooth, fine-grained tones would be approved of by Ansel, Edward, and the guys, I felt. I tried to include the little graveyard at first, but I was unable to find a satisfying composition. At the front of the church, I tried the obvious head-on shot, but it looked messy, as the tree threw the balance way out.

I headed back to the car conscious of the fact that I hadn't got it right. As I passed under a huge tree the view of the church through the foliage started to look promising. I'm not sure that my mentors would have approved of my final composition if they had been looking through my viewfinder – "too fussy" or "too pretty", I can hear them saying. But I make no apology for framing the the spire in the tree; for me it is symbolic of the aspirations of the congregation – it points through the trees toward heaven.

I shot on a 150mm lens and used an orange filter rather than a red to darken the sky just slightly. I used a slow film, Ilford Delta 100, for fine grain and sharpness. The sun had come around somewhat and was now ideal. Meanwhile, the mosquitoes under the tree were busy feasting on me.

Those of you who like large format would no doubt shoot this pic on 5 x 4in or 10 x 8in cameras, and there is no doubt at all that is the way to get that Weston quality. The great advantage that you have of course is that you can give individual attention to each neg. On

1. GRAVEYARD
Foregrounding the church with the graveyard does not work at all. The image becomes too cluttered; it doesn't capture the simple elegance of the building.

the other hand, if 35mm is your only format don't be intimidated into neglecting architecture. Slow film and a fine grain developer can give you super results also.

IN THE DARKROOM

I processed the film in Kodak Xtol. The neg was as perfect as a neg can get – sharp with a large tonal range and good density. I tested several contrasts and densities, then settled for printing on Forte warmtone semi-matt FB grade 3. The print only needed to be shaded in the bottom areas around the pillars and on the side as they were slightly in shade. I printed the church darker than anticipated, as I wanted to hold the detail in the clapperboard, but it still looks as if it is white.

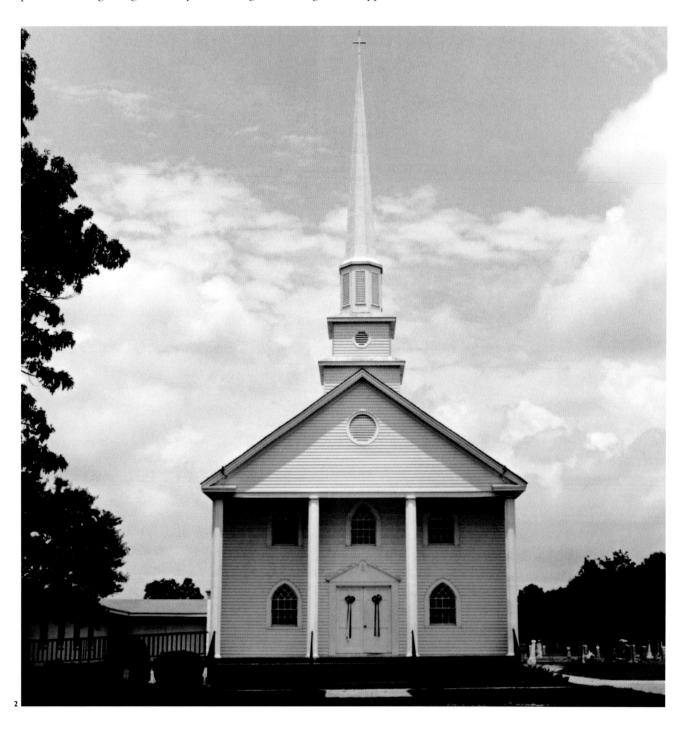
2

2. FRONT VIEW
The front of the church. In retrospect, this could have made a picture if I had come in closer and made a bolder composition, just using the shapes and the textures of the church.

3. UNCROPPED
The print using the whole neg. The print is on grade 4, which looks too hard for the subject.

4. CROPPED
As you can see, the final print has been cropped to create a more simple, elegant solution. I have also shaded the lower areas of the church and lowered the contrast to grade 3.

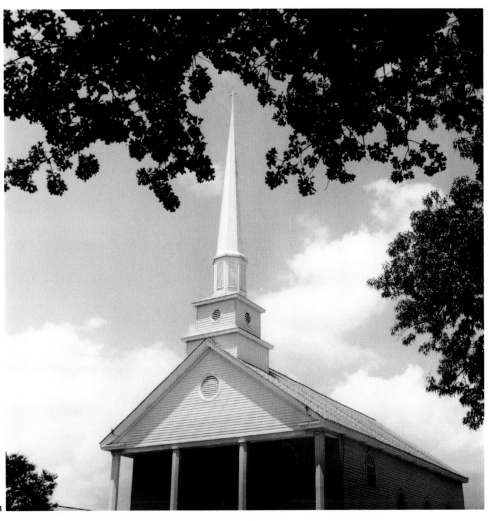

3

SUMMARY

- Medium and large format are ideal for this subject.

- Orange filters are sometimes more subtle and elegant than the red.

- Slow film brings a smooth, sharp quality that is ideal for architecture.

- **Camera** Hasselblad 503. Lens 150mm. Orange filter. Tripod.

- **Film** Ilford Delta 100.

- **Developer** Film: Kodak Xtol for 8 mins at 20°C/68°F. Print: Agfa Neophen warmtone.

- **Exposure** Camera: 1/125 at f11. Print: 14 secs at f4, shaded for 5 secs at grade 3.

- **Paper** Forte warmtone semi-matt FB.

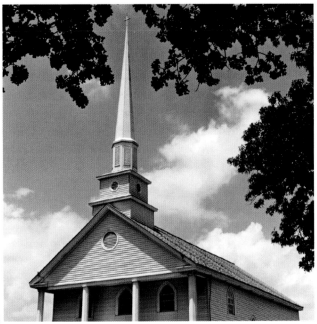

4

Available light: Canary Wharf

This was the final addition to the book; the chapter was short of an interior – pressure! The Jubilee Line on the London Underground has always made me feel good when I've passed through, so I decided to give it a go.

TROUBLE WITH THE LAW

Unfortunately I wasn't aware that a photography pass was required, and a few minutes after setting down my tripod I was being escorted off the station by a courteous but firm official. The next day I returned without the tripod (and terrorist beard), and was able to shoot two rolls. Although I wouldn't normally encourage my readers to become law breakers, sometimes you just can't let bureaucracy stand in the way of a good picture.

MONOCHROME

I've never thought of architectural photography as an art form in itself, more a case of trying to faithfully reproduce an architect's creation by understanding the essence of their building. This station is inspired by engineering: there's no attempt to cover or pretty-up the structural components. It's an unusual interior because all the conversion from colour to black and white that one normally has to visualize is unnecessary – there is no colour to be seen. It's all in shades of grey, ready for me just choose a lens and film – and, of course, compose a picture that's sympathetic to the design.

I first tried an 18mm wide angle lens but it distorted the elegant curve of the ceiling, so I ended up with the 24–85mm zoom used at 26–28mm. My film choice was Ilford HP5+, rated at ISO 320; I would have gone for the fine grain and sharpness of Ilford FP4+ but, because I was trying not to attract unwanted attention from the officials, I needed the extra film speed to enable me to hand hold.

I made several different compositions, and this is the one that works best for me. It's very simple really, just a big semi-circle with light and dark stripes coming out of it and cutting diagonally across the frame. It was important to give enough exposure to the shadow areas, and I planned to burn in the bright highlight of the sky-lit roof later in the print.

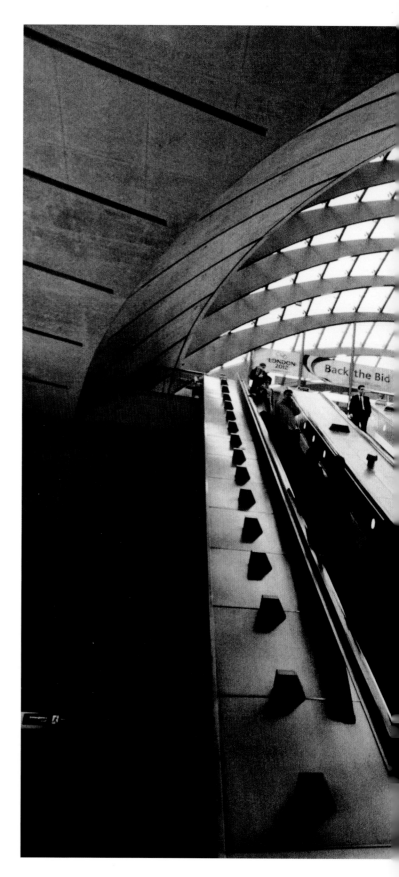

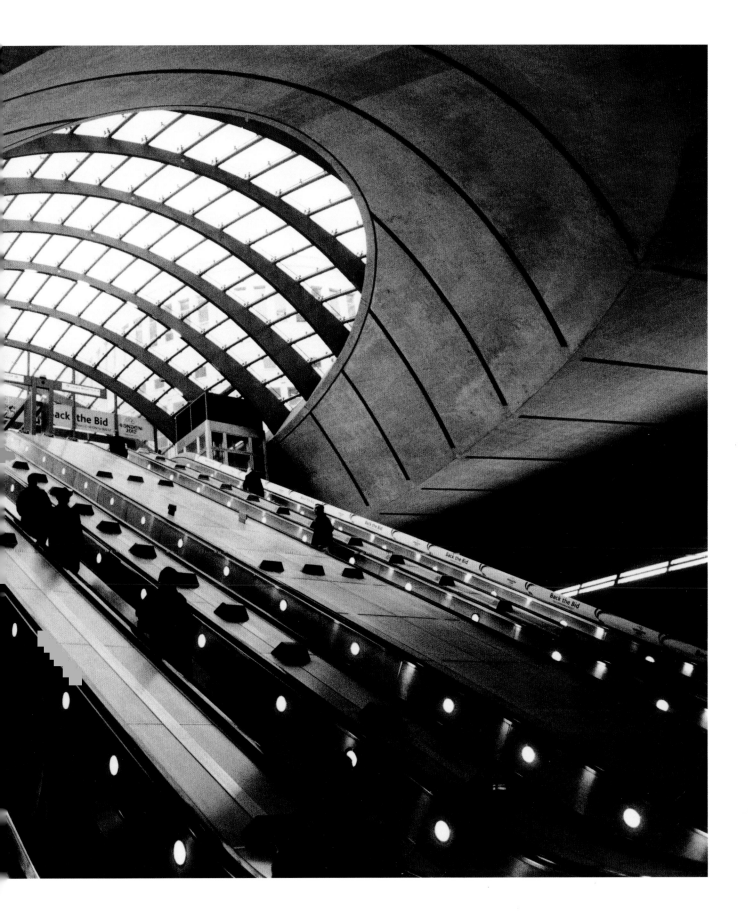

The more development you give a film the greater will be the contrast of the neg. I wanted to avoid high contrast, which is very difficult to print, so I gave a generous exposure (off the shadow areas), after already underrating the film. I then developed the film for 6½ mins, when I'd normally do so for 8. I made a clip test first to make sure my calculations were correct. The neg had a large range of tones and didn't have too much contrast. The print was 12 secs at f5.6, grade 3½. I burned in the skylight for 6 secs and I darkened off the area next to the escalator to remove some distracting highlights by burning in for 20 secs at f4. One needs to be very wary of bright reflections off metal or glass, often present in architectural subjects. This picture would have benefited from a polarizing filter to cut the reflected highlights coming from the metal surfaces.

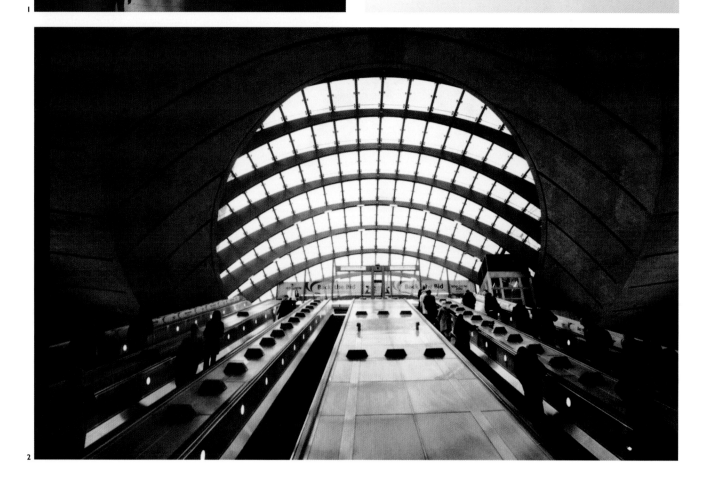

1

SUMMARY

- **Camera** Nikon F90x. 24–85mm zoom at 26–28mm.

- **Film** Ilford HP5+ rated at ISO 320.

- **Developer** Film: Ilford Microphen for 6½ mins at 20°C/68°F. Print: Ilford Multigrade.

- **Exposure** Camera: 1/125 sec at f8. Print: 12 secs at f5.6. Skylight burned in for 6 secs, left of escalator for 20 secs.

- **Paper** Ilford Multigrade glossy (unglazed) FB.

2

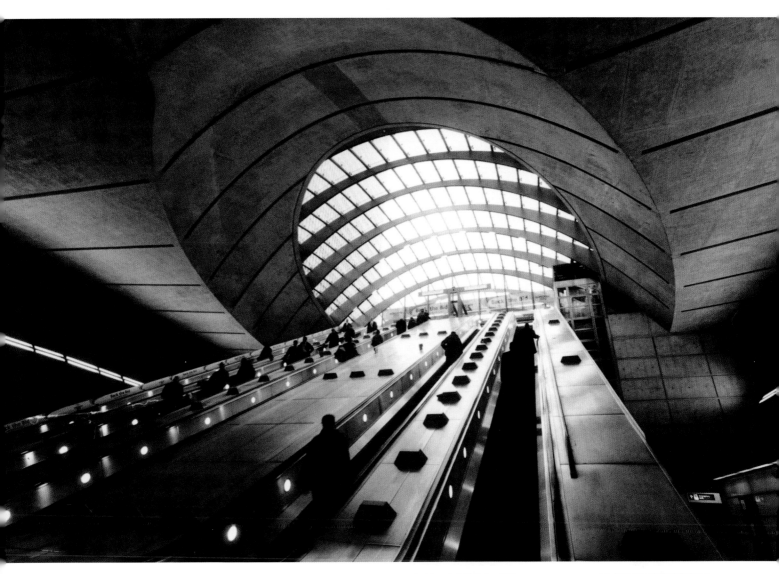

1. AUTO EXPOSURE

This is the approach to the Canary Wharf exit exposed on auto. Note how little detail has been held in the shadow areas. The intense highlights of the metal have thrown out the meter and caused underexposure.

2. HIGHLIGHT

The central highlight dominates the picture: not a good interpretation of the architect's design. Also, I have not given enough exposure to the shadow areas. I was in too much of a hurry and not reading the tones well.

3. FLARE (above)

A much better version than the last one, but there's still too much emphasis on the escalator, and the light on the ceiling isn't good. I was shooting almost into the sun the therefore picking up a slight flare on the glass.

4. FINAL PRINT

Finally the balance is pleasing, and the lighting is better from this side of the escalators. The few people dotted around tell us that it's an escalator. If I had not been shooting a case study I would have walked around visualizing the picture before I started shooting, which is what I recommend to you – more looking and less shooting is the message here.

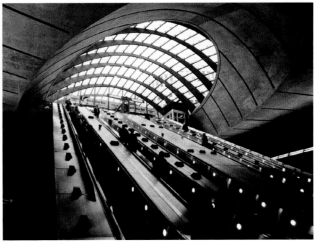

4

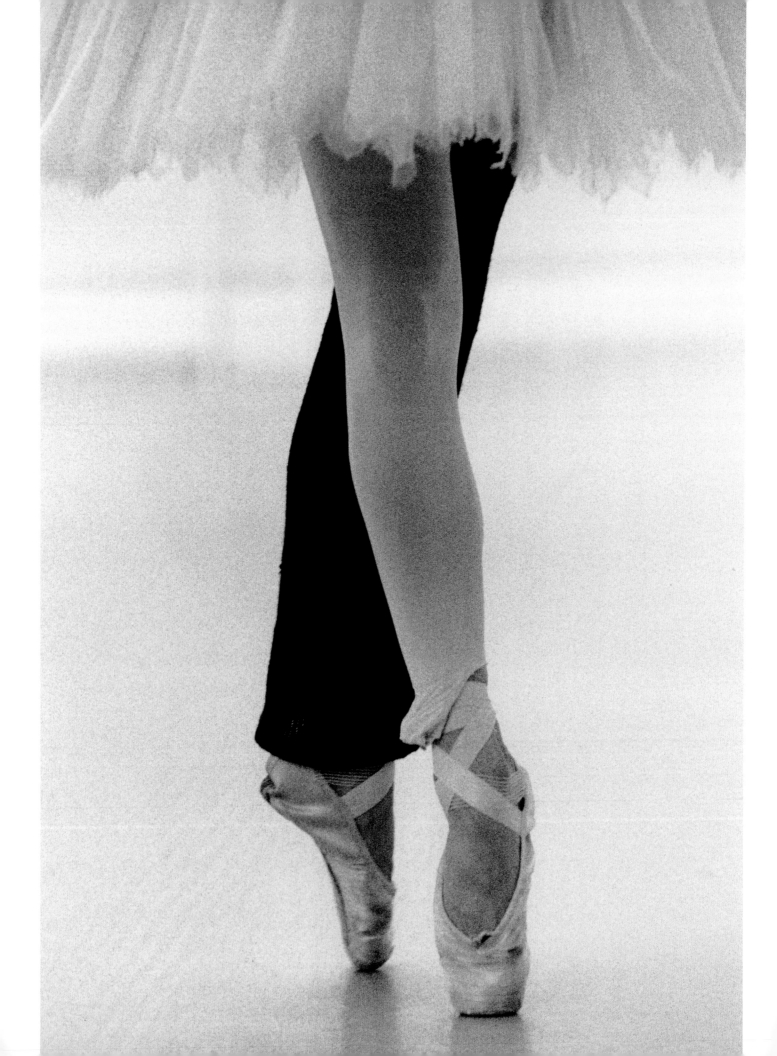

High key/low key: Abstract dancers

The legs of two great ballerinas: on the left, Darcy Bussell, on the right, Viviana Durante. The same subject, but the different lighting conditions at two locations have resulted in a low-key picture and a high-key one. I shot Vivianna in rehearsal at the old Barons Court studios. The light was pretty low, so I made a low-key picture, aided by the black rubber pants and tights. Darcy, however, was in the brightly lit, white-walled studios in Covent Garden, perfect for a high-key picture. I couldn't capture the white and black legs together until she went on point right in front of me. I was wide open on the 80–200mm zoom (f2.8) at 180mm. The long, large aperture lens cleaned up for me by throwing the distracting background detail out of focus.

SUMMARY

■ **Camera** Nikon F90x (left) and Nikon F4 (right). 80–200mm zoom at 180mm (left) and 80mm (right).

■ **Film** Ilford HP5+ rated at ISO 1250 (left), and Ilford Delta 3200 rated at ISO 2600 (right).

■ **Developer** Film: Ilford Microphen for 13 mins (left), and Kodak T-Max for 11 mins (right). Both 20°C/68°F.

■ **Exposure** Camera: 1/1000 sec at f2.8 (left) and 1/250 sec at f2.8 (right). Print: 9 secs at f4, grade 4, burned in for 2 secs and shaded for 3 secs (left), and 12 secs at f4, grade 3, burned in for 7 secs (right).

■ **Paper**: Both on Ilford Multigrade semi-matt FB.

2

1

1. LOW KEY
Shot on the 80–200mm zoom at 80mm. The print is straight with a burn-in on the top corners to get rid of rubbish and add to the low-key mood. I gave it 12 secs at f4, grade 3. I burned in for 7 secs.

2. HIGH KEY TAKE ONE
Trying to find the definitive picture. As you can see, no comparison to the final result. Note how much stronger the picture became when I removed the hands in the later simplified composition.

3. MAIN PRINT (opposite)
These few elements were all that was needed. Note the well-used pumps and the tatty tights. I gave it 9 secs at f4, grade 4. The right side was burned in for 2 secs and the leg shaded for 3 secs.

Composition by camera angle: The Painter

Above the stage of the Royal Opera House in Covent Garden is a huge area where backdrops for ballet and opera productions are painted. The fans see only a fraction of the creative work that goes into producing their night at the theatre. The performing artists that take all the applause on stage are not the only artists that contribute to the magic – far from it. During my photo story of the production of a new ballet (*Cyrano*), I photographed all the backstage artists and craftsmen at work. Designers, painters, costume designers, builders, milliners, musicians, lighting artists – the list goes on. This picture, taken from high above the stage, shows an artist scaling up a backdrop from the set designer's drawing – the early stages in the creation of a superb background for the autumnal scene of *Cyrano*.

PARING DOWN

When I arrived in the studio I was pretty knocked out by what I saw. I was at ground level, and although the work was fascinating, as a picture it was all very messy. I found a ladder to have a look from above, and took a few shots from the side, including some of the surrounding studio to fill out the story of the work in progress. This was acceptable from a narrative point of view, but didn't do justice to the artwork. From right over the top I excluded everything but the artist and the backdrop. The 20mm wide-angle lens allowed me to get right in close – my feet were only 2 metres (6½ feet) off the ground. The artist scaling up the designer's drawing using charcoal on the end of a stick was now the focal point of my composition. I shot about ten frames before I found the right body shape in the right place on the canvas. This was another paring down exercise – less is more again – but the story has still been told. You can see the artist referring to the drawing, and the stick: all the important elements are there but in a elegant composition. I was lucky that my lady was wearing black. The composition falls into the area of the law of thirds – not consciously on my part, so presumably it has become instinctive at this stage of my life.

PUSH PROCESSING

The film was Ilford HP5+ rated at ISO 1250. It was processed for 11 minutes in Microphen. The extra push development produced a higher contrast than is ideal. I

shot the whole project with this combination because I was going for a high-contrast look, but if I were doing it again I would use either of the newer T-grain films, ie Ilford Delta 3200 or Kodak T-Max 3200P, and develop in T-Max, which complements their chemistry. These films hold greater shadow detail than a medium speed film which has been pushed up in speed through increased development.

I cropped the negative slightly to remove some mess, and printed on grade 3½ on Ilford Multigrade satin RC. The face and the drawing required some shading, and the top corners needed some burning in. I think it is worth repeating that the choice of contrast for graphic prints such as this is very subjective. You may have preferred a harder or a softer interpretation than I have made.

1. JOURNALISTIC
From up on the ladder you can see what's going on – OK journalistically as a way of showing the work in progress, but not creatively. A ballet fan might like to see the studio setting.

2. CLEANING UP
I've "cleaned up" the picture, and the woman moving onto the canvas has opened up more possibilities for me. She's too centrally placed, however, and her body shape isn't good. It is a clumsy shape and not an elegant interpretation of the work she was doing.

3. FINAL PRINT
I am happy with this picture – it's descriptive of what's going on, but has a little bit of style about it also (in my humble opinion). Note how the perspective properties of the wide angle have added to the image.

2

3

SUMMARY

- Most locations you will find yourself shooting in look a confusing mess when you first arrive. Just take your time – you will find the patterns in there if you really look.

- **Camera** Nikon F4. 20mm lens.

- **Film** Ilford HP5+ rated at ISO 1250.

- **Developer** Film: Ilford Microphen. Print: Ilford Multigrade.

- **Exposure** Camera: 1/125 sec at f5.6. Print: 12 secs, grade 3½, shading on the face 4 secs and the drawing 3 secs. Corners burned in 3 secs.

- **Paper** Ilford Multigrade satin RC.

Perspective control: The grain silo

I don't think anyone would describe this old silo as an architectural masterpiece, but its no-nonsense simplicity really appealed to the "no bull" part of me. I found it in Montana, but it could equally have been anywhere in the west or mid-west of the USA.

The time was 10am and the sky was dark – great potential for using a red filter and producing a very dark grey sky. Light is such an important element in architectural photography. I say that about all areas of photography, I know, but you really can't pull a good shot of a building out of the bag if the light is not right. I was in luck this time; you can spend days waiting for the right light on a building, although the use of a compass will help to anticipate the best time of day.

I've included this picture to illustrate the use of a perspective control (PC) lens, which corrects the verticals that normally converge when looking up at a building with a wide-angle lens. It works in much the

SUMMARY

- **Camera** Nikon F90x. 28mm PC lens. Red filter. Tripod.
- **Film** Ilford FP4+.
- **Developer** Film: 7 mins at 20°C/68°F. Print: Agfa Neophen.
- **Exposure** Camera: 1/500 sec at f11. Print: 11 secs at f4, grade 3½. Sky burned in 5 secs and foreground 10 secs. Right side of silo shaded 3 secs.
- **Paper** Forte semi-matt FB.

same as the rising front on a large format camera. The lens is traditionally associated with architectural photography.

I used Ilford FP4+ rated at ISO 125. The slow film, the PC, and the red filter have combined to give a large format feel to the print – fine grained and very sharp.

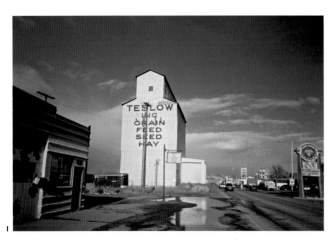

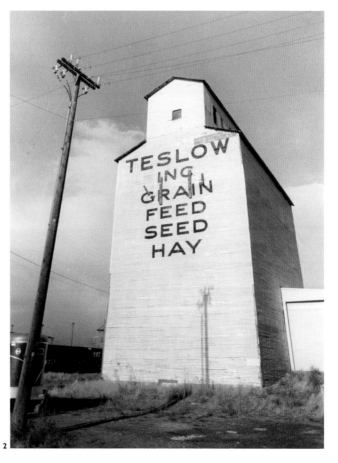

1. ORIGINAL VIEW
The silo as I first saw it. The elements were all promising, except for the huge puddle of water, which of course was just where I wanted to shoot from, and did. My new pair of trainers went slightly off colour.

2. STRAIGHT B&W
The black and white without either the PC lens or the red filter. Note the convergent verticals. Some buildings look better, in my opinion, when looked up at with their verticals falling.

away – as the eye sees them, in fact. But the old silo benefits from being straight and upright.

3. FINAL PRINT (opposite)
The finished product: walls straight and sky a rich dark grey. I burned in the sky to almost black, likewise the foreground to eliminate the rubbish. I shaded the shadowed wall to hold some detail.

Reportage

Although I have covered a very wide range of subject matter over the years, when I look back I realize that it was all based on reportage principles. I tried to tell a story even when I was taking fashion pictures. To me, reportage is what photography does best – recording the history of the time. I believe that a great moment from a wedding is just as important as a tragic moment of war, if it is well shot. Critics often praise the instinctive talents of a great reportage photographer. I don't go along with that. I think that with enough artistic and technical experience, it is possible to reach a point when compositions are *almost* instinctive, as was the case with Cartier-Bresson, perhaps. I am trying to analyse my reportage pictures here so that you can see the decision-making process at work.

Street photography: Boy and coat

PASSING TIME

I was waiting for Old Faithful to blow in Yellowstone National park. There was a couple sitting next to me; the man was sheltering their little baby inside his huge black coat. I took the first shot just to pass the time. Looking again, my interest heightened. I took the second picture and then stood up – the composition from above was really interesting, but the little chap's shirt was spoiling the tonal design. I reached over and pulled the coat collar across, leaving a little round white face inside the huge darkness of the coat. The baby was very interested in everything and he had one of those "old man of infinite wisdom" faces. It is just a snapshot, really, but it is surprising just how many critical decisions were made to get the image to print form.

IN THE DARKROOM

I shot on Kodak T-Max 400 rated at ISO 400 and used T-Max developer. The negative held very good detail in the black areas, so I had choices of how much detail I wanted to show. I decided to just keep enough to show that it is a coat that the baby is wrapped in, while keeping it a very black and white image. I printed for 11 secs at f5.6, grade 3½ with an additional 3 secs on the face.

1. FIRST GO
This first picture is quite a funny image, but a long way from the final visualization.

2. A DIFFERENT ANGLE
I moved to the front, to capture the face of the baby. A messy picture, however.

3. USING HEIGHT
From the high camera angle the composition is looking more interesting. The child's sweater was really distracting, though; the pic still needs simplification to improve the composition.

4. FINAL PRINT (opposite)
I covered up the sweater then I took a pace to my left to centralize the light face inside the dark coat. To further simplify the tonal composition, I cropped the top of the hat off in the print, taking the messy background with it. Remove the ugly and you are left with the beautiful!

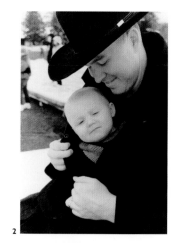

2

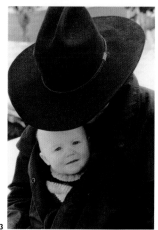

3

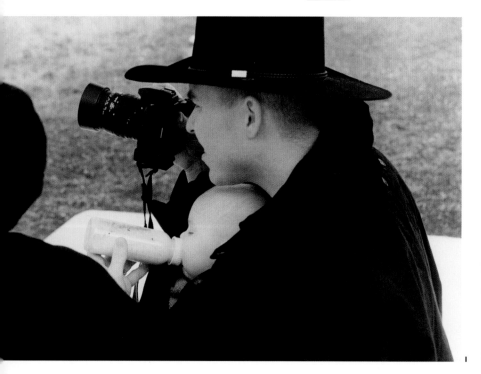

1

SUMMARY

- By choosing black and white subjects you are almost there. This image arrived custom made as a b&w image. I only needed to arrange the tones, which were easy to interpret.

- **Camera** Nikon F90x. 24–85mm zoom at 30mm.

- **Film** Kokak T-Max 400.

- **Developer** Film: Kodak T-Max 7½ mins at 20°C/68°F. Print: Ilford Multigrade.

- **Exposure:** Camera: 1/250 sec at f5.6 Print: 11 secs at f5.6 on grade 3½. Face burned in for 3 secs.

- **Paper** Ilford Multigrade glossy (unglazed) FB.

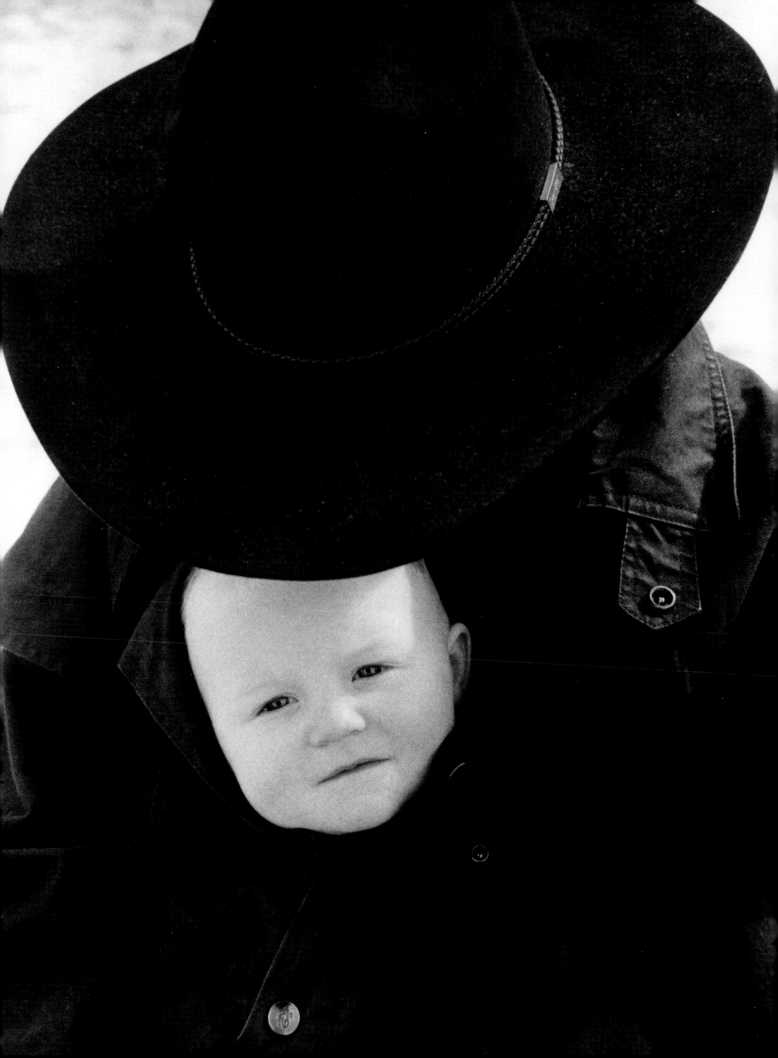

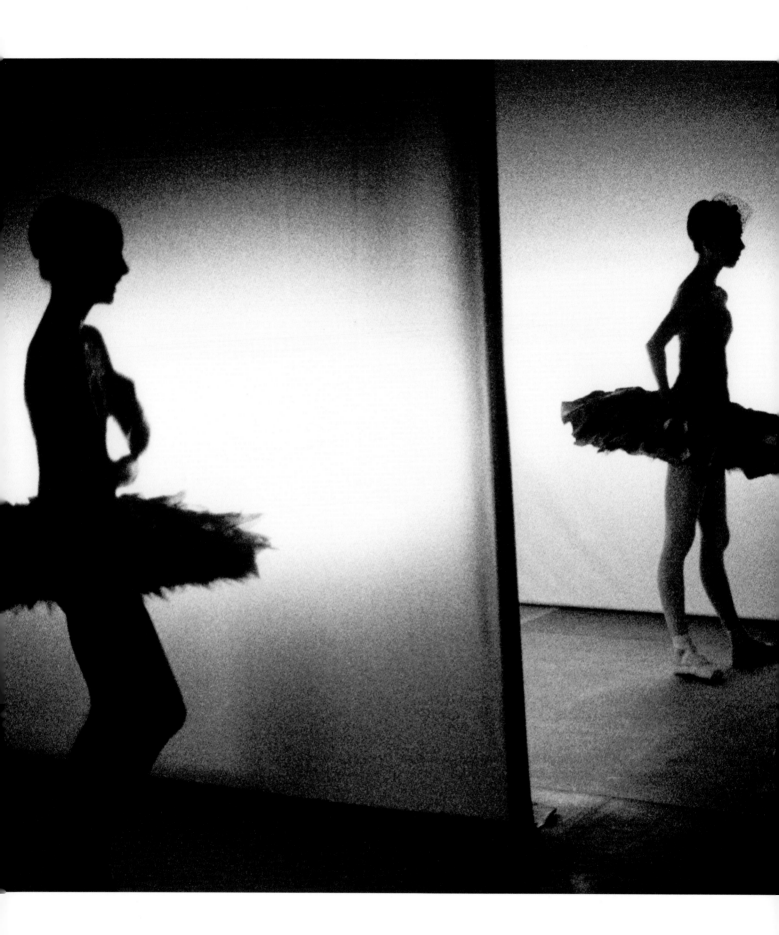

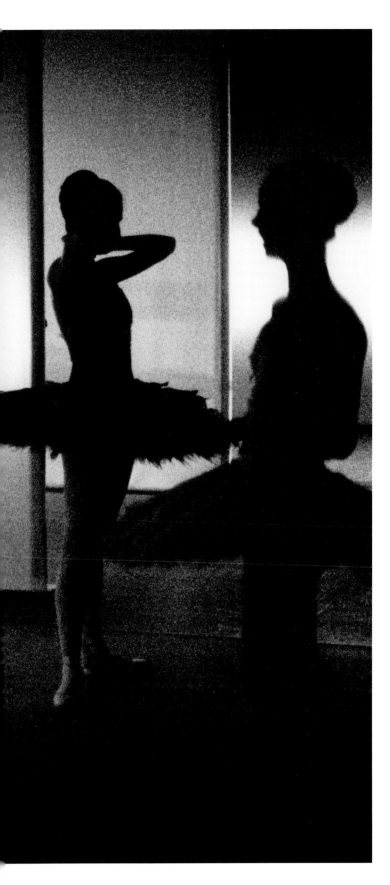

Silhouettes: Ballet

DEGAS

I have loved the Degas drawings and paintings of ballerinas since I first saw them at school. Degas wasn't interested in formal paintings of ballet being performed on the stage, but rather in backstage glimpses of the dancers preparing to go on. I share his view completely: I much prefer shooting dancers at rehearsal and backstage rather than in an actual performance. Their training leads to everything they do looking as if it is choreographed – they scratch their nose and it looks great!

When I did get the chance to go backstage myself, there were potential Degas pictures everywhere. In many ways classical ballet has never changed much – tutus are still the same shape and ballerinas still wear their hair very much in the same style. On the day of this shoot, the lighting in the wings was creating silhouettes of the girls. There was just enough light to have gone for detail in faces and costumes, but they looked so graphic in silhouette that I went for that visualization. So these photographs are sort of Dagas-ish silhouettes. (In fact, they are not entirely silhouetted, I have held some detail in the figures where it seemed appropriate.)

THE CRUCIAL GLANCE

The shoot produced quite a number of interesting pictures. I chose the main one (opposite) because it works as both a simple and a complex image. The shapes are simple: the vertical lines separate each ballerina, almost framing them individually; however, the three figures on the right cut into each other's space, connecting them into one form. The girl on the left would have been isolated to become almost a separate picture if it were not for the look across the frame that connects her to the other dancer. The picture would not have held together as a composition if I had not caught that look. The two ballerinas are almost mirror images of each other – and in fact at first glance you think they are. I feel that this adds not only complexity but also mystery to the picture.

This an obvious black and white situation. Once again, a reminder that the choice of subject and tonal relationship in the subject is the most important skill

that we need to concentrate on. And it can be learned; no photographer was born with it.

HIGH CONTRAST

The volume of light was very low, so the choice was a fast film overrated, in this case Kodak T-Max ISO 3200 rated at ISO 6000 – compensating in development by increasing the development time from 10 to 13 minutes (at 20°C/68°F). I printed at grade 4½. The high contrast emphasized the shapes and added to the graphic look of the pics. I had to shade the legs and floor at right of the image to prevent the area going black, and I burned in the top to contain the image. I printed on Ilford Multigrade coldtone semimatt FB, exposing for 12 secs at f5.6. I shaded for 3 secs and burned for 4 secs. After inspecting the dried print, I made another bleach back decision – just 20 secs in Farmer's Solution to brighten up the highlights nicely.

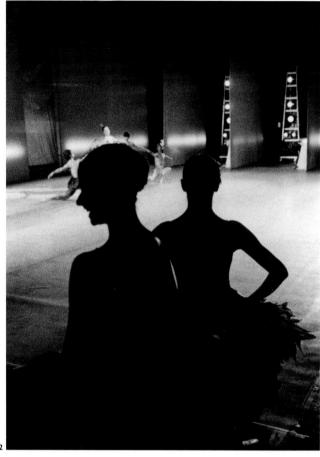

2

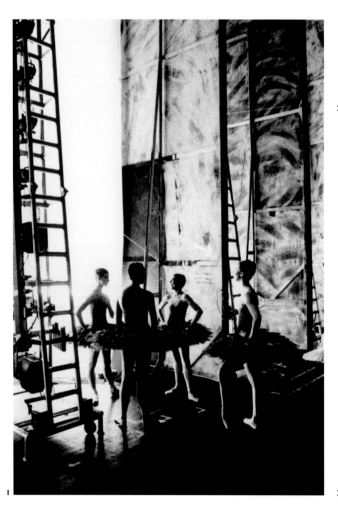

1

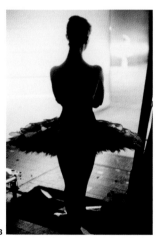

3

1. PLAYING WITH SCALE
The corps de ballet in amongst the backstage hardware. I took this shot for the scale – the dancers look so tiny there, yet in a few minutes they will dominate the whole stage of the Royal Opera House.

2. TELLING THE STORY
Seconds before going on. I printed this shot with some stage detail to tell the story. The bottom third of the pic is just a black mass, really. Looking at it again, I'd like to reprint, cropping just below the tutu on the right side.

3. A CLASSIC IMAGE
This is one of my favourites from the shoot. It is a classic ballet image, and one you see again and again when backstage – which is why I like it, I guess. The tonal composition has fallen perfectly just as you would draw it.

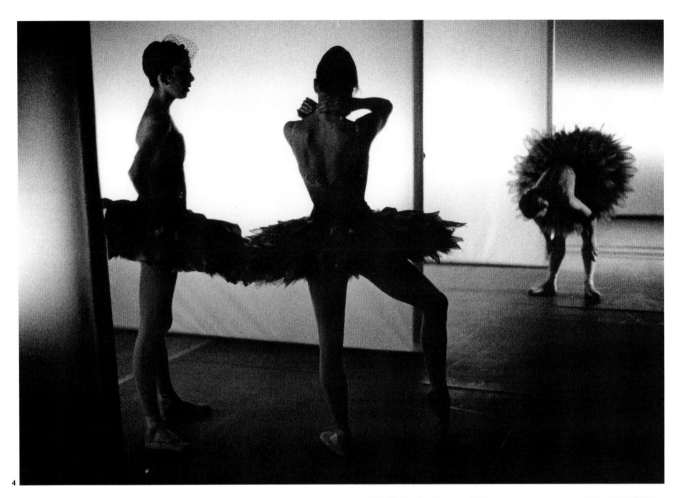

4

SUMMARY

- By resisting the modern practice of turning on the flash whenever the light seems low, you open a whole range of photographic possibilities – turn that flash off and learn to read the available light.

- I used a large aperture slightly wide angle lens because there was little light.

- **Camera** Nikon F90x. 35mm f1.4 lens.

- **Film** Kodak T-Max 3200P rated at ISO 6000.

- **Developer** Film: Kodak T-Max for 13 mins at 20°C/68°F. Print: Ilford Multigrade.

- **Exposure** Camera: 1/60 sec at f2. Print: 12 secs at f5.6. I shaded for 3 secs and burned for 4 secs. I bleached back 20 seconds in Farmer's Solution.

- **Paper** Ilford Multigrade coldtone semi-matt FB.

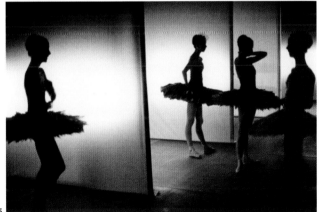

5

4. DEGAS POSE
A few frames before the main picture, with just the first three girls. This picture works well also. The position of the girl on the right of image is a typical pose seen in Degas' work.

5. FINAL PRINT
It was the connecting look that made me choose this picture. Much has been written about action photography; for me, it is the tiny action that is the most difficult to capture, not big sports-type events. The glance or the hand gesture is what often makes the difference between a fair picture and a great one.

Management: The wedding

THE REPORTAGE ANGLE

When I was a student, wedding photography was considered staid and formulaic, bottom of the list when it came to choosing what to do. But things have changed. A black and white reportage look is now very fashionable, so weddings offer a way for the reportage photographer to make some money. And wedding-as-reportage is a fascinating area – after all, you are recording the most important day in the lives of your clients.

I need to confess that I have never actually been paid for wedding pictures, but I have shot many weddings as presents for friends and relatives. Research and good planning seem to be the keys. You need to know exactly where, when, and how everything is supposed to happen. You can't take spontaneous pics that catch magic moments if you are on the run all day.

DIGITAL

If I was starting out now taking weddings professionally, I would go completely digital. Shooting colour and black and white at the same time is good for the clients. Also, as wedding photography is a big responsibility, the digital facility of being able to check the shots as you go along is very comforting. Obviously, you need to be restrained and not start checking every frame. I find that I lose my rhythm if I do too much checking. As with all forms of reportage, concentration over a long period is vital, and a wedding can be a long day.

I have just chosen pictures that concentrate on the bride, but of course that is only one part of the story.

CONTRASTING CLOTHES

I shot this story on the old reliable ISO 400 film (Ilford HP5+, rated at ISO 600). I developed in Microphen. I find the tricky part of weddings is the high contrast between the white wedding dress and the dark suit of the groom. I always have to burn in the dress, and often shade the suit as well. For the picture opposite, I exposed on grade 3 for 14 secs at f4, shading the suit for 3 secs and then burning in the dress for 5 secs to hold some detail in the whites. I think completely white areas look awful. On two of the pictures overleaf I used the flash in technique.

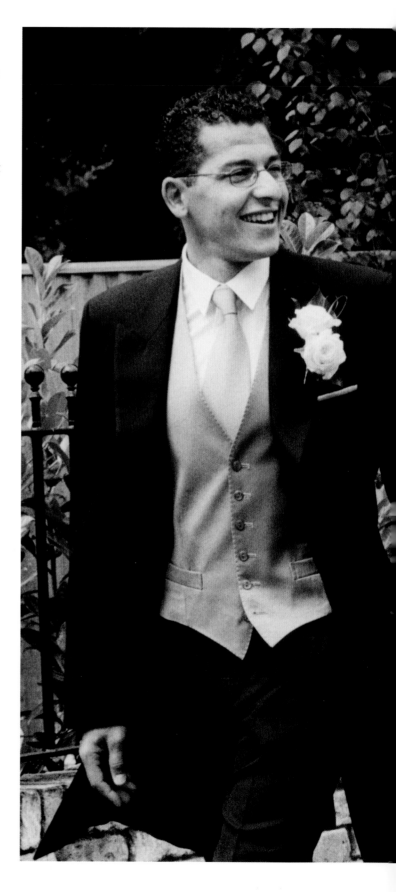

1. SPONTANEOUS ACTION
Anders suddenly picked Jamie Joe up and it made a bride and groom pic with a difference. As I said, concentration is important, so that you get the moments of the day. I flashed in to get detail in the whites.

2. THE CLASSIC IMAGE
Throwing the confetti is a wedding staple but difficult to catch. You can't do reshoot if you miss out. You have to be there.

3. "BACKSTAGE"

An intimate image with mother and maids making the final touches to the bride. It is a great moment that was captured because I knew where and when they were going to be dressing. I really like the look between the bridesmaid (right of picture) and the bride.

4. SMALL DETAILS

This is my younger son, Matt, and my new daughter-in-law, Kerry, a few moments after they tied the knot in Pittsburgh. It captures an intimate moment between them. It is these little looks and events that make a memorable wedding series.

5. PLANNING (below)

I knew the whole wedding party was going to walk from the church to the reception. I had time to get ahead of them and shoot them coming towards me. The composition is interesting – a series of triangles – two upright (the groom; the bride) and two inverted (the space between them; the space behind that contains the bridesmaids). The motordrive and the autofocus on the 80–200mm zoom did a good job. The moment was created by the party; I just had to make sure I captured it for them.

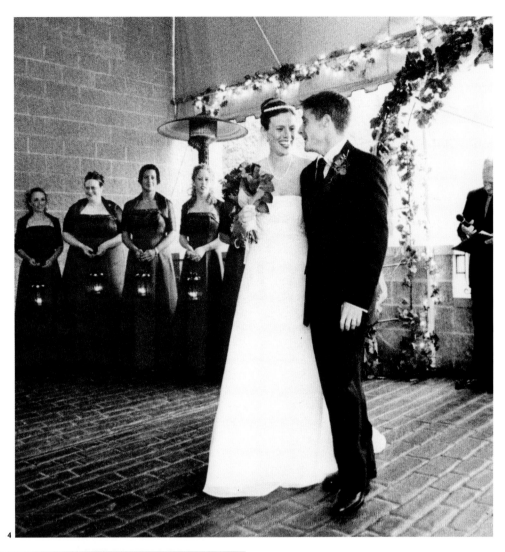

4

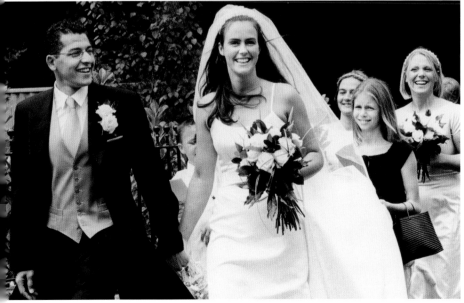

SUMMARY

- **Camera** Nikon F90x and Nikon F. 24–85mm and 80–200mm zooms.

- **Film** Ilford HP5+ and Kodak T-Max and Tri-X.

- **Developer** Film: Kodak T-Max for 12 mins and Ilford Microphen 12 mins (both 20°C/68°F). Print: Agfa Neophen.

- **Exposure** Camera: Various. Print: All prints had a basic treatment of between 12 and 14 secs at f4, and all the dresses required burning in for between 4 and 7 secs at grade 2.

- **Paper** Ilford MG glossy (unglazed) FB.

Finding symbols: A child

ANTICIPATING ACTION

I stumbled across this Orthodox festival on a stroll through ancient Jerusalem. The narrow streets acted like a funnel, forcing too many people through a small space, and I could feel that this had a potential for pictures. As the density of the crowd started to become uncomfortable, parents began to hoist their children into the air; moments before I shot the main picture I snapped a little girl safely riding on her dad's shoulders, so I was anticipating more of the same. Much of reportage is about concentration — staying with the situation and anticipating what will, or could, happen next. They say that great reportage photographers have a nose for such things, but the effectiveness of the nose is directly proportional to the amount of experience you've accumulated — in other words, the harder you work the luckier you become. It involves effort, hanging in there when the hotel bar is beckoning from across town!

Due to the aforementioned, this picture presented itself like a Christmas present, strong journalistically and, more obviously, strong graphically. The tonal relationships were perfect — it could only work in black and white — and the child's reversed cap topping off the appealing silhouette was the icing on the cake. We need to recognize good content and exciting tonal composition when it appears in front of us. It's all around us, of course, but only good photographers are able to spot it.

THE NEGATIVE

The negative that I produced was almost two in one, with an area in shade and areas in the midday sun that were about five stops denser. These were going to need a lot of burning in, though I still wanted to keep a bright, hard look. Apart from that, all I needed to decide on was the contrast and density I wanted in the area where it was all happening. Reportage pictures can be difficult to print as they're usually content led and may contain lighting situations that produce less than ideal negs. I made the basic exposure (after two tests) 9 secs at f4, grade 4. I burned in for 12 secs to the dense areas, and printed on Ilford Multigrade pearl RC — I like the punchy look that you can get with resin-coated papers.

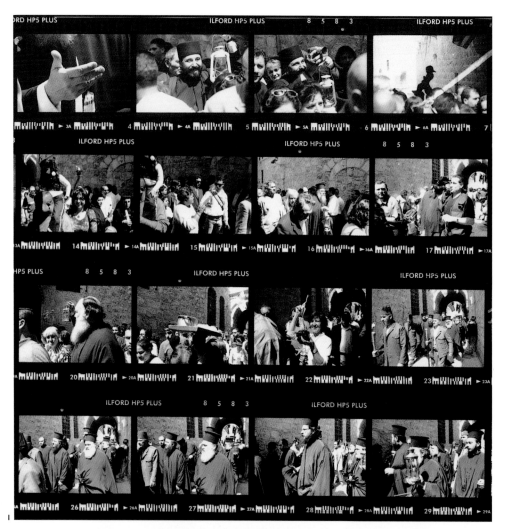

1. CONTACTS
The contacts (just a small selection) show the atmosphere of the shoot and some of the pics that lead up to the one that I chose. It's important to realize that even great photographers like Cartier-Bresson didn't produce a masterpiece with every click – we only see the best ones – so you usually need to shoot plenty of film.

2. BUILD-UP
Things were getting pretty crowded and becoming dangerous for little children close to the ground. The suggestion here was here that a more dramatic picture was on its way.

3. TEST PRINT
The shaded area is too dark and the bright area too light. It's not far off, just needing a cut of the basic exposure and an increase in the burning in. It's these subtle changes that make a great print.

4. FINAL PRINT
The best picture of the day matched with a print that does it justice. This print is my interpretation. If I gave the neg to four other printers they would all interpret it slightly differently.

3

SUMMARY

- Anticipate and concentrate.

- Practise reading the tonal potential.

- Rate ISO 400 film at 600 when shooting reportage for an extra ½ stop of speed.

- **Camera** Nikon F90x. 80–200mm zoom lens.

- **Film** Ilford HP5+ rated at ISO 600.

- **Developer** Film: Microphen for 9 mins at 20°C/68°F. Print: Ilford Multigrade.

- **Exposure** Camera: 1/1000 sec at f5.6 Print: 9 secs at f4, grade 4. Dense areas burned in for 12 secs.

- **Paper** Ilford Multigrade pearl RC .

4

Narrative: Police visit

These pictures came out of a *Sunday Times* magazine story on the working life of a typical London policeman. Shepherd's Bush was chosen as the location because it has a large racial mixture and a huge variety of problems, a major one being the need to break down barriers between the police force and the public. To that end, the police were making efforts to communicate with the locals by going door to door to listen to their problems. The lead picture I chose (opposite) was not actually used in the magazine, which was a pity because it captures one of the great problems that the police face in their public service programme – fear.

REACTION SHOT

I accompanied my PC on a visit to North African residents on a large housing estate. The plan was to check the security of the flats and find out whether the occupants were being racially harassed and offer support. But you don't have to be a genius to guess the reaction of a woman opening the door to find her neighbour accompanied by a very large policeman. I shot over the bobby's shoulder, which helped me stay out of sight and emphasized the height difference between the ladies and him. The householder was very scared at first because she thought it a visit from the immigration department. The reaction between the two women captures what fascinates me about reportage – it is another of those small pieces of action that tell the story so well.

This is also an example of the tonal organizational problems that reportage throws at you. There was a great difference between the exposure value of the dark faces in shaded light and the strongly lit right side of the pic. There was nothing I could do about that; it had to be sorted out in the darkroom. I find that printing reportage is the most difficult of all the photographic themes, as this print shows.

I chose to shoot on a fast film, Ilford Delta 3200, for two reasons. Firstly, fast film would handle any low light conditions without the need for flash. I try hard to avoid flash as it tends to kill the reality of the situation; the dingy light is probably going to be a major element in telling this story. Secondly, I used the grainy effect to add some grit to the pictures.

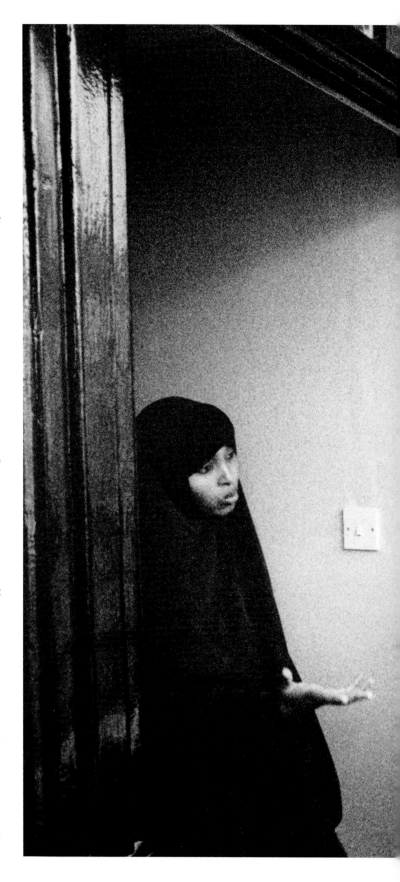

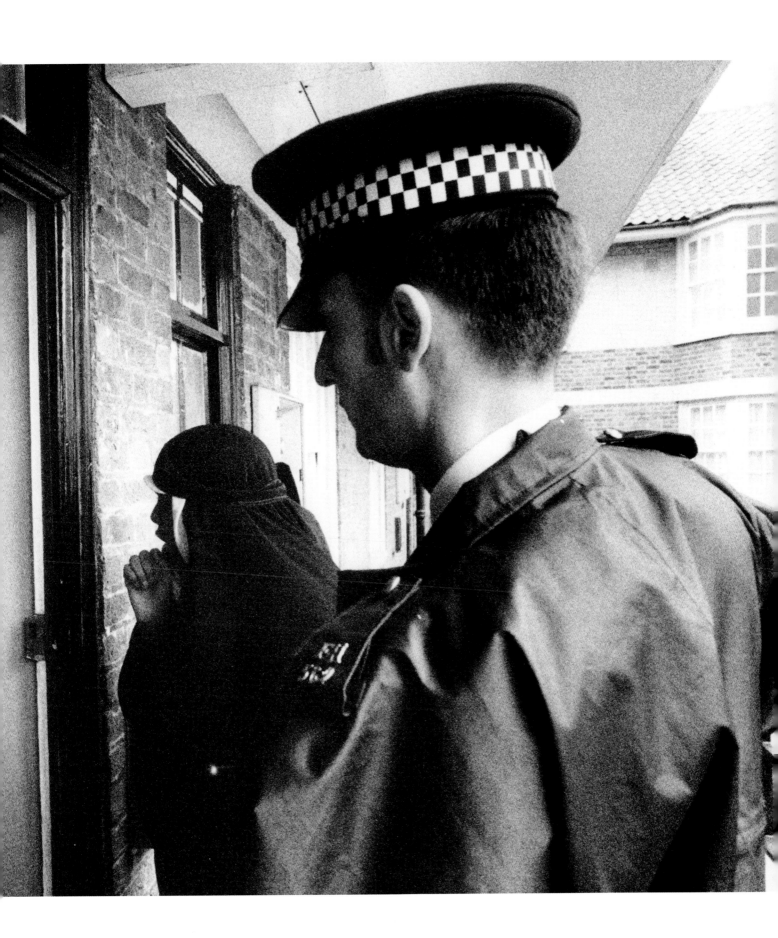

SMOOTHING THE EXTREMES

The printing task was one of smoothing out the extreme tonal range of the negatives. The lead picture was the most tricky. As you can see with illustrations 4 and 5, I started off by making two test prints, one for the ladies and one for the outside areas. These gave me the information that I needed to make the final print. My basic exposure was for the ladies (9 secs at f4 on grade 3½). I burned in the bobby for 4 secs and the background for a further 6 secs. I did not want to make the policeman too dark because he would look sinister as a dark figure. I needed just enough detail at his back to read that we were on a housing estate. I did the burning in on grade 2. Multigrade paper has been a great development. The facility to use two grades on the one print makes printing this kind of neg so much easier than on the traditional graded papers.

2

1

TECHNICAL SUMMARY

- ■ **Camera** Nikon F90x. 28–70 mm zoom at 30mm (lead pic); 300 mm lens (No 1); 28–70mm zoom at 28mm (No 2); 28–70mm zoom at 50 mm (No 3).

- ■ **Film** Ilford Delta 3200, rated at ISO 1600.

- ■ **Developer** Film: Kodak T-Max for 11 mins at 20°C/68°F. Print: Ilford Multigrade.

- ■ **Exposure** Camera: 1/250 sec at f8. Print: 8 secs grade 3, plus 5 secs on policeman and background grade 2, plus further 6 secs on background grade 2.

- ■ **Paper** Ilford Multigrade glossy (unglazed) FB.

1. STEP LADDER

I stood on a small step ladder to make this working portrait (I leave one in the car). This allowed me to get some feeling of a street behind him. I shot on a 300mm tele lens wide open (f3.5), which has pulled him right out of the street. I had to burn in his shirt a little.

2. FILL FLASH

This picture of the police attending a collapsed junkie was actually the magazine cover. I had to use fill-in flash, although the main lighting is coming from the street light above. If this had been straight flash you would not have seen any background details – the car lights, for example. I burned in the white shirt and shaded the faces. I printed on grade 3.

3. BURNING IN

The sign on the wall says it all. The resident was complaining about the outrageous behaviour of some local kids. I had to burn in the electricity meter box, as it was distractingly lit.

4. TEST PRINT 1

The print for the ladies – 11 secs at f4, grade 3. A little too dark.

5. TEST PRINT 2

A test print for the rest of the pic – 16 secs at f4, grade 3. The policeman looked a little bit threatening with so dark a tone. This was not the message that I was trying to get across.

6. FINAL PRINT

This final print did the job for me. The density of a reportage picture is very critical; it can drastically influence the point you are trying to make. I think this bobby is a committed cop, trying to do a good job for his community. And it is a tough job – I hope that shows in my pictures.

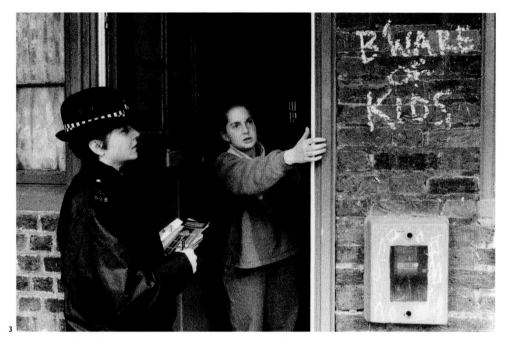

3

4

5

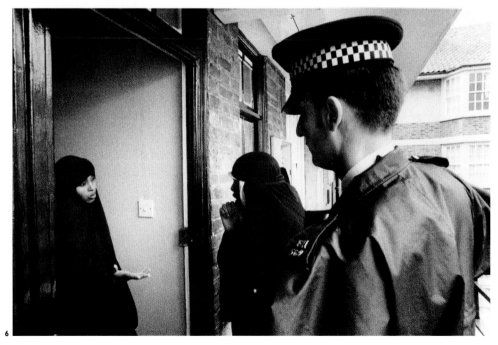

6

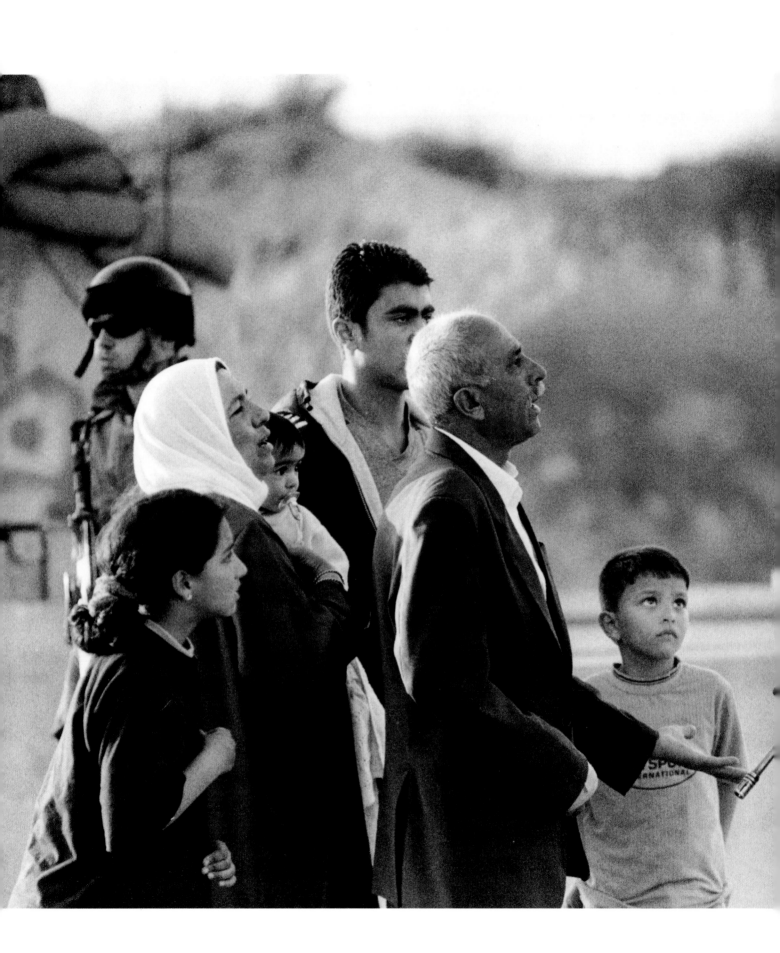

News coverage: The checkpoint

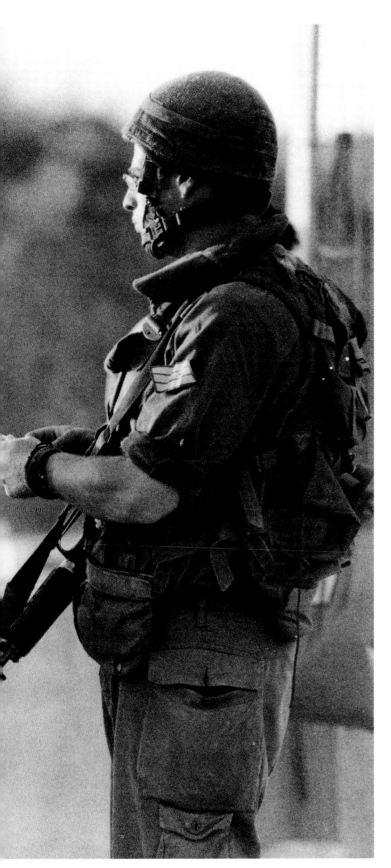

THE WORLD'S WITNESS

As a photojournalist you wonder sometimes if anyone has noticed your pictures, whether your record of the trouble and strife of the world has made any difference. The answer is, I suppose, a definite no. Nothing seems to change: the oppressed are still oppressed and the bullies still rule the playground. But the oppressed and the unrepresented still need us to be their witness. That is what current affairs reportage is all about.

This picture is from my assignment in Israel/Palestine in 2002. I was interested in the life of Palestinian people trying to live a normal existence in the Occupied Territories. This picture was taken at the Ramallah checkpoint. Palestinian families had been waiting all day in the hot sun to be allowed through the Israeli checkpoint between Jerusalem and Ramallah.

In this case study, I'm showing a series of pictures leading up to the lead pic (opposite). I spent all afternoon trying to take a picture that really sums up the frustration and humiliation the Palestinians suffer on a daily basis. The earlier pics are descriptive – the long wait, the family being sent back, etc – but the lead picture is by far the best image, and I must say it is the only frame that really captures the situation from the Palestinian point of view. And that is after four hours and four rolls of film. Photojournalism is not at the most glamorous way to make a living in the business, that's for sure.

For this picture, all the necessary elements had fallen into place finally. The family is a perfect symbol of the larger family of the Palestinans. Although the faces tell the story, the strong composition adds greatly to the tension of the picture. There is the unsettling height difference between soldier and family, of course, but once again it is capturing a tiny piece of action that really makes the composition work: the plaintive hand gesture and the gun seeming to touch. The framing of the little boy in the V shape made by the arm and the gun takes your eye straight to him, making him the most arresting figure in the photograph. This picture amounts to a split second out of a four-hour shoot. But

it is a definitive image of the checkpoint – it tells the story better than all the other pictures that I took that day put together.

AN EASY NEGATIVE
The even spread of light has provided an easy neg to print. I made a basic exposure, just shading back the little boy a touch to attract the eye to him – as you can see, he is lighter than all the other figures. I added some burning in to the sky just to hold some tone at the top of the print. I do not like the sky disappearing into the white of the paper. The exposure was 14 secs at f5.6, on grade 3. I shaded for 4 secs on the boy, and the sky received an extra 5 secs.

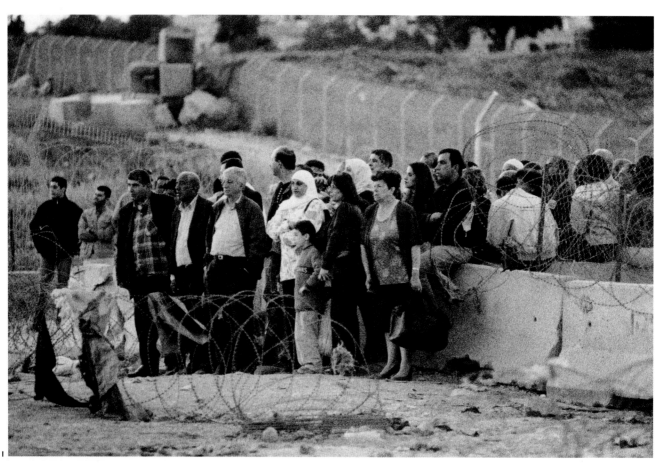

1

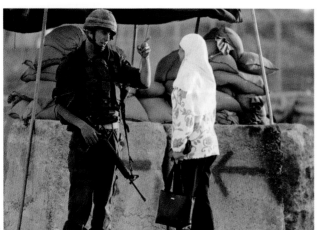

2

SUMMARY
- **Camera** Nikon F90x. 80–200mm zoom at 180mm.
- **Film** Ilford HP5+, rated at ISO 600.
- **Developer** Film: Ilford Microphen for 9 mins at 20°C/68°F. Print: Agfa Neophen.
- **Exposure** Film 1/1000 sec at f5.6 Print: 14 secs at f4, grade 3. The boy was shaded 4 secs; the sky burned in 5 secs.
- **Paper** Ilford Multigrade semi-matt RC.

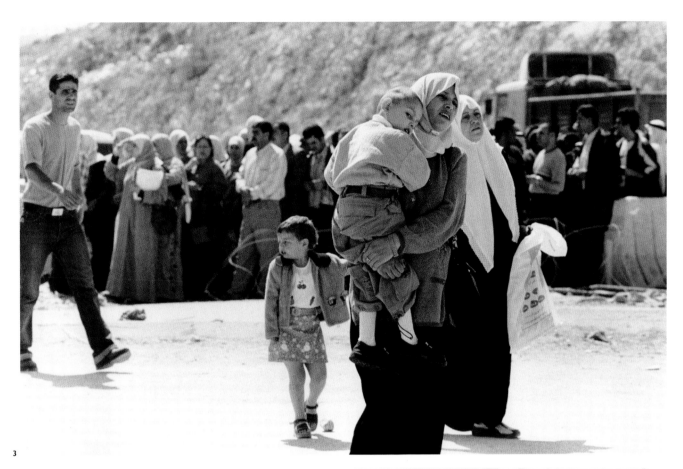

3

1. PART OF THE STORY
A section of the people waiting to be processed through the checkpoint. A useful picture as part of the story but probably not strong enough to work on its own.

2. EXPRESSION NEEDED
A young woman being turned away from the checkpoint. A day wasted, but no doubt she will try again tomorrow. This pic really needed the woman's facial expression to get the story across fully.

3. ANOTHER SERIES SHOT
Mother, grandmother, and children sent back from the checkpoint. They have been waiting in line for about five hours. Like the first picture, this one does not encapsulate the story, but it would be fine as part of a series. I was frustrated by the fact that the soldiers would not let me shoot from where I wanted to, but that is often the case in these kind of situations.

4. SHOWING BOTH SIDES
This picture includes the defensive bunkers that the soldiers need at the checkpoints. These young men are often the targets of suicide bombers, so they are naturally nervous. There are awful crimes committed on both sides, of course, and one's sympathy is always with the victims, no matter who they are.

5. FINAL PRINT
Here is the chosen pic again to show how much more evocative it is than the other frames. In these highly charged situations it is important to do everything slowly – don't attract attention to yourself and try not to add to the tension by annoying anyone – on either side of the wire. Photographers who charge in with their motordrives on full speed usually get nothing and cause more trouble.

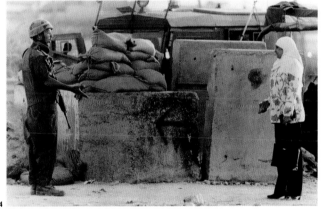

4

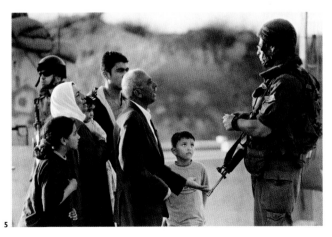

5

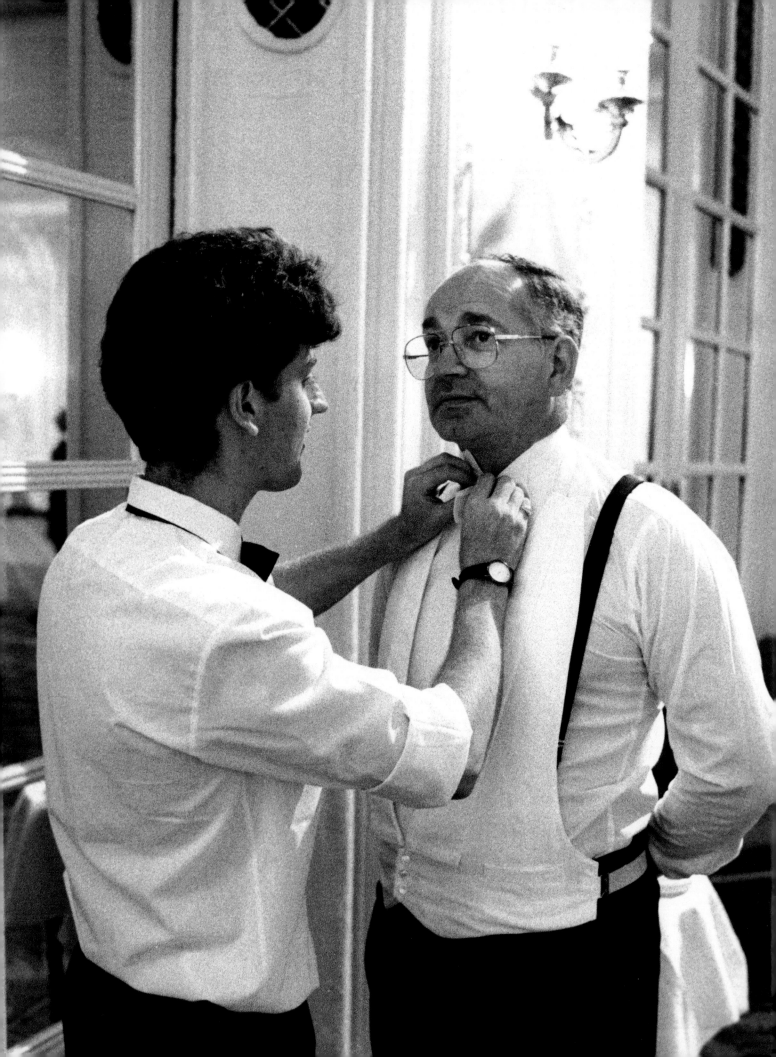

Corporate reportage: The Savoy Group

GETTING THE SHOT

The annual reports and accounts of large corporations are a profitable area for reportage photographers. When companies present the results of the last year of trading to their shareholders, they want to present a rosy picture, and photography is used extensively to add some style to the many pages of accountants' figures. I was commissioned to shoot the annual report of the Savoy group of hotels. They decided to feature the staff of the hotels, whose hard work behind the scenes is responsible for the immaculate service these famous hotels provide. I spent a very enjoyable week shooting the army of workers from early morning to late at night. I have included a variety of pictures to give the flavour of what corporate reportage is about. The Savoy wanted genuine reportage – nothing set up or posed – as if it was a magazine story. I used fast film and no flash. The staff ignored me and went about their business.

I have shot lots of annual reports over the years and travelled all over the world doing them. It is a challenging area to work in. You can be called on to produce portraits, still life, architecture – in fact, all the themes of photography have to be handled at some time or another. A large percentage of these assignments were in colour, but lately black and white has become fashionable.

BREAKING IN

Corporate work can be creatively as well as financially rewarding. These assignments can provide access to potentially great photographs denied you in normal circumstances. For those students or young professional photographers among you who want to break into the corporate world, the most important – and most difficult – task is to produce a portfolio that demonstrates your all-round competence. Obviously, nobody is going to pay good money unless they are confident that their problems are going to be solved. I started out by asking my friends who worked in various industries if they could get me in to take pictures. I gave the company a good set of prints at the end of the shoots. It can be anything from factories to restaurants. You need that portfolio and most people are out there working, so it is not an impossible task. If you are a keen amateur, you could open up a whole new source for pictures.

MULTIGRADE PAPER

Shooting available-light pictures in low-light conditions inevitably results in some difficult negatives, as we have

1. BURNING IN
Chefs preparing lunch at the Connaught Hotel – one of the burning in negs. The whites received 7 secs on grade ½ after an exposure of 6 secs on grade 3½ at f4.

2. HIGH AND WIDE
Plates laid out for lunch in the Savoy kitchens. I found a high stool to shoot down on them with an 18mm lens. The picture tells an interesting story for the client and made a satisfying composition for me.

discussed before in the book. The major problem is contrast – holding detail in the highlights of a predominantly dark picture. This is where variable contrast paper comes into its own.

I made most of the basic exposures on these prints on grade 3½ to give them a gutsy, newspaper feel when combined with the fast film (Kodak T-Max 3200P, rated at ISO 2400). Then I burned in the bright highlights (white uniforms, plates, glasses) on grade 1½. The softer contrast of 1½ made a potentially difficult print very manageable. Some of the dark corners and faces in shadow required some shading also (with dodgers).

3. A PROFITABLE PORTRAIT
The famous chef of the Connaught, Michel Bourdin, captured in his office making up the menu for dinner. He liked the portrait and responded with a great meal on the house. Lesson: don't mess up the chef portrait.

4. AN ORGANIZED IMAGE
They even make their own beds, rather than just making the beds, as it were. I did organize the men to improve my composition.

5. PORTRAIT POWER
4am: polish for the back stairs at the Savoy. Sometimes a portrait does the job best, if there is a great smile on the face. I guess the message conveyed is that a happy worker equals a happy guest.

6. BUTCHERS
The butchers prepare special cuts to the specific briefs of individual chefs.

7. A SIMPLE IMAGE
The laundry was vast and there were more spectacular images available, but my brief was to illustrate the personal attention that the staff give to the guest, which I did with this simple image.

8. COFFEE
The Savoy coffee blends being made on the premises.

9. WORKING IN KITCHENS
Dessert getting the final touches. Kitchens are difficult places to shoot in – they are seriously frantic, timing being the bottom line. I had to work fast and keep out of the way. In these situations, sit back and decide exactly what you are going to do, then go in and shoot. Don't go in and then fiddle around or ask anyone to pose... *ever!*

10. REDUCING HIGHLIGHTS
A waiter polishing up the glasses for a banquet. A very tricky print because the glasses were catching fierce highlights. It needed 25 secs. burn in on grade 1½.

11. RIGHT TIME, RIGHT PLACE
The florist building a centrepiece for the banquet. A simple reportage picture, but I had researched the timing of everything that was happening in the hotel and had it written in diary form, so I knew to be on the spot here.

12. SENDING THE MESSAGE
A waiter tying his mate's bow. The picture has some charm and it is an evocative image for my client, sending the message of a caring staff. After all, that was my job: to capture the spirit backstage of a great hotel. The print required some burning in on the shirts and a touch of shading for the faces.

7

8

9

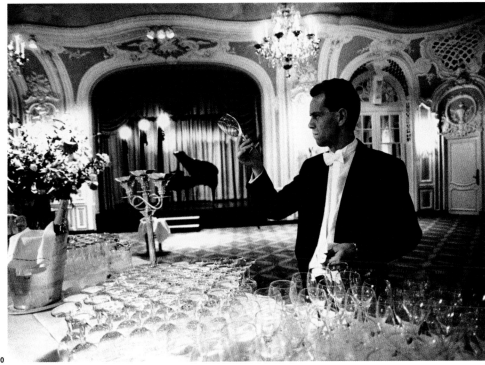
10

SUMMARY

- **Camera** Nikon F4. 20mm, 35–70mm zoom, 50mm (f1.2, f1.4, and f8.5) lenses.
- **Film** Kodak T-Max 3200P.
- **Developer** Film: Kodak T-Max for 13 minutes at 20°C/68°F. Print: Ilford Multigrade.
- **Exposure** Camera: 1/250 sec at f2 (main pic). Print: 13 secs at f5.6.
- **Paper** Ilford Multigrade satin RC.

11

12

Glossary

A

aperture

The hole in the lens that allows the light through to expose the film. The aperture is variable and is based on the iris of the human eye. The size of the aperture is measured in f stops. F stops are calculated as fractions of the focal length of the lens.

archival toning

Prints are toned to increase their archive or "wall" life. Gold or selenium toning is most often used.

auto

This refers to using the automatic setting on the camera to calculate the correct exposure.

available light

Used to describe low-level interior lighting – the lighting that is often ignored in favour of flash.

B

backlight

Light that comes from behind the subject. It can present exposure difficulties, as it pours into the lens and causes the meter to underexpose by about 1½ to 2 stops. However, it is a very flattering portrait lightsource, producing a fringe or halo light effect. This effect works best with a reflector or a flash fill in.

burning in

Adding extra exposure to a light area of the image during printing while shading the rest of it off.

D

depth of focus

The area in the foreground and the background of the focal point that is held in focus. The focal length of the lens and the aperture control the depth of focus.

dodgers

Shapes that are cut out and fixed to thin wire. They are used to shade areas of a print ("dodging").

F

farmer's solution or farmer's reducer

A combination of potassium ferrycyanide and hypo (the fixer sodium thiosulphate), used mainly for bleaching prints.

fibre base

Or FB. Refers to photographic paper that is coated on a paper base.

film speed

A film's sensitivity to light measured numerically as scale of ISO (International Standards Organization). A fast film has a high numerical rating, eg ISO 3200 (Kodak T-Max 3200P and Ilford Delta 3200, for example). A slow film has a low rating, eg ISO 100 or 125 (Ilford FP4+, for example).

filters

In black and white photography coloured filters lighten the colours in their own end of the spectrum and darken those in the opposite end. Hence, a red filter will convert a blue sky to dark grey and a red roof to a light grey. A polarizing filter works in the same way as Polaroid sunglasses, cutting the reflections. You can control the degree of reduction by spinning the filter. Neutral density filters cut the exposure in a picture, either overall or in a particular area. Grey in colour, they are used when the contrast of the light is too extreme for the film to handle.

flashing in

A short exposure to a print either before exposure in the enlarger or during development. The second exposure fogs in the highlight of a print.

focal point

The point on which you have focused. It has also has come to mean the area in a picture to which the eye is drawn.

fotospeed

The brand name of an excellent range of black and white products. Their toning kits are particularly useful.

G

grain

Granular texture appears to some extent in all film. It is

formed from the clumping together of the silver halide grains in the emulsion. The faster the film, the grainier will be the image. Long development and overexposure are also contributing factors.

gold toning

Oddly enough, this process imparts a subtle blue tone. How intense the colour is depends on the paper used and the development time. Gold toning adds a rich depth to prints and it is often used as an archival toner.

golden triangle

A classic painter's composition that uses the triangle as its base – usually for portraits.

H

high/low key

High key refers to a predominantly light image. Low key refers to one which is predominantly dark.

L

large format cameras

Term applied to cameras that use cut film that is 5 x 4 inches or larger. The most common formats are 5 x 4 inches and 10 x 8 inches. Simple in construction, they have a front panel that holds the lens (the shutter is located in the lens) and a back panel that contains the film holder. A bellows connects the two. The back panel incorporates a ground glass screen on which you focus (with a black cloth covering your head to cut out the light). The image is projected upside down and back to front on the screen. Focus is achieved by moving the front and back panels closer or further apart from each other. Both panels have movements that allow the photographer to correct verticals and hold focus throughout the image. Large format cameras are still used by photographers looking for the ultimate in fine-grained, sharp negatives with a smooth open tonal range.

M

macro

The name given to a lens that works at 1 to 1 magnification or closer.

medium format

A camera that shoots 6 x 4.5cm, 6 x 6cm, 6 x 7cm, 6 x 8cm, or 6 x 9cm format on 120 roll film.

monopod

A camera support that has one leg rather than the three of a tripod. It is used extensively by sports photographers. Monopods take up little room and give enough support to help steady long telephoto lenses.

multigrade

Trade name of Ilford's variable contrast paper. Most manufacturers use the term variable contrast. The contrast of the print is altered by the use of a filter selected from a multigrade head on the enlarger.

N

negative

Film records an image in negative, ie the dark area of the subjects are light and vise-versa. A print is required to turn the image back into a positive.

P

pushing

Increasing the development of a film to raise the film speed. In other words, to compensate for underexposure.

R

reflector

Any reflective surface that is used to bounce the main light source back onto the subject. There are a great variety of reflectors on the market.

resin coated

Or RC. Refers to photographic paper that is coated on a plastic base. It requires much less washing (2 minutes, as against 45 minutes for fibre base paper).

S

shading

Shading – also called dodging – is a technique where the

printer reduces the exposure given to areas of a print by holding dodgers or his hand between the enlarger lens and the printing paper.

skinny neg

A slang expression for an underexposed negative.

soft focus filter

This is placed over the lens to make the image soft but not out of focus. It can be very effective when used over the enlarger lens also.

spot meter

Most cameras have a spot meter built in. It takes a meter reading from a very small portion at the centre of the viewfinder. This kind of meter is very useful if the tonal range is extreme: one can find out the exposure value of extreme highlights and shadow areas, and from there calculate the correct exposure.

spotting

The removing of blemishes on the print caused by dust on the negative by means of a fine brush and dyes. The method is literally consists of adding the dye to the density of the surrounding print one spot at a time.

stopped down

This refers to a lens that has been set at a small aperture (f16 or f22).

T

T-grain films

The most recent development in film chemistry, as used in Kodak's T-Max and Ilford's Delta films. T-grain technology has been been most successful on fast films, allowing greater speed with more shadow detail and sharpness.

telephoto

A lens with a longer than normal focal length (normal lens on a 35mm camera being 50mm).

test strip

A strip of paper given several exposures section by section so that when it is developed the printer can assess the basic

exposure for the print.

thin/thick neg

Expressions used by printers to describe an underexposed and an overexposed negative respectively.

tonal range

Describes the range of tones between the lightest and darkest areas of a negative or a print.

toning

Altering the original tones and/or colours of a print by redeveloping it in a toning solution.

tungsten light

An incandescent studio light.

U

umbrella

Or brolly. Umbrellas (mostly white) of various sizes are attached to flash units. The flash light is softened by bouncing it into the umbrella and back onto the subject.

V

visualization

A description of photographers' ability to convert colour into tones of black and white in their mind. This skill is the basis of black and white photography.

W

wide open

A term that means the lens has been set at its maximum aperture (f1.2 , f2 ,or f2.8 depending on the lens in use).

Z

zoom lens

A lens with an infinitely variable focal length between two points, for example a 80–200mm zoom.

Further Reading

I could never fit in a complete list of all the great black and white photographers whose work you could learn from. Here are some of my favourites.

The books on or by individual photographers that I have listed are those I have most enjoyed over the years and regard as being significant. There are books that are more recent or more economic. I would like to recommend the excellent Aperture series "Masters of Photography". They are small volumes that give you a taste of many of the great photographers, past and present.

TEACHING BOOKS
Ansel Adams, *The Camera* (and *The Negative* and *The Print*). Little, Brown, 1995

Tom Ang, *Advanced Digital Photography*. Mitchell Beazley, 2003

Julian Calder and John Garrett, *The 35mm Photographer's Handbook*. Pan, 1999

Eddie Ephraums, *Creative Elements*. 21st Century Publishing, 1996

John Garrett, *The Art of Black and White Photography*. Mitchell Beazley, 1992

John Garrett, *John Garrett's Black and White Master Class*. Collins & Brown, 2000

John Garrett. *KISS Guide to Photography*. Dorling Kindersley, 2002

Roger Hicks and Franes Shultz, *Darkroom Basics*. Collins & Brown, 2003

Tim Rudman, *The Photographer's Master Printing Course*. Mitchell Beazley, 2004

Tim Rudman, *The Master Photographer's Toning Course*. Argentum, 2003

George Schaub, *The Digital Darkroom*. Silver Pixal Press, 2002

PORTRAITS
Richard Avedon
Observations. Weidenfeld & Nicolson, 1959
Nothing Personal. Penguin, 1964
Avedon Photographs: 1947–1977. Thames & Hudson, 1978
Richard Avedon, Evidence: 1944–94. Jonathan Cape, 1994

Richard Avedon is one of the great photographers of the 20th century. He made his name as a young fashion photographer in New York way back in the 1940s and continued working right through until his recent death. It is his uncompromising style of portraiture that he will most be remembered for. Only ever placing his subjects on a white background, he produced the stark images that had a huge influence.

Jane Bown
The Gentle Eye. Thames & Hudson, 1980

The title describes her portraits perfectly. She is one of the outstanding daylight portraitists.

Bill Brandt
Shadow of Light. Gordon Fraser, 1977

Brandt was a surrealist when it came to portraiture. His landscapes, nudes, and reportage are fascinating also.

Annie Leibovitz
Photographs: Annie Leibovitz 1970–1990. HarperCollins, 1992

Probably the most famous celebrity portraitist working today.

Arnold Newman
Artists. Weidenfeld & Nicolson, 1981

Newman's book of artists was a labour of love, but the pictures had a huge impact on my generation. He composed each picture to reflect the style of artist he was working with. Trained as a painter, he had an intimate understanding of art and artists, and it certainly shows in this portfolio.

Irving Penn
Moments Preserved. Simon & Shuster, 1960
Passage. Jonathan Cape, 1991

The other great giant, and rival to Avedon, Penn was also a minimalist. A magnificent technician and designer of pictures, his portraits are superb. Also search out his beautifully composed still lifes.

Albert Watson
Cyclops. Pavilion, 1994

The modern classic black and white portraitist. A Scot working in New York, he is very much in the Avedon/Penn mold.

LANDSCAPES
Ansel Adams
Images 1923–1974. New York Graphic Society, 1982

Undoubtably the most famous landscape photographer ever. He was a great campaigner for the national parks of the USA as well as the man who set the standards for black and white landscape photography. Adams had a parallel career as a great teacher. He evolved the zone system of exposure/development on which black and white technique has been based ever since.

John Blakemore
Photographs. British Council, 2002

An English photographer who concentrates on almost close-up landscapes – a wet rock in a river or seaside rock formations, for example. Wonderful work and a different approach to study.

Wynn Bullock
Wynn Bullock. Scrimshaw Press, 1971

Bullock's landscapes have a romantic quality very different to the Adams' style. I recommend his nudes and still life to you as well.

Edward Weston
50 years. McGraw Hill, 1973.

A great all-rounder but most famous for his landscapes of the American West. He also wrote brilliantly.

STILL LIFE, ART PHOTOGRAPHY, AND ARCHITECTURE
André Kertész
Sixty Years of Photography: 1912–1972. Thames & Hudson, 1972

I would describe him as an art photographer because he took pictures for no other reason than the subject itself – not for a client or to solve a problem, but just for the magic of the picture. I particularly like his still life.

Irving Penn
Still Life: Irving Penn Photographs 1938–2000. Thames & Hudson, 2001

Check out Penns' still life – brilliant!

Paul Strand
Paul Strand. Aperture, 1997

What couldn't this man photograph? Throughout a very long career, he pointed his camera at every subject. His architectural pictures of American clapboard architecture are great.

Minor White
Mirrors, Messages, Manifestations. Aperture, 1982

He photographed the architecture of the West of the USA, finding patterns in the buildings. He shot many other subjects as well.

Edward Steichen
Edward Steichen. Aperture, 1978.

The father of modern photography and promoter of it as a legitimate art form, he experimented with light and form in his still life. He discovered things about those elements that changed photography for ever.

Ralph Gibson
The Somnambulist. Lustrum Press, 1973

One of my favourite photographers. A still life man, really. A stark minimalist with an extraordinarily graphic design sense.

Lee Friedlander
Lee Friedlander: Photographs.

At first sight, his pictures look unstructured and almost like snapshots; however, they are extraordinarily complex compositions of rather ambiguous subjects – reflections, a house amost obscured by trees, a tangled mess of a garden. He launched an entirely new school of photographic vision.

NUDES

Bill Brandt
Nudes 1945–80. Gordon Fraser, 1980

Brandt made his famous nudes with a pinhole camera. The images are almost abstract – a unique, fresh vision.

Helmut Newton
White Women. Thunder's Mouth Press, 2001

Newton grew up in pre-war Germany, and his erotic fantasy nudes reflect that decadent period. He is also a great fashion photographer and portraitist.

Edward Weston
Nudes. Aperture, 1993

A genius who photographed any subject matter superbly. His nudes are but one section of his work, but are some of the most beautiful ever taken.

REPORTAGE

Brassai
The Secret Paris of the Thirties. Thames & Hudson, 2001

Brassai recorded the nightlife of his paris – the prostitutes, the barmaids, the drunks – but was never judgemental in his approach. His images do what photography does best: freeze a moment in history for ever.

Robert Capa
Images of War. Paul Hamlyn, 1964

The founder of the great Magnum agency, he was a very romantic character but a great photographer. He was killed on asignment in Indo-China.

Henri Cartier-Bresson
Henri Cartier-Bresson: The Man, the Image and the World – A Retrospective. Thames & Hudson, 2003.

I would say that he was the most influential reportage photographer of them all. His extraordinary compositional ability raised reportage photography to an art form.

Elliot Erwitt
Photographs and Anti-photographs. Thames & Hudson, 1972

A versatile photographer. He could handle any subject matter, but is most famous for the wicked sense of humour that pervades much of his work.

W. Eugene Smith
The Camera as Conscience. Thames & Hudson, 1998

Probably my biggest influence as a young aspiring photographer. A man with a deep commitment to his subject matter, a superb printmaker, and a great composer of photographs.

Don McCullin
Sleeping With Ghosts. Jonathan Cape, 1994

An English photojournalist who became the great documenter of the Vietnam war. He has covered much of the trouble and strife of the world since with equal skill.

Sebastiao Salgado
Workers. Phaidon Press, 1997

Salgado became a photographer in his 30s and continues to produce powerful, heroic images. He tends to choose long-term projects.

Index

Page numbers in *italics* refer to picture
captions. Those in **bold** refer to main
entries

A

Adams, Ansel 6, *8,* 76, 123

aperture 11–12, 41, 84, 131

architecture 115, **116–29, 134–5**

 composition *8,* 116–17, 123, *125*

 contrast 116

 filters 116–17, 119, 123, 136

 interiors 126–9

 lens selection *116,* 126

 lighting 126–9

 patterns 118–21

 printing techniques

 burning in 128, *136*

 cropping *125*

 exposure 128

 paper selection 119, 124

 shading/dodging 116, 124

the arts **130–5**

 camera angle 133, *134*

 composition 132–5, *144*

 contrast 133–4, 142–5

 portraits 23–5, 44–7

 printing techniques

 bleaching back 144

 burning in *131,* 144

 paper selection *131,* 144

C

camera angle

 art shots 133, *134*

 landscapes 74, 78, *81,* 83, *84*

 portraits *8,* 23, 26, *28,* 47, 57

reportage 140, *157, 163*

still life 93, 96

close-up photography 31, *33,*
 110–13

composition

 architecture shots *8,* 116–17, 123,
 125

 art shots 132–5, *144*

 nudes *106*

 portraits *9,* 30–1, *34,* 36–9, 50–3

 reportage 140–1, *144, 149,* 159–60,
 164

 still life 96, *98, 99,* 103, 110, *113*

 wedding photographs 36–9, *149*

contact sheets 14, 16

contrast 20–5, *34,* 96–9, 116, 133–4,
 142–5

corporate photography 162–5

D

developer 14, 24, 39, 84, 124, 140

digital photography

 versus film 8–9

 printing techniques 14, 70

 retouching *18,* 19

 for weddings 146

E

exposure

 auto 68, *129*

 bracketing 63, *113*

 with filters 13, 70, 93, 95

 in printing techniques 16

 architecture 128

 landscapes *68, 73, 76, 80,* 84

nudes 105

portraits 37

reportage 140, 160, 164

still life 93, 95

F

F64 Group 123

Farmer's Solution *17,* 19, 64, 88, 100,
 144

film 10–11

 versus digital 8–9

 film speed 10, 14, 23, 74, 88, 134,
 154

 grain *7,* 10, 14, 23, 74, 154

 infra red 76

filters 13

 in exposure 13, 70, 93, 95

 neutral density *13,* 70

 orange *7,* 78, 123

 polarizing 13, 83, 128

 red

 architecture shots 116–17, 119,
 136

 landscapes *7, 13,* 58, 68, 70

 still life *91*

 soft focus 93, *95,* 105

 warming 105

 yellow 28

flash fill *17,* 57, 58–9, *157*

flash guns 58, 93

focal length 12–13, 37, 88

foreground *58, 63,* 64, *66,* 84, *123*

formats 10, 123–4

G

grain *7, 10,* 14, 23, 74, 154

L

landscapes **60–83**

 camera angle 74, 78, *81,* 83, *84*

 filters *7, 13,* 58, 66, 70, 78, 83

 foreground *58, 63,* 64, *66,* 84

 lens selection 67–8, 74

 lighting 67, 70, 78, 83

 printing techniques

 bleaching back *17,* 64, *76*

 burning in *15,* 63, 64, 70, 72, *73, 76,* 80

 exposure *68, 73, 76, 80,* 84

 paper selection 74

 shading/dodging *66, 76*

 test prints 63–4, 66, *72,* 84

 toning 78, 80, *81*

 reportage 82–5

 tonal management *17*

 urban *8,* 82–5

 visualization 61, 63, 66–9, 70, 72, *76,* 78

weather *17,* 67, 74

lenses 12–13

 for architecture shots *116,* 126

 for landscapes 67–8, 74

 mirror *12*

 perspective control *8,* 12, *91,* 136–7

 for portraits *12,* 23, 26

 for still life 110

 telephoto 12, 72, *116*

 wide-angle 12, 33, 67–8, *116,* 126, *134*

 zoom *7, 9,* 23, 26, *91,* 110, 126

light boxes 110

lighting 8–9

 architecture shots 126–9

 backlight *17,* 23, 58, 70

 daylight *7,* 26–7, *28,* 96, 126–9

 diffused *17,* 23

 flash fill *17,* 57, 58–9, *157*

 flood lamps 31

 high-key 23–5, *28,* 110, 130–1

 landscapes 67, 70, 78, 83

 low-key *26,* 96–9, 130–1

 nudes 105

 portraits *7, 9, 17,* 22–7, *28,* 31, 41, 57

 with reflectors 26, *28,* 31, 33, 51, 110

 silhouettes 78, *105,* 142–5

 spotlights *28*

 still life 93, 96–9, 110

 window light *7,* 26–7, *28,* 96, 126–9

M

mirror lenses *12*

N

negatives 14

 inter negs 105

neutral density filters 13, 70

nudes 87, **104–9**

 composition *106*

 lighting 105

 printing techniques

 exposure 105

 paper selection 106

 toning 106

O

one-bath toners 18

P

paper grade selection

 architecture shots 119, 124

 art shots *131,* 144

 landscapes 74

 nudes 106

 portraits *14,* 23, *31, 44,* 52

 reportage 144, 151, 156, 164

 still life 100, 103

papers 16, 18

photojournalism 82–5, 150, 156–61

Photoshop (Adobe) 14, *18,* 19, 70

polarizing filters 13, 83, 128

portraits **20–57**

 animals 58–9

 beauty portraits 28–9

 camera angle *8,* 23, 26, *28,* 47, 57

 of children 56–7

 composition *9,* 30–1, *34,* 36–9, 50–3

 contrast 20–5, *34*

 film speed *10*

 filters 28

 group portraits 54–5

 lens selection *12,* 23, 26

 lighting *7, 9, 17,* 22–7, *28,* 31, 41, 57

 printing techniques

 bleaching back *49*

 burning in *15, 17,* 37, 41, 43, 48, 52, *54*

 cropping 47–8, *53*

 exposure 37

 flashing in *18*

paper selection *14, 23, 31, 44,* 52

 shading/dodging *15,* 23, 43

 test prints 24, *34,* 43, *44,* 52

 toning *17,* 48, *49*

reportage *9, 15,* 40–3, 46–9, *164*

studio portraits 30–1

tonal management *17,* 23, 34, 37, *38*

travel portraits 32–5, 44–5

visualization 26, 33–4, *43,* 44, 47, 48, 51

printing techniques **14–19**

 additive printing 16, 70, 72

 bleaching back 19

 art shots 144

 landscapes *17,* 64, *76*

 portraits *49*

 reportage 144

 still life 88, 100

 burning in 16

 architecture shots 128, *136*

 art shots *131,* 144

 landscapes *15,* 63, 64, 70, 72, *73, 76,* 80

 portraits *15, 17,* 37, 41, 43, 48, 52, *54*

 reportage 144, 146, 151, *152,* 156, *157,* 160, *163*

 still life 88, 95, 99, 112

 cropping 47–8, *53, 125, 140*

 exposure 16

 architecture shots 128

 landscapes *68, 73, 76, 80,* 84

 nudes 105

 portraits 37

 reportage 140, 160, 164

still life 93, 95

flashing in 16, 18

 portraits *18*

 reportage 146, *148, 157*

 still life 99

highlights 16, 18, 164, *165*

paper selection 16

 architecture shots 119, 124

 art shots *131,* 144

 landscapes 74

 nudes 106

 portraits *14,* 23, *31, 44,* 52

 reportage 144, 151, 156, 164

 still life 100, 103

retouching *18,* 19

shading/dodging 16

 architecture shots 116, 124

 landscapes *66, 76*

 portraits *15,* 23, 43

 reportage 146, 164, *165*

 still life 112

spotting *18,* 70, *73*

subtractive printing 16, 43, 70, 72

test prints

 landscapes 63–4, 66, *72,* 84

 portraits 24, *34,* 43, *44,* 52

 reportage *152,* 156, *157*

 still life 100, *103,* 112

toning 18–19

 landscapes 78, 80, *81*

 nudes 106

 portraits *17,* 48, *49*

 toning kits 18, *49*

 see also tonal management

reportage *6,* **138–65**

 camera angle 140, *157, 163*

 composition 140–1, *144, 149,* 159–60, *164*

 contrast 142–5

 landscapes 82–5

 portraits *9, 15,* 40–3, 46–9, *164*

 printing techniques

 bleaching back 144

 burning in 144, 146, 151, *152,* 156, *157,* 160, *163*

 cropping *140*

 exposure 140, 160, 164

 flashing in 146, *148, 157*

 paper selection 144, 151, 156, 164

 shading/dodging 146, 164, *165*

 test prints *152,* 156, *157*

 still life 100–1

 tonal management 151, *152,* 154–7

resolution 10, 14, *34*

revisiting shots 23, 28

S

safety issues 19, 106

shutter speed *11,* 12, 26

still life *6,* 87, **88–103**

 camera angle 93, 96

 composition 96, *98,* 99, 103, 110, *113*

 contrast 96–9

 filters *91,* 93, 95

 flowers 110–13

 hands 100–3

 lens selection 110

 lighting 93, 96–9, 110

G

grain *7, 10,* 14, 23, 74, 154

L

landscapes **60–83**

 camera angle 74, 78, *81,* 83, *84*

 filters *7, 13,* 58, 66, 70, 78, 83

 foreground *58, 63,* 64, *66,* 84

 lens selection 67–8, 74

 lighting 67, 70, 78, 83

 printing techniques

 bleaching back *17,* 64, *76*

 burning in *15,* 63, 64, 70, 72, *73,*
 76, 80

 exposure *68, 73, 76, 80,* 84

 paper selection 74

 shading/dodging *66, 76*

 test prints 63–4, 66, *72,* 84

 toning 78, 80, *81*

 reportage 82–5

 tonal management *17*

 urban *8,* 82–5

 visualization 61, 63, 66–9, 70, 72, *76,*
 78

weather *17,* 67, 74

lenses 12–13

 for architecture shots *116,* 126

 for landscapes 67–8, 74

 mirror *12*

 perspective control *8,* 12, *91,* 136–7

 for portraits *12,* 23, 26

 for still life 110

 telephoto 12, *72, 116*

 wide-angle 12, 33, 67–8, *116,* 126,
 134

 zoom *7, 9,* 23, 26, *91,* 110, 126

light boxes 110

lighting 8–9

 architecture shots 126–9

 backlight *17,* 23, 58, 70

 daylight *7,* 26–7, *28,* 96, 126–9

 diffused *17,* 23

 flash fill *17,* 57, 58–9, *157*

 flood lamps 31

 high-key 23–5, *28,* 110, 130–1

 landscapes 67, 70, 78, 83

 low-key *26,* 96–9, 130–1

 nudes 105

 portraits *7, 9, 17,* 22–7, *28,* 31, 41,
 57

 with reflectors 26, *28,* 31, 33, 51, 110

 silhouettes 78, *105,* 142–5

 spotlights *28*

 still life 93, 96–9, 110

 window light *7,* 26–7, *28,* 96, 126–9

M

mirror lenses *12*

N

negatives 14

 inter negs 105

neutral density filters 13, 70

nudes 87, **104–9**

 composition *106*

 lighting 105

 printing techniques

 exposure 105

 paper selection 106

 toning 106

O

one-bath toners 18

P

paper grade selection

 architecture shots 119, 124

 art shots *131,* 144

 landscapes 74

 nudes 106

 portraits 14, 23, *31, 44,* 52

 reportage 144, 151, 156, 164

 still life 100, 103

papers 16, 18

photojournalism 82–5, 150, 156–61

Photoshop (Adobe) 14, *18,* 19, 70

polarizing filters 13, 83, 128

portraits **20–57**

 animals 58–9

 beauty portraits 28–9

 camera angle *8,* 23, 26, *28,* 47, 57

 of children 56–7

 composition *9,* 30–1, *34,* 36–9, 50–3

 contrast 20–5, *34*

 film speed *10*

 filters 28

 group portraits 54–5

 lens selection *12,* 23, 26

 lighting *7, 9, 17,* 22–7, *28,* 31, 41,
 57

 printing techniques

 bleaching back *49*

 burning in *15, 17,* 37, 41, 43, 48,
 52, *54*

 cropping 47–8, *53*

 exposure 37

 flashing in *18*

paper selection *14*, 23, *31*, *44*, 52

shading/dodging *15*, 23, 43

test prints 24, *34*, 43, *44*, 52

toning *17*, 48, *49*

reportage *9*, *15*, 40–3, 46–9, *164*

studio portraits 30–1

tonal management *17*, 23, 34, 37, *38*

travel portraits 32–5, 44–5

visualization 26, 33–4, *43*, 44, 47, 48, 51

printing techniques **14–19**

additive printing 16, 70, 72

bleaching back 19

 art shots 144

 landscapes *17*, 64, *76*

 portraits *49*

 reportage 144

 still life 88, 100

burning in 16

 architecture shots 128, *136*

 art shots *131*, 144

 landscapes *15*, 63, 64, 70, 72, *73*, *76*, 80

 portraits *15*, *17*, 37, 41, 43, 48, 52, *54*

 reportage 144, 146, 151, *152*, 156, *157*, 160, *163*

 still life 88, 95, 99, 112

cropping 47–8, *53*, *125*, *140*

exposure 16

 architecture shots 128

 landscapes *68*, *73*, *76*, *80*, 84

 nudes 105

 portraits 37

 reportage 140, 160, 164

still life 93, 95

flashing in 16, 18

 portraits *18*

 reportage 146, *148*, *157*

 still life 99

highlights 16, 18, 164, *165*

paper selection 16

 architecture shots 119, 124

 art shots *131*, 144

 landscapes 74

 nudes 106

 portraits *14*, 23, *31*, *44*, 52

 reportage 144, 151, 156, 164

 still life 100, 103

retouching *18*, 19

shading/dodging 16

 architecture shots 116, 124

 landscapes *66*, *76*

 portraits *15*, 23, 43

 reportage 146, 164, *165*

 still life 112

spotting *18*, 70, *73*

subtractive printing 16, 43, 70, 72

test prints

 landscapes 63–4, 66, *72*, 84

 portraits 24, *34*, 43, *44*, 52

 reportage *152*, 156, *157*

 still life 100, *103*, 112

toning 18–19

 landscapes 78, 80, *81*

 nudes 106

 portraits *17*, 48, *49*

 toning kits *18*, *49*

 see also tonal management

reportage *6*, **138–65**

camera angle 140, *157*, *163*

composition 140–1, *144*, *149*, 159–60, *164*

contrast 142–5

landscapes 82–5

portraits *9*, *15*, 40–3, 46–9, *164*

printing techniques

 bleaching back 144

 burning in 144, 146, 151, *152*, 156, *157*, 160, *163*

 cropping *140*

 exposure 140, 160, 164

 flashing in 146, *148*, *157*

 paper selection 144, 151, 156, 164

 shading/dodging 146, 164, *165*

 test prints *152*, 156, *157*

still life 100–1

tonal management 151, *152*, 154–7

resolution 10, 14, *34*

revisiting shots 23, 28

S

safety issues 19, 106

shutter speed *11*, 12, 26

still life *6*, 87, **88–103**

camera angle 93, 96

composition 96, *98*, 99, 103, 110, *113*

contrast 96–9

filters *91*, 93, 95

flowers 110–13

hands 100–3

lens selection 110

lighting 93, 96–9, 110

minimalist 88–91, 102–3

printing techniques

 bleaching back 88, 100

 burning in 88, 95, 99, 112

 exposure 93, 95

 flashing in 99

 paper selection 100, 103

 shading/dodging 112

 test prints 100, *103,* 112

reportage 100–1

shadows 88–91

tonal management 88, 92–5

T

telephoto lenses 12, 74, *116*

tonal management 12

 landscapes *17*

 portraits *17, 23,* 34, 37, *38*

 reportage 151, *152,* 154–7

 separation 12, 63, 64, *74,* 76

 still life 88, 92–5

V

visualization 7–8

 landscapes 61, 63, 66–9, 70, 72, *76,* 78

 portraits 26, 33–4, 37, *43,* 44, 48, 51

 still life 88, 93, 99, 110

W

washing 18

wedding photography 36–9, 139, 146–9

Weston, Edward *8,* 96, 123

wide-angle lenses 12, 33, 67–8, *116,* 126, *134*

Z

zoom lenses 7, *9,* 23, 26, *91,* 110, 126

Acknowledgments

Thanks to Graeme Harris for all his wise advice and support. To Michelle Garrett for her help in choosing pictures. To Bob Siebenmann for his help with the computer. To Agnieszka for her support throughout the book's birth. To my editor Peter Taylor for his expertise and also his patience. To Anna Sanderson for commissioning the book. To Michèle Byam for her wise counselling when things were difficult. To Sarah Rock and Jeremy Williams for their perseverance in putting up with a bolshie author and coming through with a fine layout.

And special thanks to all the people who became the subjects for my pictures.

My website is www.johngarrett.co.uk